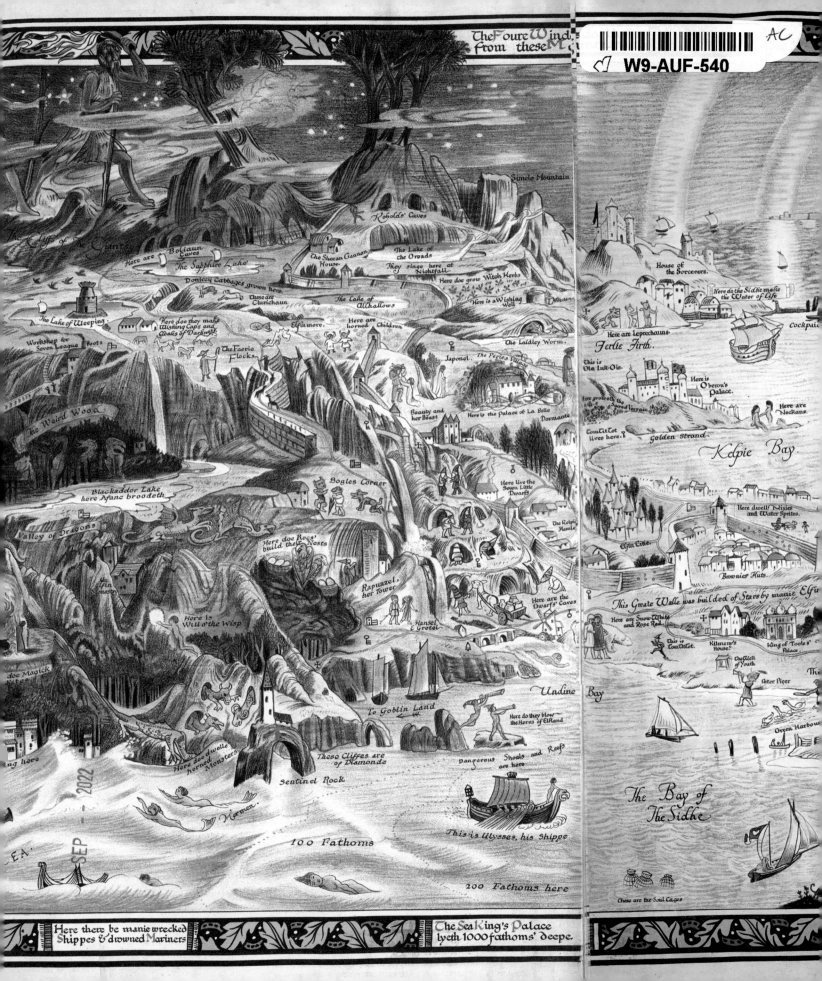

THE FANTASY OF THE MIDDLE AGES

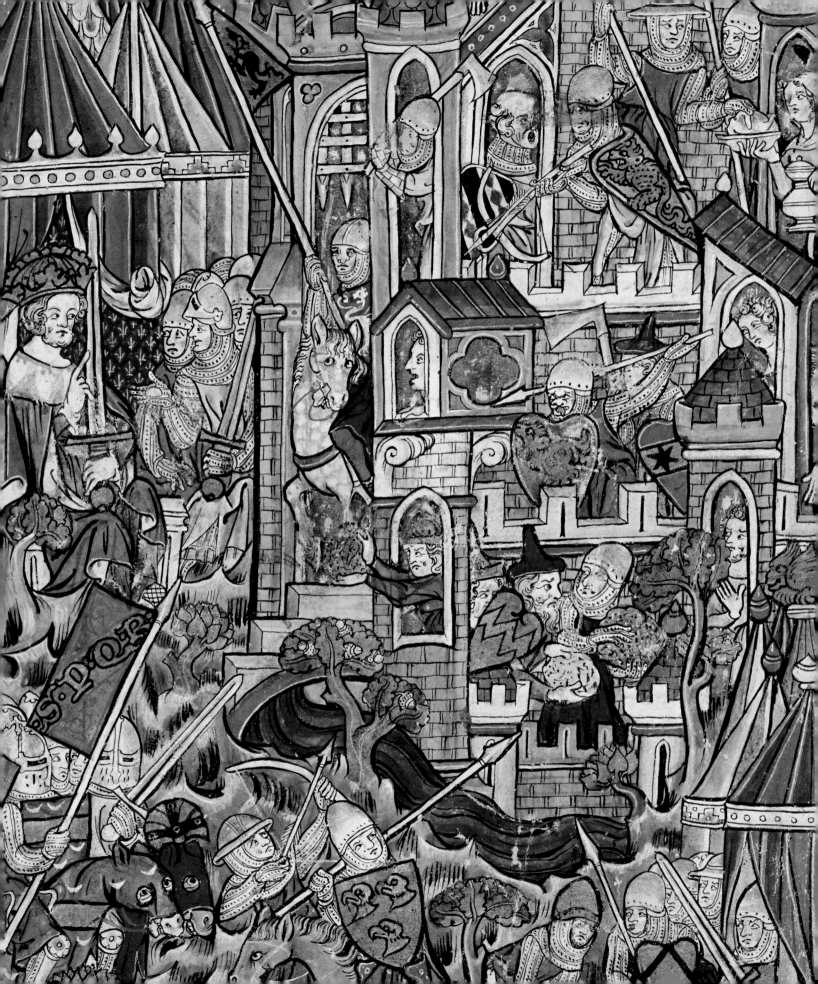

The Fantasy of the Middle Ages

An EPIC JOURNEY THROUGH IMAGINARY MEDIEVAL WORLDS

LARISA GROLLEMOND and BRYAN C. KEENE

J. PAUL GETTY MUSEUM LOS ANGELES

Contents

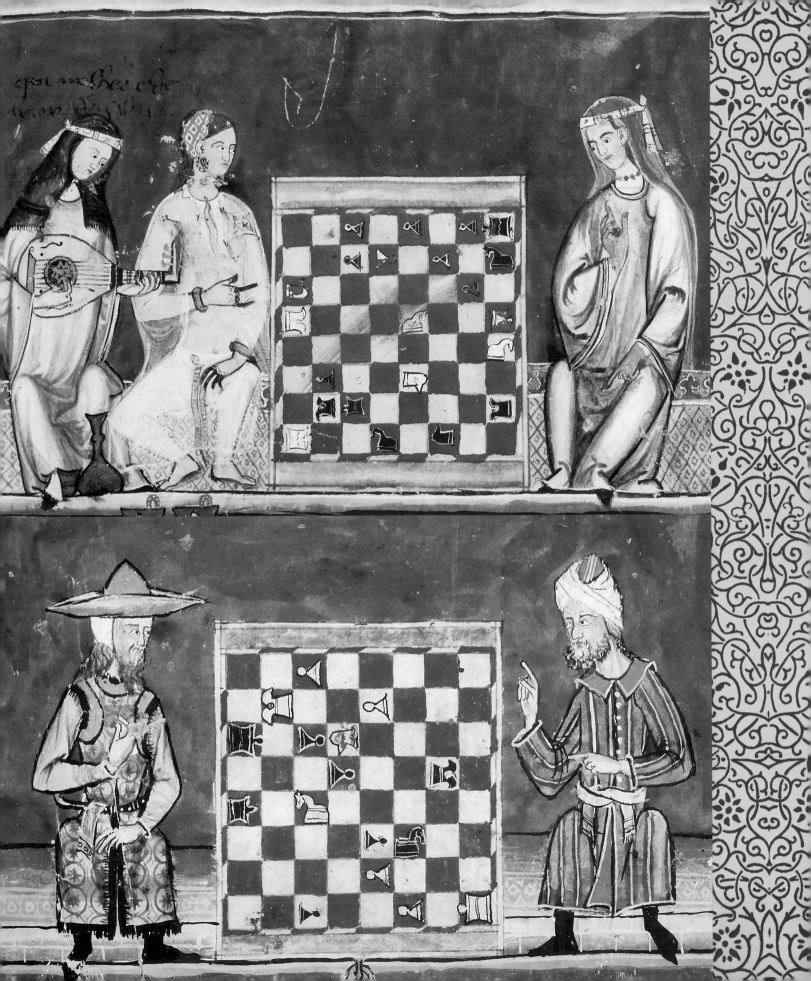

foreword

The history and culture of the Middle Ages have long been a source of fascination and imaginative (re)creation by later generations, from the Gothic Revival in nineteenth-century architecture to the nostalgic idealization of Disney's *Sleeping Beauty* (1959) and the brutal intrigues portrayed in the recent television series *Game of Thrones*. Such tropes, however, despite their insistently visual representations, are largely based not on medieval reality but on fantastical reimaginings of the period. But how and why and for whom did these episodes of medievalizing emulation come about? What are the kernels of truth to be found in these modern constructs, and what has been erased from the reality of medieval life in favor of popularization and commodification?

The Fantasy of the Middle Ages addresses these questions through an exploration of how the Middle Ages has been interpreted, manipulated, rejected, exploited, and revitalized to suit modern tastes and needs. Bridging a thousand years of culture history, we hope that this volume will serve both to deepen knowledge and appreciation of medieval art and culture and play a key role in our outreach to the diverse communities we serve in Los Angeles and beyond. Indeed, many of the issues of identity, migration, oppression, faith, and prejudice that characterized medieval life find echoes in today's movements for social justice and inclusion. This is fertile ground for new narratives and fresh perspectives, showing how medieval visual culture impacts and intersects with the modern age.

This publication accompanies an exhibition of the same title presented in June to September of 2022 at the J. Paul Getty Museum. Our thanks are due to the two curators of that exhibition, who are also the authors of this publication: Larisa Grollemond, assistant curator of manuscripts at the Getty Museum; and Bryan C. Keene, assistant professor of art history at Riverside City College and a former associate curator of manuscripts at Getty. Numerous other departments of the museum contributed to the success of this enterprise, including teams in Curatorial, Exhibitions, Conservation, Design, Education, Interpretive Content, Public Programs, Publications, and Communications. We are greatly indebted also to colleagues across California for loans and image rights. I especially thank staff at the institutions who allowed their treasures to be displayed in our galleries: Getty Research Institute; William Andrews Clark Memorial Library at UCLA; Special Collections at the Charles Young Research Library at UCLA; the English Reading Room at UCLA; Fine Arts Museums of San Francisco; Mark Hilbert and the Hilbert Museum of California Art; Los Angeles County Museum of Art; Walt Disney Animation Research Library; and Walt Disney Archives.

Timothy Potts
Maria Hummer-Tuttle and Robert Tuttle Director
J. Paul Getty Museum

Preface

Michele Clapton

Fantasy is a genre with epic scope, often with an abundance of characters, places, and elements that can feel real and familiar, even grounded in history, but which are enhanced with magical effects. This last component of the magical or the fantastical—dragons, unicorns, wizards, fairies, or paintings that speak—tells us we are in some other reality or perhaps in the wondrous and possibly terrifying realm of the imagination. With works of art, theater, television, or fashion that reference elements of medieval history, we as viewers glimpse a readymade world from humankind's collective past, and we learn about documented events that have been passed down through material evidence as fact. Fantasy, by contrast, offers creators boundless possibilities for conceiving a unique world. But herein lies the great challenge: for a fantasy world to be believable, it needs a structure. Successful world-making often requires a considerable amount of research and time spent gathering sources of inspiration. The contours of these fantasy-realities are most clearly defined when there are specific societies based on localized resources, climate, and social hierarchy. If we want our audiences to believe that there is plausibility behind the fantasy, it must feel real even when it is firmly planted in fiction.

When I started working as the costume designer for the HBO series *Game of Thrones* (based on George R. R. Martin's popular book series *A Song of Ice and Fire*), I decided after discussions with the writers and creatives that the costumes for this fantasy show would be rooted

in reality and would not appear too fantastical or over-the-top. I wanted there to be a reason why people wore each look and that it was appropriate to their environment and history.

For this fantasy set in a dystopian, medieval-inspired realm, I gathered my references from everywhere—I cast my net widely! The sartorial language of medieval and early modern European clothing, for example, provides references for establishing status through dress. I also researched Mediterranean manuscripts, samurai armor from Japan, and Northern European armor and weaving. I explored everything from Byzantine imperial visual sources to the crafts of Indigenous peoples living in climate extremes. I think there is a risk with fantasy to pursue one source material too directly, so much so that it becomes too dominant and the fantasy element is lost and comparisons with a true historical period become distracting.

Costume and accessories—including textiles, embroidery, armor, and even the furnishings of a room or trade goods of a place—are essential storytelling devices, just as much in fantasy as in period pieces. That was a guiding principle when I worked on the series *The Crown*, about the life of Queen Elizabeth II. As with *Game of Thrones*, I again immersed myself in research, but this time the specific historical source material was of key importance, knowing that viewers would be able to compare quickly how we did with the originals, from photographs and news media and sometimes surviving ensembles.

The color, texture, and silhouette of a garment each play a role in helping me to establish a character's personality and identity. These aspects help draw us into the worlds created by artists, writers, filmmakers, and designers.

It is also incredibly interesting to see how styles and designs from much earlier periods continue to influence costumes through history, even into more contemporary periods. For example, the shape of sleeves or trousers or even shoes are revisited and sometimes re-appropriated. Medieval armor techniques can be seen as an influence in the construction of protective motorbike gear and sportswear, using new high-tech materials. In other instances, a few brave souls might create a fashion cult using costume cuts from an earlier era. The New Romantics, a fashion movement of the 1980s characterized by flamboyant and glamorous androgyny, embraced looks from medieval times through the Renaissance, Gothic Revival, and beyond, mixing them to create original looks. These styles are then often picked up by fashion designers and in turn eventually influence mainstream fashion, albeit in a less original way. Fashion, like fantasy, is open to possibility, expanded by this mix of borrowing and creation that can lead to something entirely new.

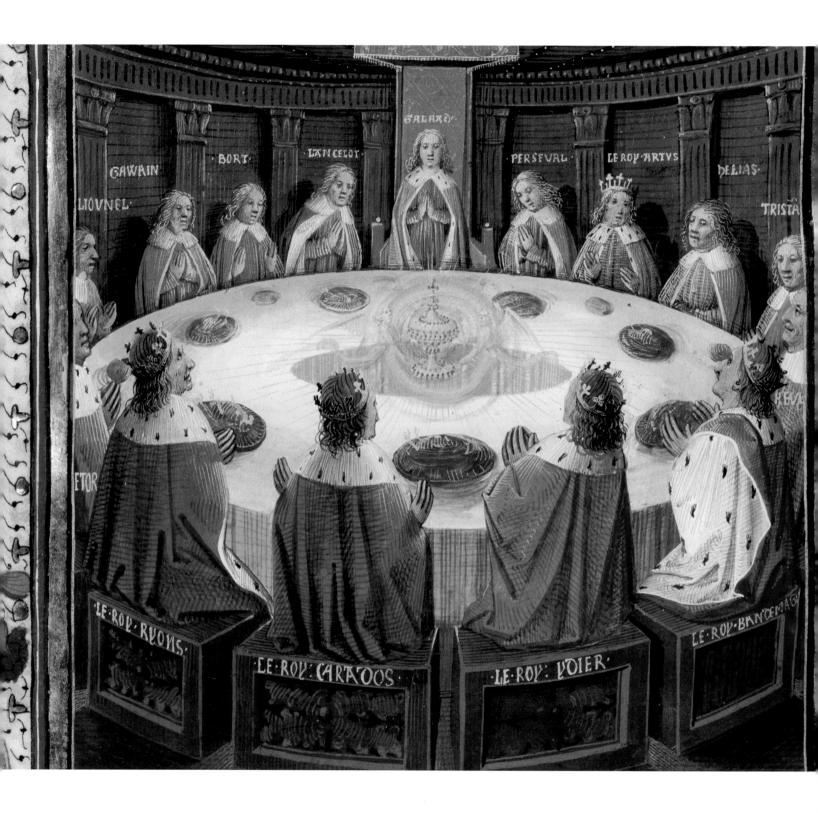

Introduction:
An Arthur Tale
for Every Generation

Imagine the tale of King Arthur and the Knights of the Round Table. Which characters come to mind? What is the setting? When does the story take place? Is there magic? If you imagined a gallant cohort of chivalrous knights dressed in gleaming armor and gathered at a round table, damsels with long hair and flowing gowns, a mighty sword either pulled from a stone or bequeathed by an aquatic nymph, a wizard, fantastical fey folk, and a luxuriously furnished court, then you might be surprised to learn that those elements are an amalgamation of Arthur stories as told over many centuries **(Fig. 1)**. Though there is sparse evidence that Arthur was a historical figure who

may have lived in England in the fifth or sixth century, his story quickly moved into the realm of legend, taking on larger-than-life elements from the first handmade decorated books chronicling his adventures in about the twelfth century to today.

The path of the Arthur stories, from about 500 to 1500, bookends what scholars call the European "Middle Ages" or "medieval" period, which might conjure

Figure 1
Évrard d'Espinques, *King Arthur and the Knights of the Round Table* in vol. IV of *Lancelot in Prose*, by Robert de Boron, about 1475. Paris, Bibliothèque nationale de France, Ms. fr. 116, fol. 610v

images of castles, cathedrals, crusades, and chronic diseases. Indeed, the "Dark Ages"—an idea evoked by the Italian writer Petrarch in the 1300s as a contrast to his own time and a phrase used pejoratively in texts from the 1500s to today—were always the Illuminated Ages, as you will discover by turning these pages. During this time, kingdoms across Europe and the Mediterranean witnessed the growth of cities, the emergence of new religious orders, large-scale military conflicts, and higher mortality rates than today. From this corner of the world, people were connected to communities throughout greater Europe, Africa, Asia, and briefly North America, and some traveled

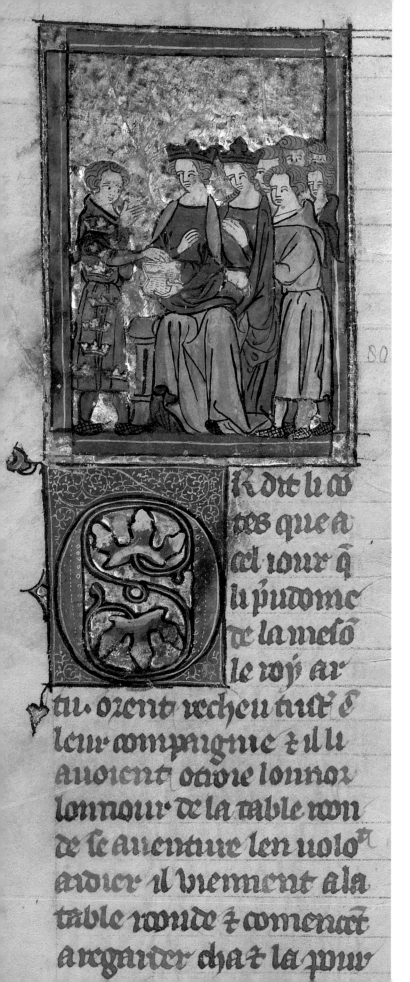

extensively. Scribes and artists of the time produced a vibrant culture of illuminated manuscripts, whose stories and images have inspired many creative genres to the present, especially that of fantasy. The understanding of this period has been expanded to encompass what can be called a global Middle Ages that includes traditions beyond Europe, and that critiques the combined legacies of European colonialism and even the Eurocentric term "medieval" itself as a time supposedly marking the middle of the history between ancient Rome and the Renaissance. Some myths about the period have created a misperception of the Middle Ages as predominantly for and about fully abled, white, wealthy, Christian, heterosexual, cisgender men (and sometimes women). Looking back to this past has become ingrained in popular culture, influencing revivalist versions of the medieval in art, architecture, literature, photography, film, television, reenactment, graphic novels, video games, and theme parks. These works of fantasy, sometimes referred to as medievalisms, blend historical source material to create worlds with legendary or magical elements in their characters, creatures, costumes, and cultures.

There are as many medieval variations about King Arthur, Queen Guinevere, the knight Lancelot and his companions of the Round Table, the wizard Merlin, and the elusive Lady of the Lake as there are published, theatrical, and cinematic versions. In the 1130s, Welsh cleric and writer Geoffrey of Monmouth (about 1095–1155) wrote the chronicle *The History of the Kings of Britain*, in which Arthur defeated the Saxons, wielded the sword Caliburnus (which in French becomes Excalibur), and established himself as King of the Britons. We also meet Arthur's beloved Guinevere, and in other texts by the author, we encounter the prophet-seer (wizard) Merlin. Later, in the 1170s–90s, the French poet-composer Chrétien de Troyes (active 1160–1191) added the court at Camelot, the quest for the Holy Grail—the cup that Christ drank from during the Last Supper—as well as the knight Lancelot and his love affair with Guinevere, and Morgan Le Fay as Arthur's sister. The 1100s also saw the emergence of narratives centered on other members of the chivalric entourage, including Tristan and Iseult **(Fig. 2)** and Perceval.

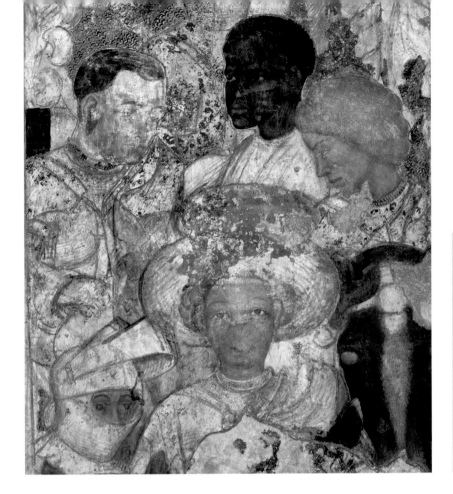

Many of the Arthur stories developed as part of the genre known as Romance—action-packed adventure stories involving heroes or quests that were popular in court settings—or as non-rhyming and non-metered prose accounts. Some of these quests are well known in later retellings, while others have received greater attention by scholars. In the 1200s, Arthur's world expands, beginning with the French poet Robert de Boron (fl. late 1200–early 1300s) who told of the famed Sword in the Stone and provided a lengthy Christian backstory for the Grail. Contemporaneous texts also describe Black Africans as key protagonists, including the German poem *Parzival*, in which the titular protagonist's half-brother, Feirefiz, was born to Gahmuret and the Black queen Belacane, as well as the Dutch *Legend of Sir Morien* (also called *Moriaen*) or the French prose tales of *Tristan* and *Palamedes*, each of which includes Black knights of the Round Table **(Fig. 3)**. By the 1300s, Jacques de Longuyon (active about 1290–1312) situated King Arthur of the Britons, as he is called, among his Nine Worthies, heroic rulers from antiquity and Jewish and Christian history (Hector of Troy, Alexander the Great, Julius Caesar; Joshua, David, and Judah Maccabee; and King Arthur, Holy Roman Emperor Charlemagne, and Godfrey of Bouillon, knight of the First Crusade) **(Fig. 4)**. The 1300s also saw the addition of new stories, especially that of *Sir Gawain and the Green Knight*, which follows one of the most well-known knights of the Round Table, Gawain, in his quest to accept a combat challenge from the mysterious Green Knight. In the late 1400s, *Le Morte d'Arthur* by English author Sir Thomas Malory (1415–1471) became the definitive version of the Arthur tale from the period and remains a popular account today **(Fig. 5)**. A century later, Edmund Spenser (1552–1599) included Arthur as a prince of perfect virtue amid a litany of characters and lovers of the titular Faerie Queen, demonstrating the wide-ranging appeal of this singular figure. The Arthurian stories of the Middle Ages, though concentrated in England and France, were popular across Europe, with

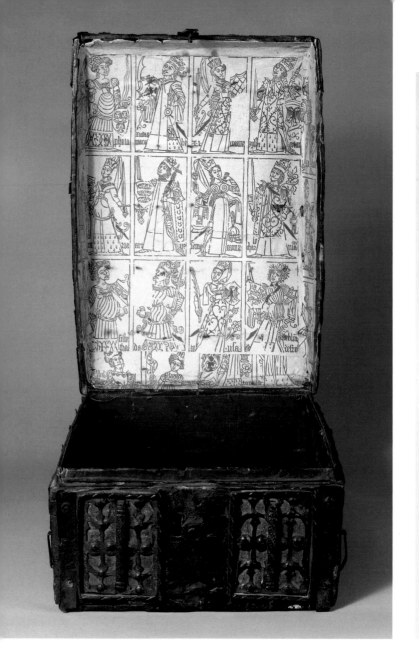

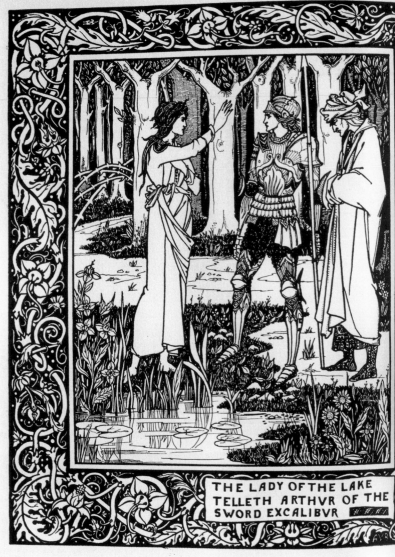

Figure 4
The interior of this medieval casket reveals a print of a fifteenth-century set of playing cards showing the Nine Worthies together with some of their female counterparts (Deiphylle, Hippolyta, Tomyris, Semiramis, Theuca) and a few rulers and servants shown as Black Africans (an individual called "Jacques," Lampheto, Penthesilea, the last of which was a mythical Amazon queen and one of the Female Worthies). King Arthur stands in the second row, second image from the left. Messenger's casket with a print of *Male and Female Worthies*, France, about 1500. Paris, Musée du Moyen-Age, Thermes de Cluny, Cl. 23527

Figure 5
Aubrey Beardsley, *The Lady of the Lake Telleth Arthur of the Sword Excalibur* in *Morte d'Arthur*, by Sir Thomas Malory, England, 1893–94 (text originally published by William Caxton, 1485; this printing, New York: E. P. Dutton, 1909). Fine Arts Museums of San Francisco, Achenbach Foundation for the Graphic Arts, 1963.30.38650.35

accounts in Czech, Dutch, German, Icelandic, Irish, Italian, Portuguese, Spanish, and Welsh.

As the legend developed gradually over time, the artwork and visual culture that continually shaped Arthur for new audiences reflected the costumes, architecture, and ideology of the periods in which they were created. Arthur stories always tell us much more about the social priorities, expectations, and values of the creators or historical moment in which they are made—concerns related to the Holy Land and Crusade, of chivalric courtly virtues, or of matters of national identity formation, for example—than they do about the Middle Ages as a whole. Many literary retellings and the artwork associated with them therefore have shaped these centuries-old ideas of who Arthur is, some of which are more indebted to the medieval source material than others.

The 1800s and 1900s witnessed a boom in Arthuriana, or accounts about the ruler. The most influential retelling is *Idylls of the King* (1859) by Alfred, Lord Tennyson (1809–1892), a dramatic, poetic version of Arthur's life based largely on Malory's work **(Fig. 6)**. Julia Margaret Cameron (1815–1879) staged photographs in the

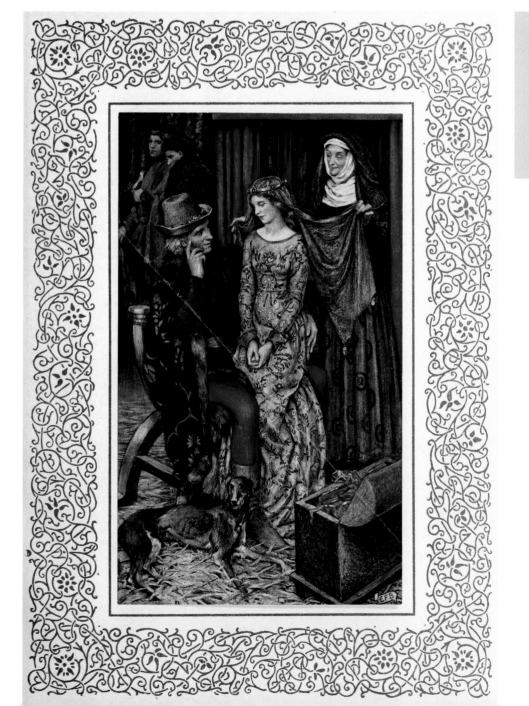

1870s of friends and family members as characters from Tennyson's account **(Fig. 7)**. This tradition for tableau vivant, or living picture, photographs can be seen as a precursor to the eventual moving pictures of cinema **(Fig. 8)**. A more satirical, lighthearted take (but with racist attitudes toward Indigenous peoples of North America) is Mark Twain's *A Connecticut Yankee in King Arthur's Court* (1889), which follows the adventures of an American industrialist who time travels to Camelot **(Fig. 9)**. Twain's version eventually reached Broadway (1927) and cinemas (1931 and 1949). Arthur stories for children became popular sites for illustration, including *The Story of King Arthur and His Knights* (1903), written by Howard Pyle (1853–1911) and based on both Malory and Tennyson

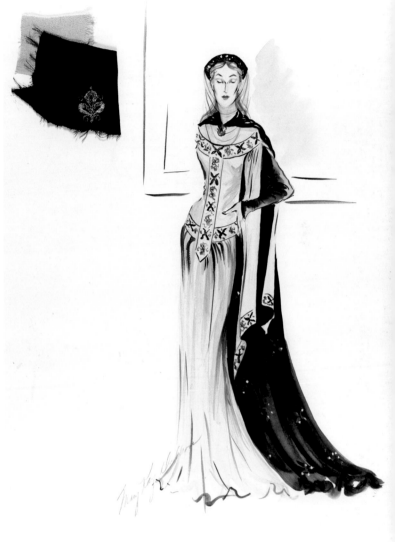

Figure 7
Julia Margaret Cameron, *The Passing of King Arthur*, Isle of Wight, England, 1874. Albumen silver print. Los Angeles, J. Paul Getty Museum, 84.XO.732.1.1.13

Figure 8
Ronald Ruthven Leslie-Melville, *Lady Middleton as "Elaine of Ascolat" and Sophy L. M.* in a tableau vivant from *Idylls of the King*, by Alfred, Lord Tennyson, England, 1871. Albumen silver print. Los Angeles, J. Paul Getty Museum, 86.XA.21.75

Figure 9
Mary Kay Dodson, costume sketch of Virginia Field as Morgan Le Fay in *A Connecticut Yankee in King Arthur's Court*, 1948 (Paramount Pictures). Gouache and pencil on paper with fabric swatch. Los Angeles County Museum of Art, Costume Council Fund, M.85.144.15

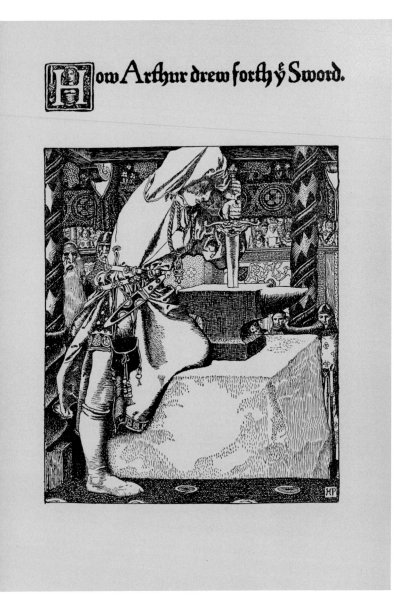

How Arthur drew forth ÿ Sword.

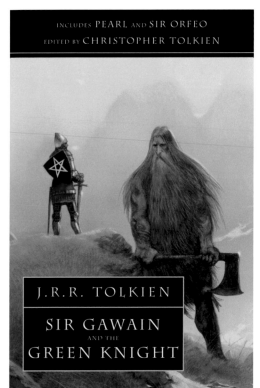

|||

Figure 10
Howard Pyle, *Arthur Pulling Excalibur from the Stone* in Pyle's *The Story of King Arthur and His Knights* (New York: C. Scribner's Sons, 1903). University of California, Los Angeles, Special Collections, Modern Juvenile Collection, PZ8.A7 P9a 1903

Figure 11
John Howe, cover art for *Sir Gawain and the Green Knight*, *Pearl*, and *Sir Orfeo*, translated by J. R. R. Tolkien (London: HarperCollins, 1996).

|||

(Fig. 10). Prior to introducing the world to the legendary land of Middle-earth, Oxford medievalist and philologist J. R. R. Tolkien (1892–1973) published a version of *Sir Gawain and the Green Knight* (1930) together with other tales from the past and also spoke publicly and wrote about medieval languages, fairy tales, and more **(Fig. 11)**. Everything is possible in the realm of Arthuriana, fantasy, and medievalism.

Arguably the most influential modern literary version of Arthur is by T. H. White (1906–1964): *The Once and Future King* (1958) portrays the legendary leader as a fourteenth-century Anglo-Norman ruler and casts Nimue, one of the names of the Lady of the Lake, who bestows the sword Excalibur on Arthur, as a water nymph and enchantress who ultimately traps Merlin. White leaves behind the possible historical origins of the fifth/sixth-century British king and embeds the idea of Arthur, and the romance between Guinevere and the knight Lancelot that has so captured the modern imagination, firmly in the fantasy of the Middle Ages. By contrast *The Mists of Avalon* (1982) by Marion Zimmer Bradley (1930–1999) is notable for telling the familiar Arthurian myths

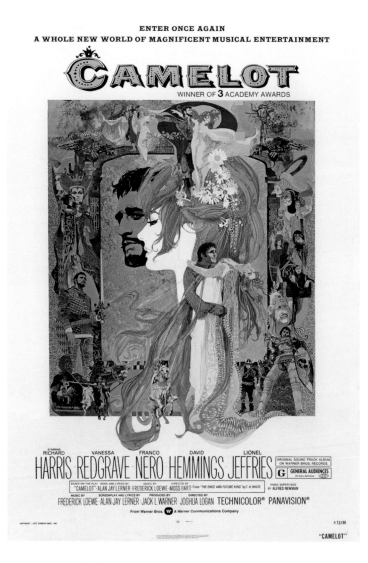

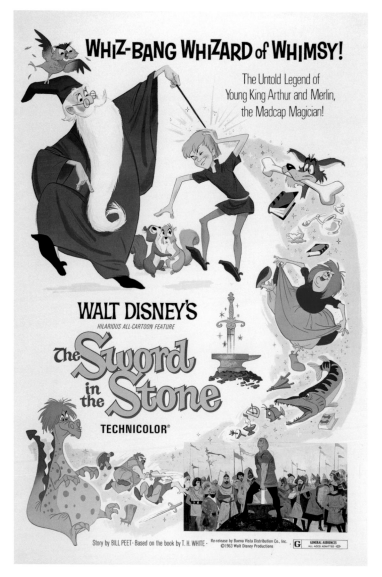

with the female characters at the center. These textual re-creations of the familiar Arthur legends helped to set the stage for a multitude of modern retellings in a wide variety of media: movies, television shows, video games, and graphic novels, among others.

Numerous stage and cinematic tellings of the story rely on White's version for plot and setting to varying degrees. The Broadway musical *Camelot* (1960), Disney's *The Sword in the Stone* (1963), *Excalibur* (1981), and *First Knight* (1995) all find inspiration from White **(Figs. 12–14)**. While actor Sean Connery may have been memorable

Figure 12
Winner of Academy Awards for best score, production design, and costume design, this film offered a romantic view of Arthur's court that also presented the legendary king as disillusioned with endless war, a subtle political commentary on the Vietnam War. Bob Peak and Bill Gold, poster for *Camelot*, 1967 (Warner Bros. Pictures)

Figure 13
Before becoming king, Arthur was just a boy called Wart who learned everything about the world from the wizard Merlin. Disney's animated version tells of King Arthur's coming-of-age in a story concerned with the themes of intellectual and technological progress. Poster for *The Sword in the Stone*, 1963 (Walt Disney Productions)

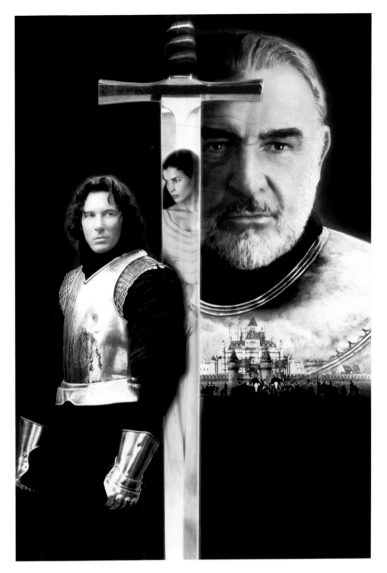

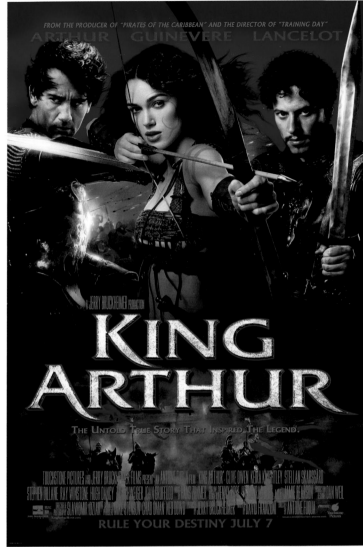

as King Arthur in *First Knight*, all of these versions of the story reflect an American nostalgic (and ultimately ahistorical) idea of the European Middle Ages as entirely populated by white people and embedded in nineteenth-century romantic ideas of chivalry and stories of unrequited love.

Arthur stories can also take the form of direct political commentary or simply provide entertainment even where we might not expect it. In the satirical *Monty Python and the Holy Grail* (1975) and its musical adaptation, *Spamalot* (2004), Arthur shares how the Lady of the Lake gave him Excalibur. The response from the peasant is a classic line: "Listen, strange women lying in ponds distributing swords is no basis for a system of government! Supreme executive power derives from a mandate from the masses, not from some farcical aquatic ceremony!" More tenuous connections to courtly Camelot can be found in DC Comics' *Camelot 3000* (1982–85), the extra-dimensional and occasionally time-traveling Marvel comics superhero team *Excalibur* (debuted in 1988), and the Las Vegas hotel and casino also named after the famed sword (opened in 1990).

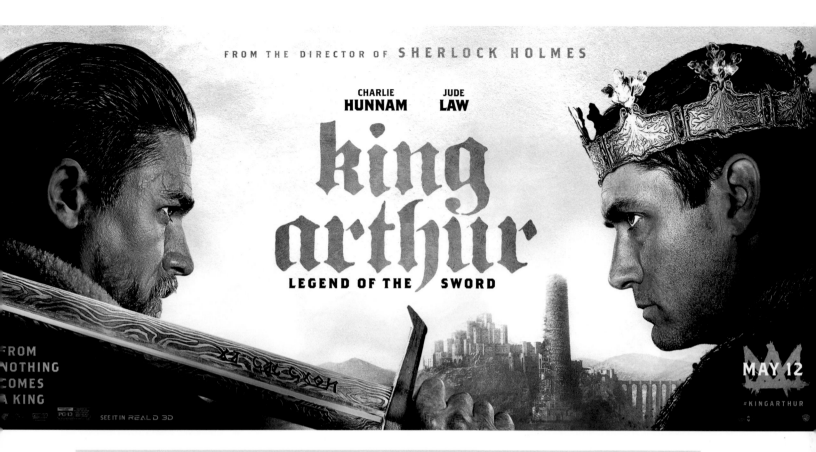

Figure 14
Chivalry and romance take center stage in a film that presents conventionally attractive white actors in the roles of Arthur, Lancelot, and Guinevere, reinforcing the vision of a heteronormative Middle Ages. As the tagline says, "Their greatest battle would be for her love." Poster for *First Knight*, 1995 (Columbia Pictures)

Figure 15
Guinevere was revised for twenty-first-century audiences as a warrior in an insurgency led by Merlin and the native Woads against Arthur, a British-Roman military commander. Despite the attempt at "historical accuracy," the film's marketing campaign showcases the love triangle between the protagonists. Poster for *King Arthur*, 2004 (Touchstone Pictures)

Figure 16
Vikings feature prominently as the antagonists while Arthur remains an idealized version of royal masculinity in this attempt at historicizing the legendary tale (which still features magical happenings). Poster for *King Arthur: Legend of the Sword*, 2017 (Warner Bros. Pictures)

In the last twenty years, filmmakers have attempted to revive the "historical" King Arthur, adding a grittier layer to the otherwise tame modern versions of the tale. *King Arthur* (2004) and Guy Ritchie's *King Arthur: Legend of the Sword* (2017) both set the story amid the collapse of the Roman Empire **(Figs. 15–16)**. In the former, Clive Owen stars as Arthur and Keira Knightly is the warrior-archer Guinevere, who is depicted as a pagan working with Merlin, the leader of the Woads (indigenous Britons fighting against Roman rule). In the latter, Charlie Hunnam plays Arthur in a film with Vikings, magic, and a cameo from the Lady of the Lake. These films give us a sense of how tenacious the legend is; their silk costumes and overall Gothic settings (which specifically reference the architecture of fourteenth- and fifteenth-century England and France) have been substituted for leather and various early "medieval" time periods when peoples migrated to or invaded England.

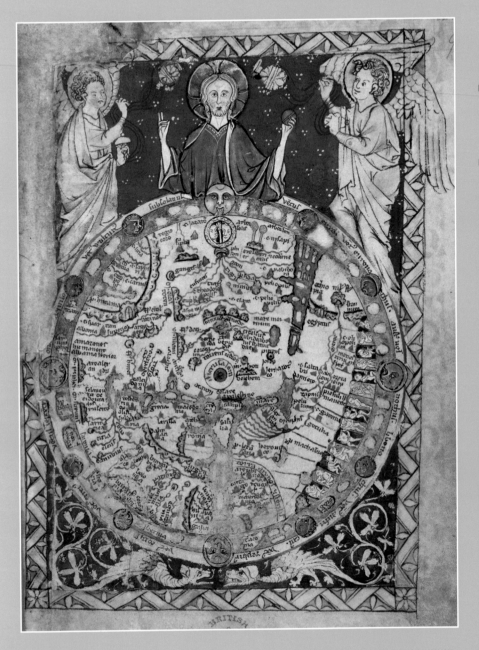

Figure 17
World map from a Psalter, London, about 1260.
London, British Library, Add. Ms. 28681, fol. 9

MAPPING MYTHICAL MEDIEVAL WORLDS

Maps existed in myriad forms in the Middle Ages, from manuscripts to murals, and these charts provide a glimpse into the medieval worldview and imagination. One of the best-known types shows the Earth, which people at the time knew was round, divided into Europe, Africa, and Asia (the so-called T-O map based on the arrangement of landmasses). The artist of one such map in a thirteenth-century manuscript included the names of cities, rivers, and mountains, as well as legendary creatures at the periphery **(Fig. 17)**. Mapmaking was both an art form and a skilled craft, which built upon centuries of scientific, geographic, and astrological studies.

Many fantasy texts inspired by the Middle Ages begin with or include a map as a reference to establish a credible geography for a magical realm. Maps of imaginary places play an integral role in the fantasy genre and are part of what we expect from this form of storytelling. Tolkien's Middle-earth of *The Hobbit* and *The Lord of the Rings* and George R. R. Martin's Westeros-Essos in *A Song of Ice and Fire* (HBO's *Game of Thrones*), for example,

both situate adventurers within the story spatially, with distinct kingdoms and households whose customs are informed by geography and climate **(Figs. 18-19)**. In the former, the elegant treetops of Lothlórien and sylvan abodes of the Greenwood (Mirkwood) are home to tall and willowy elves, while the deep places of the world are the dwellings of hard-edged dwarfs. Meanwhile, in the latter, the Starks of Winterfell—defenders of the North and all that lies beyond the frozen Wall—keep the old gods and ancient traditions, whereas the Lannisters of Casterly Rock and King's Landing govern the sunset sea and the capitals of the West and South.

Like their medieval counterparts, fantasy maps represent the "known world" from a particular vantage point, providing readers or viewers with a primarily visual point of reference for navigating the story. Maps also establish worlds in gaming and live-action role play (LARP) communities, from *Dungeons & Dragons* to *World of Warcraft*. Printed guides of attractions and events add to the immersive experience of theme parks, such as Disneyland. Iconic landmarks featured on maps are important starting points for location scouts and cinematographers who visually adapt fantasy texts for the screen.

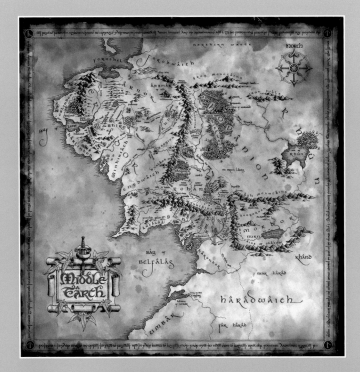

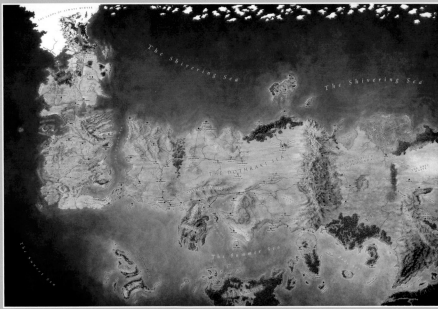

Figure 18
Maps were fundamental to Tolkien's conception of Middle-earth. He took an active role in revising the maps that appear in the various publications of *The Hobbit* and *The Lord of the Rings* trilogy at the insistence of his publishers. J. R. R. Tolkien and Pauline Baynes, *Map of Middle-earth*, 1969

Figure 19
Jonathan Roberts, *The Known World: Westeros and Essos* from *A Song of Ice and Fire*, by George R. R. Martin, 2011

Figure 20
A fey folk, Arthur, Nimue, Gawain, and Morgana gather at the Round Table in the Iron Wood in this adaptation of the illustrated YA novel that refreshes every major character's backstory. Film still from *Cursed*, 2020 (Netflix)

In Netflix's action-and-magic-packed series *Cursed* (2020), the Lady of the Lake, Nimue, is the leading character **(Fig. 20)**. Based on the 2019 graphic novel of the same name, *Cursed* draws upon more than a thousand years of Arthuriana. From past to present, most Arthur stories were written or produced by white men, and *Cursed* is no exception—it is by Frank Miller and Tom Wheeler. But in Netflix's *Cursed,* Arthur is Black and Nimue is the powerful warrior-queen of the fey (magical beings). *Cursed* fits nicely within this well-established tradition of updating the legend for the present. It joins a handful of other re-creations that include people of color as key cast members, including *Black Knight* (2001), starring Martin Lawrence; and the BBC series *Merlin* (2008–12), with Angel Coulby as Gwen (Guinevere) and Santiago Cabrera as Lancelot. Yet certain stereotypes about the Middle Ages persist. Both *Cursed* and *Merlin* perpetuate the idea that medieval people were superstitious of magic.

Cursed is a prime example of the way medieval history becomes compressed into a monolithic category, with tales drawing from numerous periods from the Middle Ages to the present. A key heroine presents as kin of a Viking marauder (they were around from the eighth to the eleventh centuries); at one point Merlin references Charlemagne, the eighth/ninth-century Holy Roman Emperor who reigned long after Arthur's supposed rule, and later refers to Byzantium (the Roman Empire centered in Constantinople until 1453). Throughout the series, we see wondrous examples of English architecture, including twelfth-century Romanesque ruins (such as Waverley Abbey) and later Gothic cloisters (Lacock Abbey), each of which was added to in subsequent eras. And the Pope's Red Paladins are something like sixteenth-century Catholic inquisitors, who hunt down heretics (or magical beings in *Cursed*).

Cursed sets itself apart from other Arthur adaptations through bold plot and casting decisions that align well with medieval fantasy and history. The legendary storyline now includes a powerful female lead, lesbian nuns, a central conflict between fey folk and the church, and actors of color in several prominent roles, including that of Arthur, all of which may seem surprising at first given how masculinist, heteronormative, non-magical, and whitewashed previous cinematic versions of the story have been. The more inclusive cast of *Cursed* and the choice of Dev Patel for the role of the legendary knight Sir Gawain in the 2021 film *The Green Knight* offer a glimpse into what Arthur and his knights can be imagined as today **(Fig. 21)**. These portrayals, however, should not surprise viewers. Medieval Europe was home to Black knights and citizenry, as well as to queer individuals and relationships, though the church and state often

persecuted such communities. Black Africans lived in Europe throughout the Middle Ages, as soldiers in armies, ambassadors at court, clerics and pilgrims, enslaved members of households, and some became venerable saints **(Fig. 22)**. Europeans were also well aware of Black African rulers and sometimes recorded accounts about them, such as the legendary Prester John and the Queen of Sheba (both generally thought to come from Ethiopia) or the powerful king Mansa Musa of Mali (1280–1337). There also exist many accounts of individuals who chose to dress and live according to their gender identity (rather than based on societal norms for their sex assigned at birth), such as Marinos (born Marina but who lived as a monk) or Matrona (who escaped an abusive marriage and passed as a eunuch-monk). Other documents, in the form of history-chronicles or satirical poems, describe the same-sex relationships of rulers, working-class people, and religious figures alike, including Jean de France, duc de Berry, and his reported male lover Tacque-Tibaut. One particularly queer episode in *Sir Gawain and the Green Knight* is the exchange of winnings: Lord Bertilak (who we later learn is actually the Green Knight) gives Gawain the spoils of the daily hunt in return for whatever the Arthurian knight receives in the castle that day. Having been repeatedly seduced by Lady Bertilak, Gawain kisses Lord Bertilak on multiple occasions in order to faithfully deliver what he had received. Ideas about race, gender, and sexuality developed in myriad ways during the Middle Ages even if most works of fantasy have suppressed this diversity.

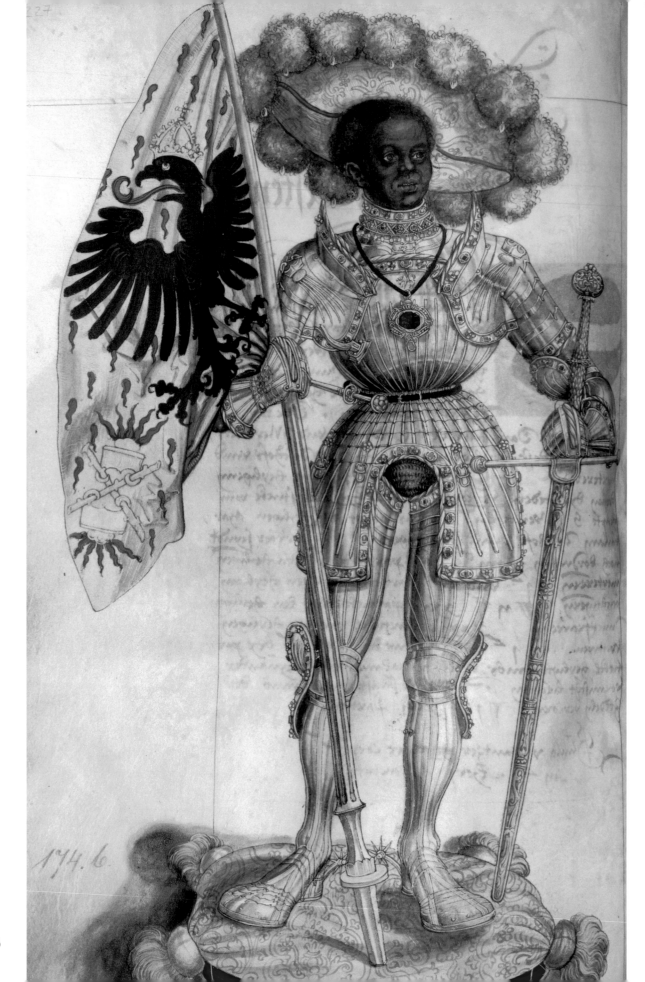

Postmedieval Fantasy

The enduring stories of Arthur, layered on each other over the course of many centuries, are an example of the many ways in which "the medieval" has been reimagined and reconstituted for new audiences. As Brian Stock, a scholar of the Middle Ages, wrote is his book *Listening for the Text: On the Uses of the Past* (1996):

> The Renaissance invented the Middle Ages in order to define itself; the Enlightenment perpetuated them in order to admire itself; and the Romantics revived them in order to escape from themselves. In their widest ramifications "the Middle Ages" thus constitute one of the most prevalent cultural myths of the modern world.

As iconic as illuminated manuscripts are of the Middle Ages, so too are illustrated books immensely popular within the fantasy genre in the modern era. From the Gothic stories in the 1700s, the emergence of the fairy-tale genre and manuscript facsimiles in the 1800s, to pulp fiction and dime magazines, comic books, graphic novels, and children's and fantasy literature from the 1900s to today, images on covers and across the pages transport readers to the world of the past or to another realm **(Fig. 23)**. One of the aims of this publication is to show just how connected illustration is to historical book traditions and how, in turn, creators of fantasy often revive or retell centuries of stories anew and rely upon art for creating unique lands and creatures. Just as Tolkien's Middle-earth was brought to life in many editions featuring the art of Barbara Remington, Alan Lee, and others, so too is Robert Jordan's fourteen-volume *The Wheel of Time* series (1990–2013, completed by Brandon

Sanderson) inextricably linked to the cover art by Darrell K. Sweet, who animates the tale of timeless struggle between good and evil. The same can be said about the connection between artist and cinematographic renderings that support the worldmaking of Ursula K. Le Guin's cycle *Earthsea* (1968–2001).

A global Middle Ages provides especially popular source material for Japanese graphic novels, known as manga (some are called "light novels" to indicate a young adult readership). A few examples include *The Heroic Legend of Arslan* (1986–2017), based on a Persian epic, by Yoshiki Tanaka with illustrations by Yoshitaka Amano and Shinobu Tanno; the dark fantasy set in a dystopian medieval Europe called *Berserk* (1989–present), by Kentaro Miura; Makoto Yukimura's *Vinland Saga* (2005–present **(Fig. 24)**, based on Scandinavian sources about the so-called Vikings; and *Spice and Wolf* (2006–present), about the adventures of a young merchant and a wolf-deity. Each of the manga just mentioned has also become an anime series.

Medieval fantasy is of course part of the broader genre of fantasy, which can also include reinterpretations of Greco-Roman, Egyptian, Maya, and other mythologies or folklore traditions. Each of these can be based in some part on or set in history combined with aspects of legend or pure imagination. Medieval fantasy is often perceived as white, heterosexual, and cisgender, among other exclusive categories, because the formation of the idea of the Middle Ages in historical writing was founded on those principles. This perpetual cycle of a homogenous European Middle Ages is conditioned by and continually shapes the whiteness of conventional fantasy. But some fantasy writers, especially women of color, are creating worlds that resist such hegemony: Nigerian American author Nnedi Okorafor blends fantasy and science fiction in what she calls "Africanfuturism" or "Africanjujuism," to describe the roots in African and Black diaspora traditions; the American writer N. K. Jemisin describes fantasy as "a way to train for reality" and a genre that helps readers assess the forces that cause inequality; and American comic book writer and novelist Saladin Ahmed imagines a world of shape-shifters and monsters partially based on *One Thousand and One Nights*, a compilation of enchanting stories in Arabic that were collected over centuries and

Figure 22
Saint Maurice in the Halle Relic Book, possibly by Simon Franck, 1526–27. Aschaffenburg, Germany, Hofbibliothek, Ms. 14, fol. 227v

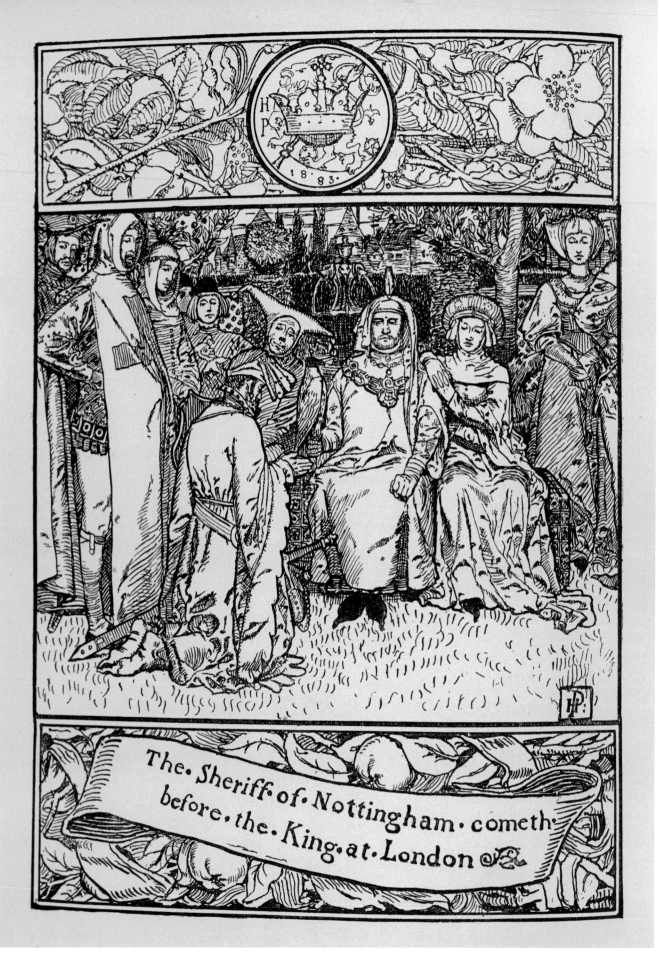

The . Sheriff . of . Nottingham . cometh
before . the . King . at . London

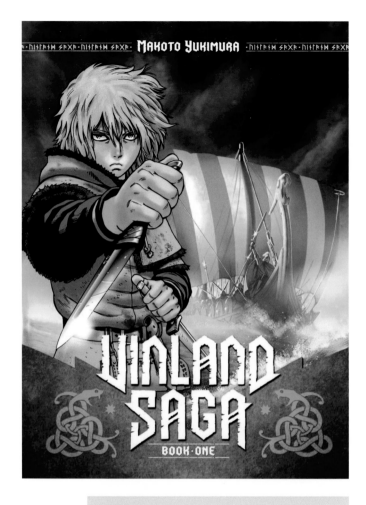

which feature the famed storyteller Scheherazade. These creators do not rely solely on the Middle Ages for inspiration but broadly draw upon the concept of epic narratives with feats that expand beyond reality as some might know it. The focus of academic and museum circles on fact-checking medieval fantasy for historically accurate visualizations of events, dress, magic, or art is fundamentally beside the point. This scrutiny, and the inevitable "inaccuracies" uncovered by it, do not reflect the value found in works of medievalism. In every medium and from every period after the Middle Ages, medievalisms offer many relevant insights into this bygone era. Even in medieval sources themselves, there is always a degree of artistic or authorial license. Many of the stories preserved in medieval manuscripts are themselves a fantasy version of the Middle Ages, just as postmedieval imaginings of the period often blend a range of visual traditions. We hope this publication encourages you to examine and unravel your ideas about the Middle Ages—those informed by childhood stories, classroom history books or stories, and contemporary digital media, from the silver screen to TikTok.

This book is a choose-your-own-adventure for exploring the visual history of the fantasy Middle Ages. You can begin in chapter 1 with an exploration of the medieval imagination as presented through the pages of illuminated manuscripts, or embark upon a quest through many different historical medievalisms. Chapter 2 introduces you to the knight and the princess among other characters, from Chaucer to Monty Python. Chapter 3 casts its spell through the magical stories of fairy tales, from the Brothers Grimm to Disney. Chapter 4 brings the Middle Ages to life, from tournaments and Shakespearean theater to Medieval Times and the pleasures of the Renaissance faire. Finally, chapter 5 takes you behind the scenes to designing the Middle Ages for screen, from film locations that feature remnants of medieval architecture to the realms and costumes that add texture to Tolkien's Middle-earth, Harry Potter's Hogwarts, and *Game of Thrones'* Westeros.

Prithee, settle in with some mead, a feast fit for royalty, perhaps some soothing lute-and-flute music or choir song, and join us on an epic adventure to see the Dark Ages in a new, bright light. Huzzah! 🤓

Defining Medieval, Medievalism, and Fantasy

Disclaimers from the medieval specialists who authored this short tome:

"**Medieval**" typically refers to a thousand-year period situated sometime between Antiquity and the Renaissance (ca. 500–1500 CE) and is generally located in Europe or the broader Mediterranean world, at times including the lands of Byzantium, kingdoms in Africa, and the vast territories of Islam or imperial East Asia and the Americas beyond. The phrase "a global Middle Ages" or "early globalities" refers to the expanded remit of medieval studies and also focuses on the problematics of applying a term for European periodization to other parts of the globe, with a critical lens to the history of imperialism and colonialism. Scholars have fixated on dividing this time into ever-smaller segments using dynastic reigns and artistic styles, such as Carolingian (for Charlemagne's rule and dominion) and Gothic (a term historically equated with "barbarians" or the antithesis of Classicism/Renaissance but more commonly used to refer to a particular artistic style). In this volume we underscore that the "medieval" can convey events or people from this thousand-year period, from a quasi-historical Arthur to the Jedi Order of space knights, and can encompass sites and stories from France to China and from the oases of Arabia to the maritime networks of Pacific islands.

"**Medievalism**" (sometimes "neo-medievalism") is a serious field of scholarly inquiry, which interrogates the afterlives of the entire medieval creative spectrum: art, architecture, fashion, music, and performance. Coined in the nineteenth century by writers of John Ruskin's ilk and developed further by medieval scholar Umberto Eco and many others, the term and its applications now have expanded to include everything with even a remote connection to the Middle Ages and the iterative processes by which this history and these visual traditions are layered with fantasy. One especially problematic term from early medieval English studies is "Anglo-Saxon," which was used sparingly in the Middle Ages and which white supremacists of today use to create false accounts about nationhood and race. These and other alt-right groups have co-opted terms, images, symbols, peoples, and events to advance a political and racist agenda that ultimately rests on a myth or fantasy of a white, heteronormative Middle Ages. We emphasize that many medievalisms perpetuate stereotypes that marginalize anyone from the past who was not a full-abled, white, wealthy, Christian, heterosexual, cisgender male. This book presents our critique of those views and offers a vision for the future.

Fantasy as a literary and visual genre is as expansive as the idea of the Middle Ages: from the subgenres of Gothic fiction, sword and sorcery stories, graphic novels or comics (including Japanese manga), and fairy tales, all of which may contain some form of magic, to high versus low fantasy (those with fully formed worlds or magical happenings in our own, respectively). Folklore, by contrast, generally takes place in a familiar world with stock characters and plots, but these too may involve magic. The Aarne-Thompson-Uther Index (ATU Index), founded in 1910 and revised in multiple expanded editions (from 1928 to the present), provides a classification system for folk and fantasy literature, which may or may not include medieval themes, based on the title, plot, and characters, with a focus on archetypes. In this volume, our primary aim is to trace the ways in which history and aesthetics have become entwined with legend and magic both in the Middle Ages and in medievalisms to the present. The Venn diagram of "medieval" and "fantasy" so closely overlap that they are almost inextricable. Though not all fantasy features medieval elements, some creators of fantasy worlds have been uncritically attracted to the Middle Ages while others have leveraged the misperceptions mentioned above to perpetuate prejudices. This volume will feature plenty of magic and wondrous images, but it will also ask that readers (re)assess their relationship with medieval fantasy.

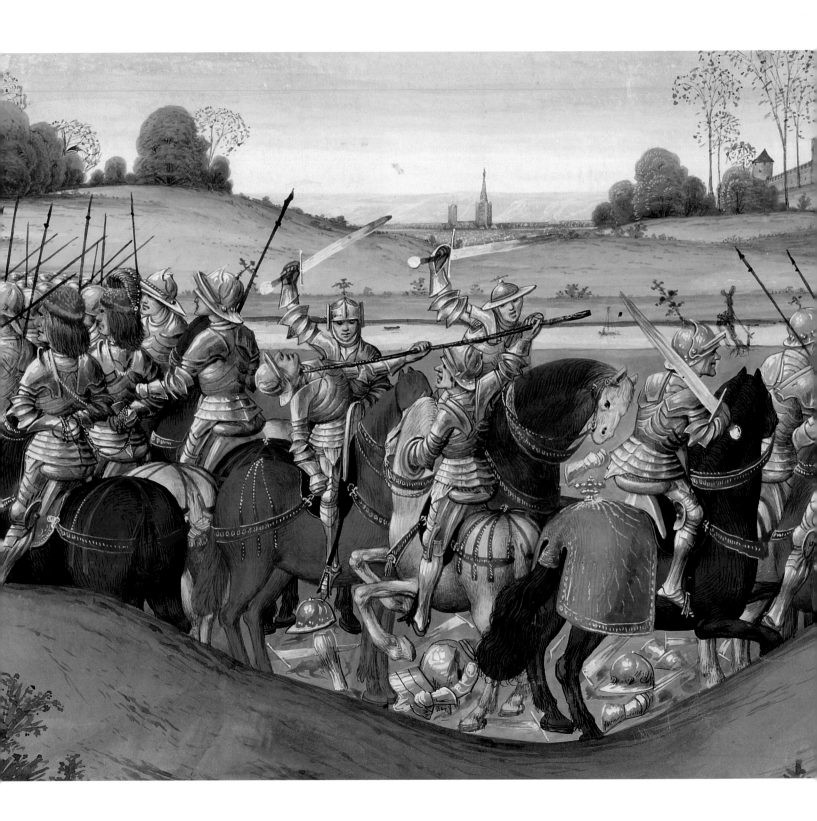

Once Upon a Time in the Middle Ages: The Medieval Imagination

1

A fierce battle rages in a verdant field beside a river with passing ships and well beyond the walls of the city. At the center of the onslaught, a knight thrusts a spear into the throat of an enemy soldier as swords clang, blood and dismembered corpses stain the battlefield, and prisoners of war are led away in defeat **(Fig. 25)**. This image, from a several-thousand-page manuscript in four volumes, Jean Froissart's *Chronicles*, depicts just one of countless episodes from the historical events of the Hundred Years' War (1337–1453), a period of political rivalry between England, France, and their allies. The artist who illuminated this manuscript about three decades after

the conflicts ended creatively reimagined and visually reconstructed the scene with details of the armor, weaponry, action, landscape, and architectural setting that are at once removed from their historical reality and at the same time combine to dramatize the events for new audiences in perpetuity. Within this relatively short time, history became legend, legend became myth, and myth passed into memory. Even in

the Middle Ages, the genres that we might distinguish as "history" and "fantasy" were closely connected— as seen in the most important texts for large-scale manuscripts commissioned for elite patrons and decorated by the top artists of the time. This and other fifteenth-century artistic source material provided inspiration for later book arts, and indirectly laid the foundations and offered visual inspiration for many fantasy medievalisms of the modern era.

The visual vocabulary of modern medievalisms—broadswords, shining armor, horses in elaborate regalia, Gothic castles and cathedrals, costumes of rich brocade—feels authentic because it has its

Figure 25
The Battle Between the Duke of Julich and Gelders and the Duke of Brabant in *Chronicles*, by Jean Froissart, vol. 3, Master of the Getty Froissart, Bruges, Belgium, about 1480–83. Los Angeles, J. Paul Getty Museum, Ms. Ludwig XIII 7 (83.MP.150), fol. 265

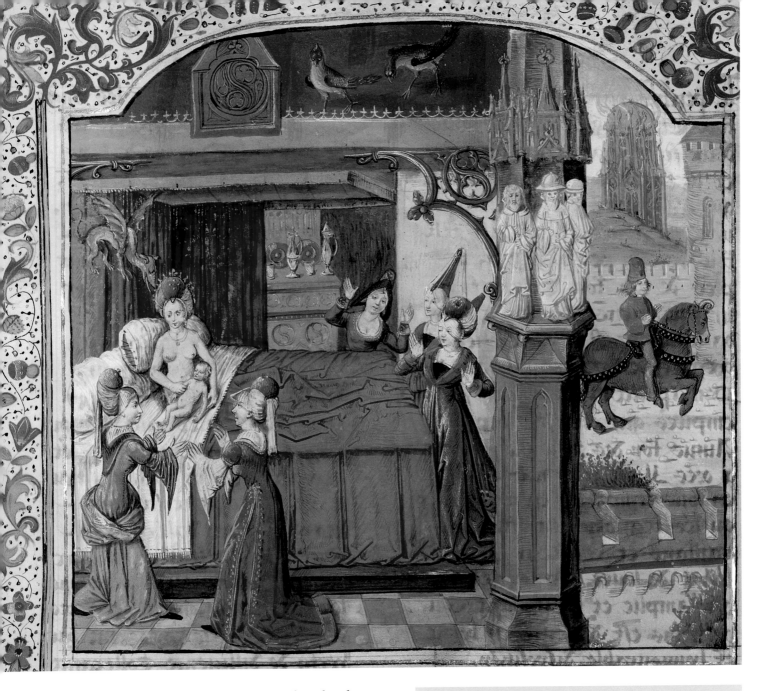

origins in medieval books and other media. Already in the Middle Ages, though, these images were entangled in the representation of fiction blended with classical and contemporary history that often transcended boundaries of chronology. This complex layering of history was a staple of the medieval imagination, which forms the foundations of subsequent attempts to recapture the spirit of the Middle Ages in fantasy books, movies, television, and beyond.

Figure 26
Master of the *Jardin de vertueuse consolation* and assistant, *The Birth of Alexander* in Vasco da Lucena's translation of *Book of the Deeds of Alexander the Great*, by Quintus Curtius Rufus, Lille, France (written); Bruges, Belgium (illuminated), about 1470–75. Los Angeles, J. Paul Getty Museum, Ms. Ludwig XV 8 (83.MR.178), fol. 15

Figure 27
Lieven van Lathem, *King Haldin Accusing the Sultan's Daughter Gracienne of Dishonorable Behavior* in *The Romance of Gillion de Trazegnies*, Antwerp, Belgium, 1464. Los Angeles, J. Paul Getty Museum, Ms. 111 (2013.46), fol. 150v

The Boundary Between History and Fantasy

In the same decade that the Froissart manuscript was illuminated, artists in other nearby workshops decorated codices that contained equally epic stories. *The Book of the Deeds of Alexander the Great* (*Livre des faits d'Alexandre le grant*) is a French translation of a Roman Latin source about the Macedonian world ruler from the fourth century BCE, yet the painted vignettes set the events in northern European courtly estates and attire that would have been familiar to the book's readers. In the scene of Alexander's birth, the infant and his mother sit on a canopied bed in a well-furnished chamber, attended by ladies-in-waiting dressed in fashionable garments and headdresses, while a dragon (his divine father, the god Zeus Ammon in disguise) hovers above **(Fig. 26)**. Though the event is supposed to take place in the distant past, the pointed Gothic architecture of the "Greek" temple in the background and the costumes that blend fifteenth-century fashion with imagined "Eastern" or "ancient" styles bring the past into the medieval present. Elsewhere in the volume, the author intentionally re-genders Alexander's male-eunuch lover Bagoas as a maiden called Bagoe (the female version of the name), "in order to avoid a bad example," as we are told. A character who once fought valiantly alongside Alexander and offered counsel became a temptress. This episode and others reveal the text's primary role as a "mirror of princes" genre, one that is meant to guide a ruler with models of good and bad leadership from the past together with prejudices of the time. In *The Romance of Gillion de Trazegnies*, the author weaves a tale about a fictional knight from northern Europe who travels throughout the Mediterranean and North Africa en route to Jerusalem. The text details his exploits as prisoner, then high-ranking soldier in Muslim-occupied Egypt, and also as an unknowing bigamist when he took a Muslim convert for a wife after being misinformed that

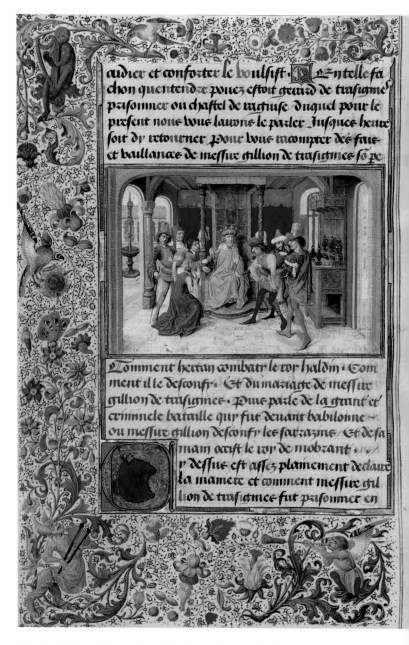

his family back home had died. On the page showing the sultan's daughter—the princess Gracienne—pleading for Gillion's life, the illuminator filled the margins with a host of strange creatures, including a harp-playing monkey, a hybrid man-lion musician, and a trumpeting angel **(Fig. 27)** (see chapter 2 for the archetypal European knight and princess). The aesthetics of such manuscripts that tell epic tales—with great tapestry-lined halls,

WHOSE MIDDLE AGES?

During the Middle Ages, people often described themselves in relation to those around them, especially in terms of geography, religion, and race. A person's local identity, based on their city or region of residence, gradually grew to encompass national consciousness. While Judaism, Christianity, and Islam were practiced across Europe and throughout parts of Africa and Asia, there were many different branches of each, such as the Ashkenazim of Central Europe or Sephardim of the Iberian Peninsula or diasporic groups in Italy and elsewhere; Catholic and Orthodox Catholic (or Eastern Orthodox); and Sunni and Shia, respectively **(Fig. 28)**. Numerous other faiths or spiritual beliefs were also practiced with variation by place, including animism, Buddhism, Hinduism, Taoism, Zoroastrianism, and many more.

Categories of race in the medieval world could be based on religion, skin tone, culture, or a combination of those, and were often informed by ideas about climate and geography. Works of art demonstrate the diversity of communities in the premodern world, and the texts that accompany them sometimes reveal the difficult realities faced by such groups at the hands of those in power **(Fig. 29)**.

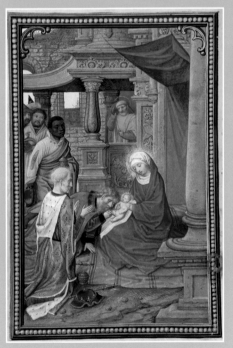

Figure 28
A man awaits his sentence before a court of law. One outcome could involve a duel, here visualized as a joust. Attributed to the Master of the Barbo Missal, page from the Mishneh Torah, about 1457. New York, Metropolitan Museum of Art, 2013.495

Figure 29
The presence of the Black king among the magi fulfilled the European fantasy of Christianity's global reach. Elsewhere in the manuscript, the Queen of Sheba was whitewashed, but sometimes she was represented as a Black African ruler. Simon Bening, Prayer Book of Cardinal Albrecht of Brandenburg, about 1525–30. Los Angeles, J. Paul Getty Museum, Ms. Ludwig IX 19 (83.ML.115), fol. 36v

The complexities of religion, race, and these intersecting identities (together with ability, class, gender, and sexuality) are not often apparent in the visual record of medievalisms, which too often default to the stereotypical (and inaccurate) view of a white, Christian, European past. As a genre, fantasy has the potential to be inclusive, if creatives can shake outdated and ultimately inaccurate views of the past.

Persian artists of the fifteenth century also produced a stunning range of manuscripts whose texts from earlier periods and painted images blended past and present. The *Shahnama* (Book of Kings) by Firdawsi (about 935–1019) and the writings of Nizami Ganjavi (1141–1209) include accounts about regional rulers and leaders from other

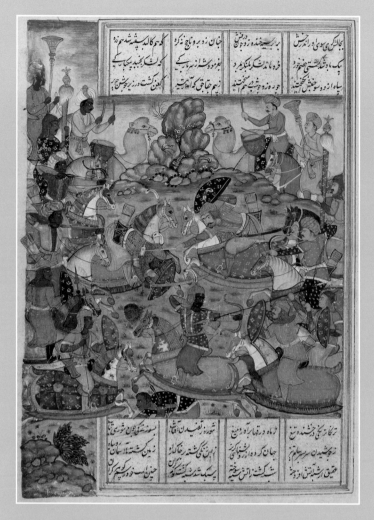

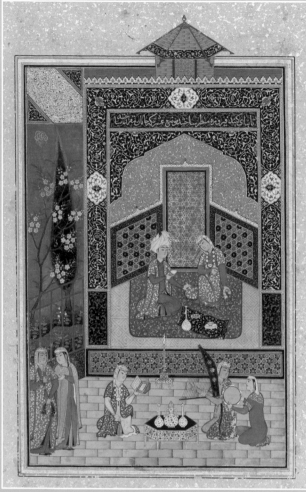

lands, including Iskandar (Alexander the Great). Iskandar's adventures include encounters with Swahili coast warriors, an audience before the Great Khan of China, and a visit to the Kaaba in Mecca, all of which offered painters from the premodern period to the present countless opportunities to create scenes that blend real and imagined elements **(Fig. 30)**. Nizami chronicled historical and archetypal characters in his *Khamsa* (Quintet), specifically in the section known as the *Haft Paykar* (Seven Portraits), which recounts an imagined tale about Sasanian Persian ruler Bahram Gur,

who has seven wives: princesses from India, Byzantium, the Tartars of Rum (Turkmenistan), Slovenia, the Maghreb in northwest Africa, China, and Iran **(Fig. 31)**. Some of the most elaborate and well-known manuscript versions of these texts were produced from the fourteenth to the sixteenth centuries. Similar to their European counterparts, historical and fictional characters often inhabit the same world during the Middle Ages, and these premodern works have inspired artists all the way to the present day.

Figure 30
The Battle of Iskandar with the Zangi from a manuscript of the *Khamsa* (Quintet) of Nizami, Shiraz, Iran, about AH 1027/1618 CE. The Morgan Library & Museum, MS M.445, fol. 271. Purchased by J. Pierpont Morgan (1837–1913) in 1910

Figure 31
Bahram Gur in the Turquoise Palace on Wednesday from a manuscript of the *Khamsa* (Quintet) of Nizami, Herat, Afghanistan, dated AH 931/1524–25 CE. New York, Metropolitan Museum of Art, 13.228.7.10, fol. 216

richly embroidered fabrics, stonework with pointed arches and vibrant stained glass, epic battle scenes, and decorative margins teeming with fantastic creatures—are precisely what many later artists referenced and even people today think of as "medieval."

Modern Medievalisms

Visual cues from illuminated manuscripts were deliberately taken up in the late 1800s by artists including William Morris (1834–1896) after a century that had already seen many revivals of medieval art and culture. Morris's printing press at Kelmscott House in England produced editions of such notable texts as *Beowulf* (based on a tenth- or eleventh-century manuscript), the twelfth-century Persian *Rubaiyat* of Omar Khayyam, the thirteenth-century *Saga of the Völsungs,* and the four-teenth-century works of Geoffrey Chaucer. Morris also authored *The Story of the Glittering Plain or the Land of Living Men*, a fantasy story that draws on the precedent of the medieval quest, inspired specifically by Icelandic sagas **(Fig. 32)**. Readers follow in the footsteps of Hall-blithe of the House of the Raven through a utopian land of immortals. Morris's writing is an early example of the ways in which medieval aesthetics are mobilized to legit-imize a fantasy story, setting it in a plausible historical context through its manuscript-inspired page layout and decoration. In Walter Crane's illustration on the opening pages, the young Hallblithe meets three cloaked riders who seek the undying land of the Glittering Plains of the north. His journey begins.

 The "medieval" look in these revivalist and fantasy versions of the Middle Ages is a product of the continual layering of history and aesthetics throughout the centuries. The Gothic Revival, of which Morris was a part, traces its origins to a mid-eighteenth-century interest in the High Middle Ages (roughly the thirteenth through fifteenth centuries, also known as the Gothic period) that was pan-European, driven in part by self-conscious nationalism. Horace Walpole's *The Castle of Otranto: A*

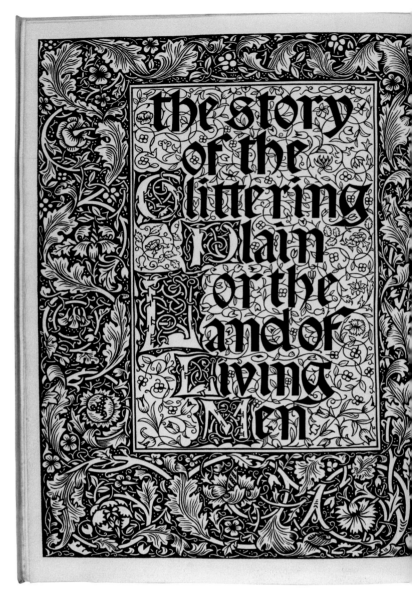

Gothic Story (1764) provides one starting point in this lineage. The author published the work with the conceit that the text—set near the Bay of Naples during a noble wedding in an enchanted castle with animate paintings and suits of armor **(Fig. 33)**—was a recently rediscovered medieval text from the library of a prominent Italian family. The illustrations to the early editions of the story were integral to the understanding of how "the Gothic" appeared and was represented from then onward.

 Though Walpole is often credited with the cre-ation of the first "Gothic" novel, he was in fact part of a

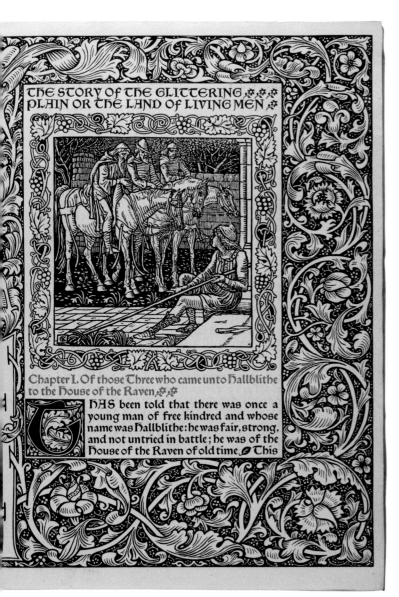

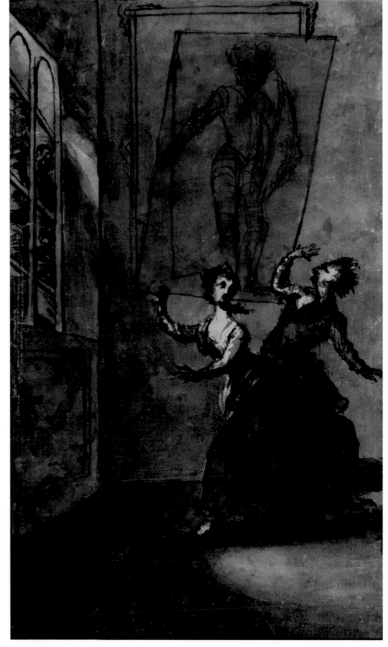

Figure 32
The Story of Glittering Plain or the Land of Living Men, by William Morris; prints designed by Walter Crane and William Morris, Kelmscott, England, 1894. Palo Alto, CA, Stanford Libraries, Z239.2.K29 M87SG 1894F, pp. 15–16

Figure 33
Susanna Duncombe, "As Isabella flees the embraces of Duke Manfred, a portrait of the former Duke Alfonso steps out of its frame," or *The Ghost Scene* from *The Castle of Otranto*, by Horace Walpole, after 1764. London, Tate Gallery, presented by Mrs. Joan Highmore Blackhall and Dr. R. B. McConnell, 1986, T04244

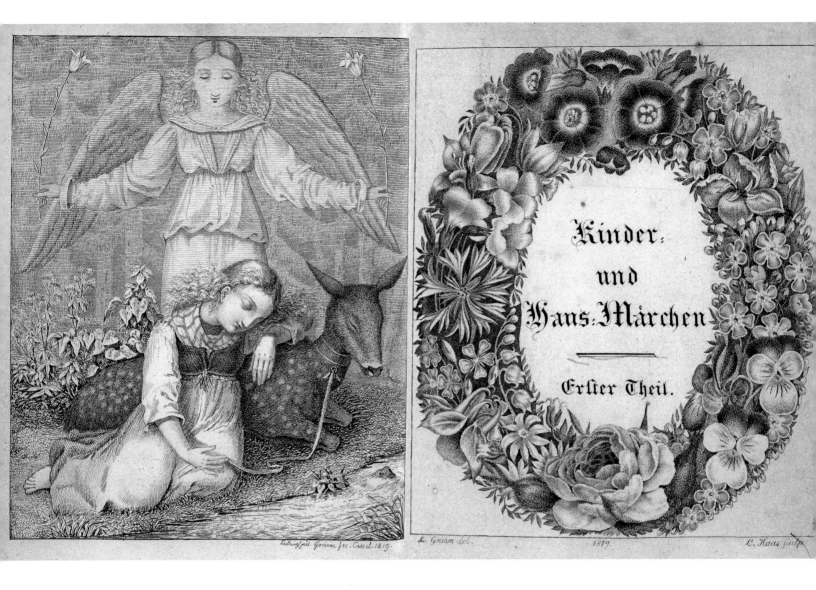

generation of writers interested in re-creating or pre-serving the Middle Ages in several ways. As with the late-fifteenth-century manuscripts from the beginning of this chapter, some set their stories in medieval history (such as Thomas Leland's *Longsword, Earl of Salisbury: An Historical Romance*, 1762, which takes place during the reign of King Henry III [1216–75]), while others penned reflections about tales that were already fantastic during the Middle Ages (including Thomas Warton's *Observations on Faerie Queene of Spenser*, 1754/62, and Richard Hurd's *Letters on Chivalry and Romance*, 1762). The titles of these works align with the spirit of Enlightenment discovery while perpetuating the idea of the Middle Ages as a period of magic and supernatural events.

Figure 34
Ludwig Emil Grimm, frontispiece to *Children's and Household Tales* (*Kinder und Haus Märchen*), by Jacob and Wilhelm Grimm, 1819 edition. Toronto Public Library

Figure 35
Jean-Louis-Ernest Meissonier, *Louis XI at the Bastille* (left) and Eugène Viollet-le-Duc, *Notre-Dame in 1482* (right) in *Victor Hugo illustré: Catalogue-album* (Paris: Librairie Hugues, 1870). Los Angeles, Getty Research Institute, 93-B12030, pp. 11 and 12

LOUIS XI A LA BASTILLE

NOTRE-DAME EN 1482

The same layering of history and legend can be seen in the creation and popularization of fairy and folk tales that were embedded into the imaginations of readers by evoking "medieval" visual tropes. In Germany, Johann Herder's *Folk Songs* (1778–79) inspired the world-renowned *Children's and Household Tales* of Jacob Grimm (1785–1863) and Wilhelm Grimm (1786–1859) (1812; **Fig. 34)**. The illustrations to these "Once upon a time" fairy tales, which were integral to the experience of the Grimm stories from the first edition on, adopt "medieval" European characters, creatures, and overall aesthetics: princesses wearing flowing gowns, knights in shining armor, castles that dominate idyllic landscapes, dragons and fairies, witches and wizards, forbidden forests, and all the rest (see chapter 2).

In France, Victor Hugo's *Notre-Dame de Paris* (1831) sets the story firmly in fifteenth-century Paris with an invented cast of characters, the "hunchback" named Quasimodo and the French-Roma dancer Esmerelda among them **(Fig. 35)**. The story later provided the source material for Disney's *Hunchback of Notre Dame* (1996). The tradition of casting fairy tales in the guise of the Middle Ages lives on in other Disney films, from *Snow White and the Seven Dwarfs* (1937) to *Sleeping Beauty* (1959), the latter of which is based on a tale that finds its early origins in a fourteenth-century romance text, filtered through the seventeenth-century French author Charles Perrault (1628–1703) and, of course, eventually the Brothers Grimm (see chapter 3 for nineteenth-century magical medievalisms).

Cinematic versions of these fantasy tales frequently feature luxury books as prime actors in the "medieval" stories. Imagine, for example, the jeweled binding of the illuminated manuscript in *Sleeping Beauty* as it opens to the heavily decorated page that begins the story (see fig. 60), or picture the series finale of *Game of Thrones*, in which Ser Brienne of Tarth finishes her writing of the heroic exploits of knight Jaime Lannister in an illuminated copy of *Book of the Kingsguard* and maester Samwell Tarley presents hand-of-the-king Tyrion Lannister with a freshly illuminated copy of *A Song of Ice and Fire*. The faux-manuscript as a storytelling device is also famously parodied in *Monty Python and the Holy Grail* **(Fig. 36)**.

The practice of preserving and, in the process, re-creating medieval manuscripts from the nineteenth century to the present involves many of the same techniques used to produce these on-screen counterparts. With the inventions of lithography (1796), chromolithography (1837), and photography (1826/1839), images of medieval art began to circulate as prints, photographs, or facsimiles (high-quality reproductions) of manuscripts. Some of these editions blended medieval and imaginary images, as in Alberto Sangorski's handwritten and illuminated copy of Tennyson's *Morte d'Arthur* (1912) **(Fig. 37)**. Many of these handmade books were later issued as luxury facsimile editions themselves, demonstrating the popular appeal of medievalizing manuscripts. More recently, print and even digital surrogates of these books have made them iconic and accessible, especially when or if the original codex cannot be readily studied. The aesthetics of these later books are at once revivalist versions of fourteenth- and fifteenth-century decorative motifs, including scrolling vine borders and intricate initials, and also characteristic of the nineteenth century, containing portraits and other features that could only be products of the modern age. The bookbinding firm that Sangorski's brother Francis operated with George Sutcliffe beginning in 1901 re-created jeweled bindings that recalled medieval examples, preserving the technique of luxury binding that was visually tied to the Middle Ages while inventing something new and very much a product of the twentieth century.

Many medievalisms, especially those preserved in centuries of book arts, are fundamentally based on the visual cues of codices, specifically illuminated manuscripts created during the fourteenth and fifteenth

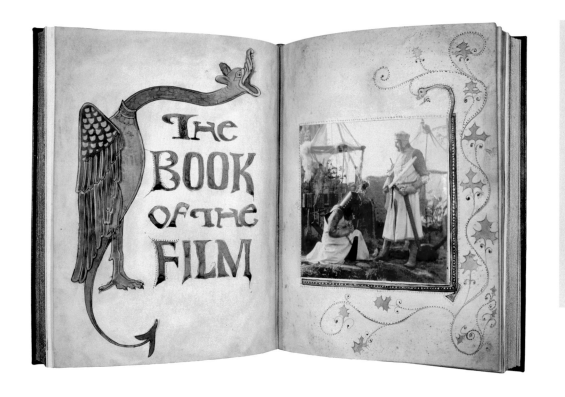

Figure 36
In addition to the comedic satire of medieval stereotypes, an illuminated manuscript both organizes and contains the action of this Arthurian film, sometimes adapting real medieval art as part of the visual effects. *The Book of the Film* from *Monty Python and the Holy Grail*, 1975 (Python Pictures)

Figure 37
The Lady of the Lake in *Morte d'Arthur: A Poem by Alfred, Lord Tennyson*, by Alberto Sangorski (London: Graphic Engraving Company for Chatto & Windus, 1912). Los Angeles, Getty Research Institute, 91-B34838, p. 10

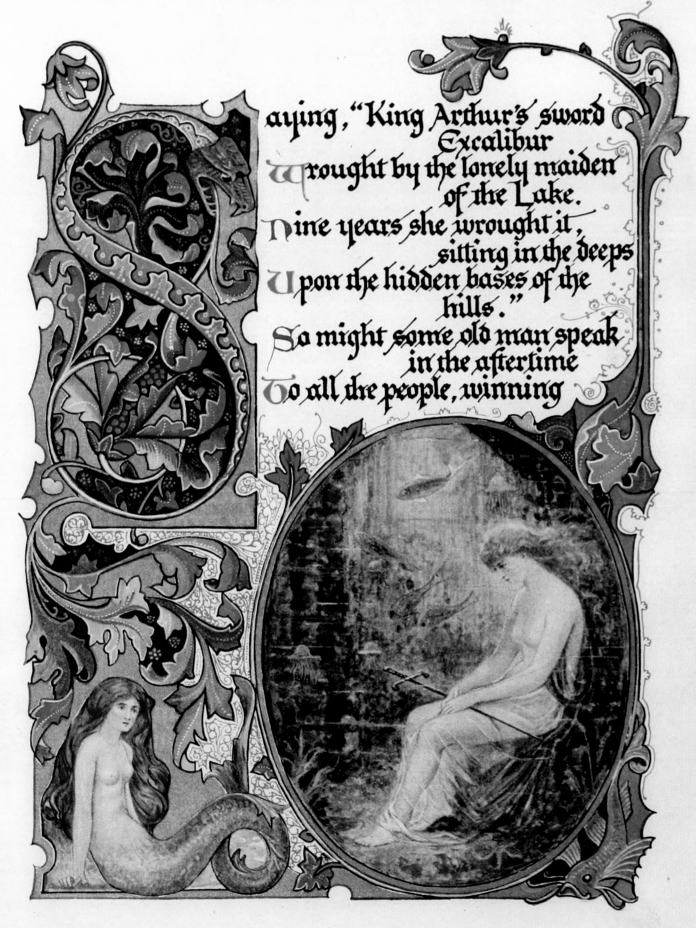

aying, "King Arthur's sword
Excalibur
Wrought by the lonely maiden
of the Lake.
Nine years she wrought it,
sitting in the deeps
Upon the hidden bases of the
hills."
So might some old man speak
in the aftertime
To all the people, winning

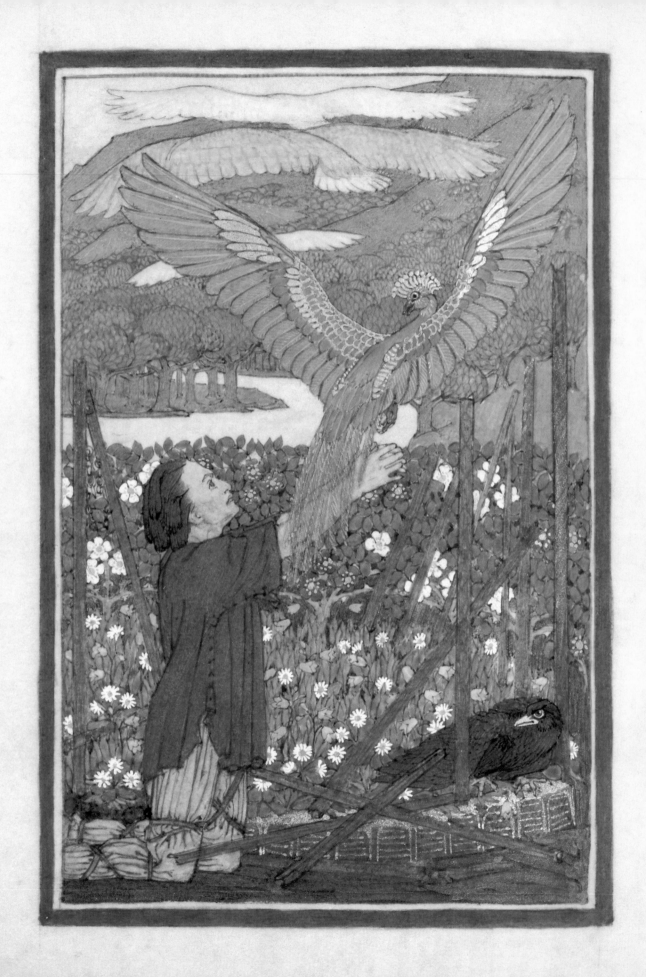

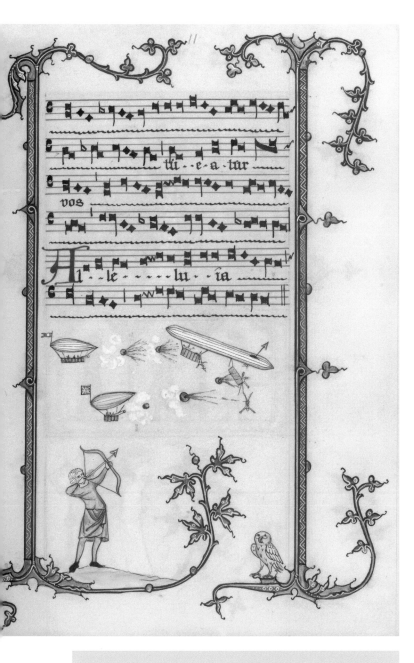

centuries in Northern Europe for high-ranking courtly patrons and royalty. The revival of and return to the Middle Ages in these medievalisms are in the spirit of the medieval imagination in their blending of genres and layering of actual history with elements of the fantastical and the legendary. For example, in 1908 Florence Kingsford Cockerell wrote and illuminated a copy of Olive Schreiner's 1883 *The Story of a Hunter*, an allegory of truth, wisdom, and the pursuits of youth **(Fig. 38)**. Kingsford Cockerell's use of gold-leaf text and vibrantly painted scenes—including the youth's brown tunic and loose trousers, as well as the verdant landscapes—are all familiar tropes in medieval manuscripts. The nuns of the Abbaye de Maredret in Belgium made even greater reference to the past through strikingly political scenes in the margins of a manuscript made during World War I: in one instance an archer shoots an airship from the sky while an owl looks on, and in another an American warship brings supplies to European shores **(Fig. 39)**. In yet another example from Disney, the 1971 live action and animated film *Bedknobs and Broomsticks* (based on children's books about witches) incorporates scrolling credits reminiscent of the Bayeux Tapestry (eleventh century), which depicts the Norman conquest of England (1066–75), and the movie culminates in an epic battle between enchanted suits of armor from all of English medieval history against soldiers of the Third Reich.

The aesthetics of "the medieval," that is, art, fashion, and architecture primarily from fourteenth- and fifteenth-century France and England, have become firmly embedded in the imaginations of viewers over centuries of repetition in many different media. Medieval history has been continually reimagined, accruing magical and supernatural elements over time, resulting in the modern understanding of the Middle Ages as a place that is simultaneously "real" and entirely imaginary, moving fluidly between fact and fiction. These boundary crossings are very much in the spirit of the medieval imagination and intersecting ideas of history and myth; every generation reimagines the Middle Ages, changing and expanding the very notion of who and what belongs in these stories, and what is old becomes new again. ⛊

Knights and Princesses: The Cast of Characters of the Middle Ages

For I have the pride, the privilege, nay, the pleasure of introducing to you a knight, sired by knights. A knight who can trace his lineage back beyond Charlemagne. I first met him atop a mountain near Jerusalem, praying to God, asking his forgiveness for the Saracen blood spilt by his sword. Next, he amazed me still further in Italy when he saved a fatherless beauty from the would-be ravishing of her dreadful Turkish uncle.
—Paul Bettany as Geoffrey Chaucer in *A Knight's Tale* (2001)

Sir Ulrich von Liechtenstein of Gelderland is the false noble name that Geoffrey Chaucer (portrayed by Paul Bettany) bestows upon William Thatcher (Heath Ledger) so the young, poor thatcher's son may realize his dream of jousting in the 2001 film *A Knight's Tale* **(Fig. 40)**. This seemingly fanciful moniker is in fact the name of a thirteenth-century German knight and poet who wrote treatises about virtues for knights and nobles **(Fig. 41)**. The plot of this Hollywood medievalism follows the story of a peasant who dreams of becoming a knight, rising above his preordained social station and overcoming the obstacles of feudal society to ultimately achieve fame and win the love of a girl. The film is framed as one of Chaucer's "tales"—in the spirit of the late-fourteenth-century text *The Canterbury Tales* (1387–1400), which introduced a cast of characters that still appears in many modern retellings of medieval history and fantasy.

The inhabitants of Chaucer's feudal society have crystallized into the archetypes that many have come to expect of the Middle Ages: knight, cook, friar, nun, maiden, merchant, squire, prioress, man

Detail of Figure 43.

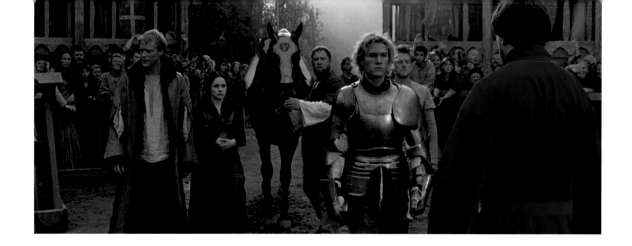

Figure 40
Chaucer meets teen romance with a heartthrob lead, a motley crew of sidekicks, an unattainable princess, and a scheming villain. Film still of the cast of *A Knight's Tale*, 2001 (Columbia Pictures)

Figure 41
Portrait of Ulrich von Liechtenstein in Codex Manesse, about 1305–15. Heidelberg, Universitätsbibliothek, Codex Manesse, Cod. Pal. Germ. 848, fol. 237

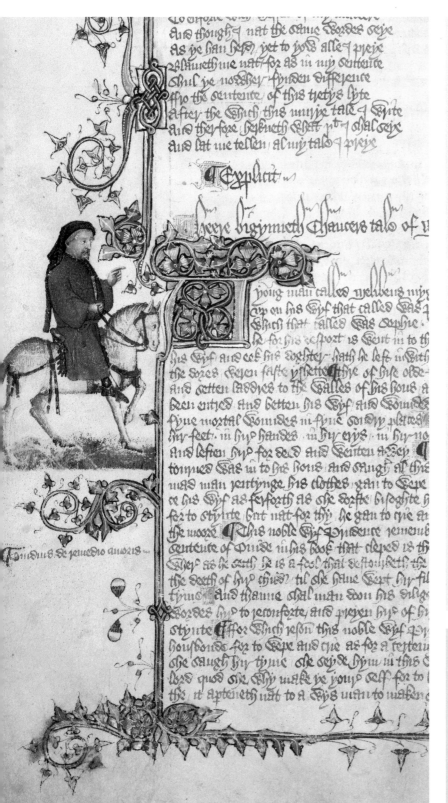

of law, miller, and others **(Figs. 42–43)**. Some of these figures have also become stereotypes, oversimplified and biased versions standing in for a group (of women or queer individuals, for example). Added to this list are kings and queens, artisans and travelers, jesters and mercenaries, the outcasts of society, foreign dignitaries and pilgrims, and even magical beings such as witches and wizards, all of whom emerge from the pages of illuminated manuscripts (see chapter 3 for fairy tales and a magical Middle Ages). Christian personal devotional texts called books of hours are the medieval sources for depictions of many of these individuals from all classes to prejudicial representations of people from around the world or of other faiths. All of these "medieval" characters—those who rule, fight, work, and pray—crop up again and again, from prints and Shakespeare plays of the early modern period to a range of films and television series in our own era, including Disney animated features, *Monty Python and the Holy Grail*, and more recently, *Miracle Workers: Dark Ages* (2019).

Famous historical figures have also found their places within the retelling of medieval stories, transgressing the boundary between history and legend. Our images of real people from history—including Viking hordes and continental European kingdoms, Saladin and Richard the Lionheart, Ghengis Khan and Marco Polo, powerful women from Eleanor of Aquitaine to Joan of Arc—are often largely based on their frequent appearance in stories from both the medieval and modern periods. When they do appear in either instance, their presence sometimes references documented events from the past, while in other cases they become an almost entirely fictionalized version of themselves. Over centuries, this range of representations has blended, creating an avatar that is both informed by history and entirely fictionalized. In effect, from illustrated books and Renaissance faires to film and video games, these historical figures have also become archetypes of medieval "characters": marauders versus fledgling Christian communities; the victorious sultan and "Saracen" armies versus the crusader king or Templar Knights; Mongol lord versus Mediterranean merchant-explorer; and ambitious queen versus the

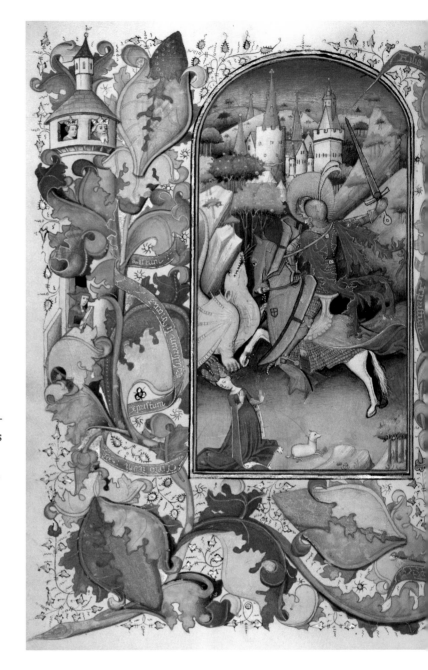

expectation-defying martyr. This chapter introduces two of the most enduring types of medieval people—the knight and the princess—including a few examples of individuals whose depiction in the visual arts demonstrates the instability of categories of gender, sexuality, and race.

Medieval Gender Roles Expanded and Their Afterlives Examined

Monty Python performer and medievalist Terry Jones described two of the most prominent medieval archetypes in his book and BBC series *Terry Jones' Medieval Lives* (2004):

> There was once a knight in shining armor: handsome, noble, and strong. He dedicated himself to God and love. Wherever he went, he brought justice and mercy. Many a time he rescued a damsel in distress, and jousted to win his lady's fame.... Once upon a time there lived a damsel: she was the fairest in the land. Her beauty was celebrated far and wide. And she was as modest as she was chaste....Helpless, threatened, and forever in need of rescuing.

When does an archetype become a stereotype? Were there really people like this in the Middle Ages? Maybe, but our impressions of these most enduring symbols of the time are based more on how they are described in later centuries than in historical sources. One answer to these rhetorical questions can be found by looking closely at an image of Saint George, a popular medieval subject in all art forms. Clad in armor and mounted on a rearing and mighty steed, the knight defeats a fire-breathing dragon to rescue an elegantly dressed princess in a sapphire gown lined with ermine, as the king and queen look on from a tower set amid exuberant foliate borders **(Fig. 44)**. Beyond this rocky landscape lies a fortified castle, with crenelated walls, blue-roofed turrets,

Figure 44
Master of Guillebert de Mets, *Saint George and the Dragon* and *Decorated Text Page* in a book of hours, probably Ghent, Belgium, about 1450–55. Los Angeles, J. Paul Getty Museum, Ms. 2 (84. ML.67), fol. 18v–19

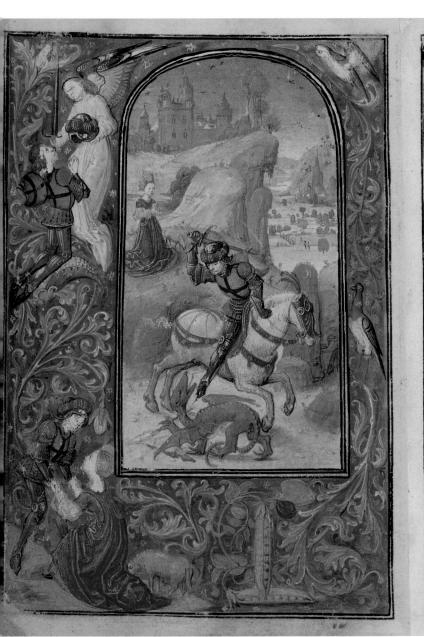

and a white-tented encampment. This visual tradition became widespread with Jacobus de Voragine's *The Golden Legend* (about 1260) and continues to influence the image of the knight and the damsel to the present **(Fig. 45)**. Of course, there are other traditions of valiant knights from throughout a global Middle Ages, from the legendary Byzantine-Arab dragon-slayer Basil (known as Digenes Akritas) to the defender of Japan against the Mongols called Takezaki Suenaga (1246–1314) (see fig. 119).

The picture of the chivalrous knight is encapsulated by Ledger's William Thatcher in *A Knight's Tale*: blond with handsome features and a sturdy, muscular build. How did we get here from the Saint George example shown above? In the Prayer Book of Charles the Bold (1433–1477), a double-page illumination shows the ruler venerating an image of his patron saint, George, who defeats the dragon in the main miniature and kneels before both his lady and an angel in the margins **(Fig. 46)**. Charles was a member

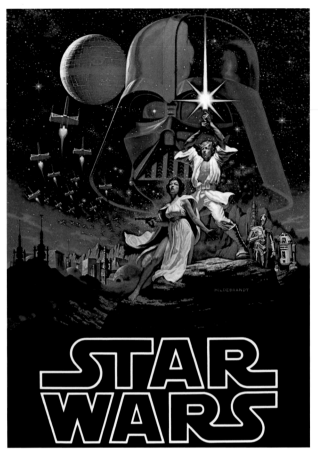

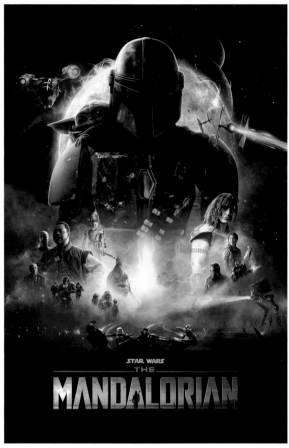

of the chivalric Order of the Golden Fleece and deeply devoted to the teachings of religious orders, including the brown-robed Franciscans. A long leap forward—and in a galaxy far, far away—we see another blend of chivalry and mysticism in George Lucas's *Star Wars* saga, in the figure of the Jedi knight who rescues a rebel princess and receives training from a wizard-like mentor while on a crusade against an evil empire **(Fig. 47)**. Another example from this fictional universe is the galactic clan of Mandalorians, who share a common creed, "This is the Way," and who don suits of armor and a head covering reminiscent of a *barbuta* helmet, an Italian design of the fifteenth century that features a similar T-shaped opening in the front **(Fig. 48)**. The code of proper conduct that chivalry described was formative for this idea of the virtuous knight in its many manifestations. In Charles Mills's *The History of Chivalry, or Knighthood and Its Times* (1825), engraver Alexander Le Petit portrayed a knight kneeling

before a lady with her confessor in the first volume and defeating a Muslim soldier in the second **(Fig. 49)**. The victor's Christian righteousness is clearly communicated, from his crossed shield to the rosary held by his confessor at left. Mills defined chivalry thus: "A moral and personal knighthood…a military barrier against oppression and tyranny, a corrective of feudal despotism and injustice." Islamophobia was a major motivator behind chivalry, past and present.

In the modern age, medieval chivalry became another component of European nationalism. In an 1869 edition of the magazine *Art Journal*, chivalry was visualized in three works of art: King Arthur's funeral barge; a young boy "glowering into an old helmet with his eyes full of the stories of chivalry he had been taught or had read," thinking, "I wonder who lived in there!"; and a scene from a Scottish ballad of a mortally wounded knight whose lady died of a broken heart **(Fig. 50)**. For an American audience, the publication of these works provided a glimpse into the contemporary British art world and perhaps nostalgia for the past. Numerous Pre-Raphaelite paintings of John Keats's poem *La Belle Dame sans Merci* (1819), based on a poem by Alain Chartier (about 1385–1430), have become visual surrogates for the Middle Ages as ubiquitous poster art in novelty stores and in dorm rooms across North America **(Fig. 51)**.

By the time Orlando Bloom stars as Balian, a twelfth-century French blacksmith-turned-crusader-knight, in the film *Kingdom of Heaven* (2005), the trope of the idealized knight had been replaced with a grittier look at sexual desire and the grim reality of battle. Of course, those elements of knight-as-heartthrob had already been well established by the memorable performances of Charlton Heston and Jaime Lorente López as an

Figure 49
Title page for *The History of Chivalry, or Knighthood and Its Times*, by Charles Mills, engraved by Alexander Le Petit from a sketch by Robert William Sievier (London: Longman, Hurst, Rees, Orme, Brown, and Green, 1825). Los Angeles, Getty Research Institute, 91-B16260, vol. 1

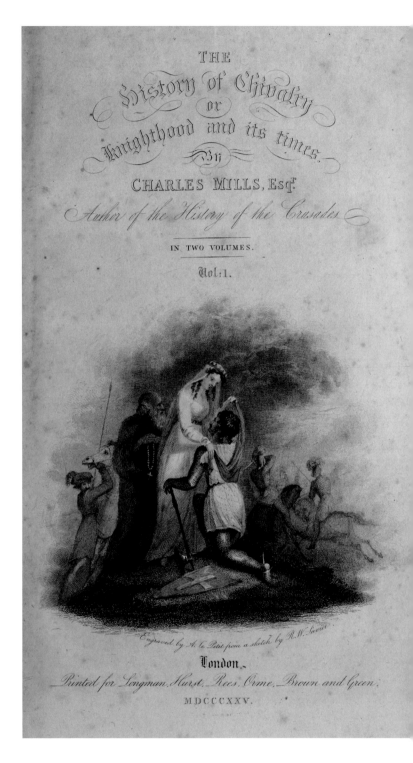

as the representatives of the ancient Celtic Earls of Atholl, and, through them, of the family which occupied the throne of Scotland from the eleventh to the fourteenth century, and from whom, through Robert the Bruce, the Stuart race was descended—could scarcely fail to exercise an influence on the character, habits of thought, and feeling of a youth so constituted, and surrounded by everything calculated to foster such tendencies.

We have in these preliminary remarks somewhat of a key to the after career of this painter. In 1843 Sir Noel Paton came to London and studied for a short time in the schools of the Royal Academy, receiving from Mr. George Jones, R.A., then keeper, much kindness and courtesy. His artistic teachings began and terminated with the instruction given by Mr. Jones. Before the period just alluded to, he had, however, exhibited some proofs of early talent in illustrations, supplied gratuitously, for the *Renfrewshire Annual* for the years 1841-2. On his return to Scotland he painted, and sent to the Royal Scottish Academy, 'Ruth Gleaning,'

his first exhibited painting; this was in 1814; when he also produced a series of designs, in outline, illustrating respectively, Shelley's "Prometheus Bound," and "The Tempest;" these were etched and published through the liberality of Mr. Lewis Pocock, F.S.A., and received due notice at the time in the pages of this Journal. In the following year he contributed to the Scottish Academy 'Rachel weeping for her Children,' and 'The Holy Family,' and he also executed a series of etchings, illustrating the late James Wilson's poem, "Silent Love." This year, 1845, was marked by the cartoon exhibition in Westminster Hall. Young as the artist of whom we are writing then was, he boldly entered into competition with many of the most eminent painters of the day, and not without justification, for the Royal Commissioners awarded to him one of the three prizes of two hundred pounds, for his cartoon of 'The Spirit of Religion,' a work which showed a mind richly endowed with poetic imagination, and, at the same time, evinced an amount of technical attainment which called

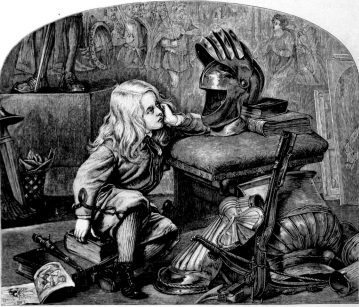

Drawn and Engraved by] "I WONDER WHO LIVED IN THERE!" *[Stephen Miller.*

forth the favourable notice of some of the most distinguished artists of the time. It was about this time he made several admirable drawings for Mr. S. C. Hall's "Book of British Ballads."

Passing over two charming illustrations of fairy-land,—a world with which Sir N. Paton has frequently made us acquainted,—'The Quarrel of Oberon and Titania,' exhibited at the Scottish Academy in 1846, and 'Puck and Fairy,' in the same gallery the following year, we again arrive at Westminster Hall, where, also in 1847, another competitive display was opened to the public, that of oil-paintings. To this he contributed two works, 'The Reconciliation of Oberon and Titania,' and 'Christ bearing the Cross.' For these joint productions, so dissimilar in character, yet each with merits peculiar to itself, he received one of the three prizes of three hundred pounds. The former of the two pictures was purchased in the most liberal spirit by the Royal Scottish Academy, and is now in their gallery. In this year he was elected Associate of that institution. To its annual exhibitions he sent, in 1848, 'The Meeting of Zephyr and Aurora,' and

'Silenus surprised by Ægle;' in 1849, 'Theodore and Honoria,' and 'Puck's *Soirée Musicale*;' in 1850, the year in which he was enrolled Member of the Scottish Academy, 'The Quarrel of Oberon and Titania;' in 1851, 'Thomas the Rhymer and the Queen of Fairie' (engraved), 'The Father Confessor,' 'Death of Paolo and Francesca da Rimini,' and 'Nimrod the Mighty Hunter;' in 1852, 'Dante meditating the Episode of Francesca da Rimini,' 'The Eve of St. Agnes; flight of the Lovers,' and a beautiful specimen of sculpture, a basso-relievo representing 'Christ Blessing Little Children.' The 'Oberon and Titania' picture just mentioned is a different work from that of 1846, and was bought for the Scottish National Gallery by the Royal Association for the Promotion of the Fine Arts in Scotland.

The year 1853 was a blank, but in the next he contributed to the Scottish Academy, 'The Dead Lady' (engraved), 'Bacchus and Nereides,' 'Pan Piping,' 'Faust and Margaret Reading' (engraved), and 'Dante and Beatrice in the Lunar Sphere.' In 1855 he contributed the grand composition of 'The Pursuit of

Pleasure,' now well-known from the large engraving of it. Critics—who are not always reliable judges—are sometimes found to express very contrary opinions of the same work; and this picture was not exempt from such fiery ordeal. But, estimated by results, it found special favour with the public; for Mr. Hill, the eminent print-publisher of Edinburgh, bought it for one thousand pounds, had it engraved, and cleared a very considerable sum by the prints, which were largely subscribed for; having previously disposed of it for two thousand guineas to Mr. Graham Briggs, of Barbadoes.

Hitherto, with the exception of the works sent to Westminster Hall, Sir Noel Paton had not exhibited in London; but in 1856 he commenced contributing to our Royal Academy, thus affording the English public the opportunity of becoming acquainted with the productions of an artist of whom they knew little, save by reputation. The first of these, 'Home,' was designated by Mr.

Ruskin "a most pathetic and precious picture." 'The Bluidy Tryste,' and 'In Memoriam,' exhibited in 1858, found less favour with this fastidious critic, but mainly on the ground of the gloominess of the subjects; and it may be noticed that unless the artist invades fairy-land, the themes of his pictures are more frequently sad than cheerful; even his 'Hesperus' (1860), two lovers seated at eventide on a mossy bank, and 'Dawn—Luther at Erfurt,' have each a tinge of melancholy too obvious to be overlooked; while his 'Mors Janua Vitæ' (1866), though designed to convey the most cheering doctrines of the Christian faith, is not altogether free from this tinge of sadness.

We are reluctantly compelled to pass over many works we should gladly speak of, in order to say a few words on those that form the subjects of our illustrations. Tennyson's noble poem supplied the subject of the first picture, 'MORTE D'ARTHUR,' engraved here. It is a grand theme, treated by the painter

Drawn and Engraved by] THE DOWIE DENS O' YARROW. *[Stephen Miller.*

with a feeling akin to that of the poet's conception, and with great artistic power.

The second of these, 'I WONDER WHO LIVED IN THERE!' will be remembered by many of our subscribers as in the Royal Academy exhibition of 1866. The composition is not an ideal one, but, as we have heard, is the representation of a fact. The scene is the artist's studio, in which, on entering one day, he saw his young son, chin on hand, "glowering" into an old helmet, with eyes full of the stories of chivalry he had been taught or had read. "I wonder who lived in there!" was the boy's remark to his father. The incident could scarcely fail to attract the special notice of a mind so constituted as that of the latter, who saw at once how well adapted it was for a picture both original and pleasing; the result is before us.

The third illustration, 'THE DOWIE DENS O' YARROW,' is from one of a series of six pictures, painted for the Royal Association for Promoting the Fine Arts in Scotland, for the purpose of engraving. The popular old Scottish ballad known by the above

title contains no such actual scene as is represented here, but it may be accepted as a fit sequel to the story, and shows the lifeless bodies of the knight who fell in mortal combat and his lady who died beside him when she found him stricken down, carried by retainers to their castle home.

These three compositions serve to exhibit the medieval and chivalric "groove" in which the painter's mind is found so constantly to run. His pictures, whatever the subject, are always poetical, yet are realistic in treatment; and he may fairly lay claim to the royal and academic honours respectively which have been awarded him. In 1866 the Queen appointed him her "Limner for Scotland," and the year following conferred on him, at Windsor, the honour of knighthood. But it is not only as an artist that Sir Noel Paton has won reputation; his two published books, "Poems by a Painter," which appeared in 1862, and "Spendrift," in 1866, were both most favourably noticed by the press, ourselves included, in England and Scotland.

JAMES DAFFORNE.

eleventh-century Castilian knight (*El Cid*, 1961 and 2020), Richard Gere as Lancelot (*First Knight*, 1995), and Clive Owen and Devon Terrell as King Arthur (*King Arthur*, 2004; *Cursed*, 2020).

All the characteristics of the knight find their complements in the personage of the princess or damsel. Beautiful, gentle, well-behaved, and in need of rescuing, these women are paragons of virtue and femininity. In some historical sources, unnamed, high-ranking

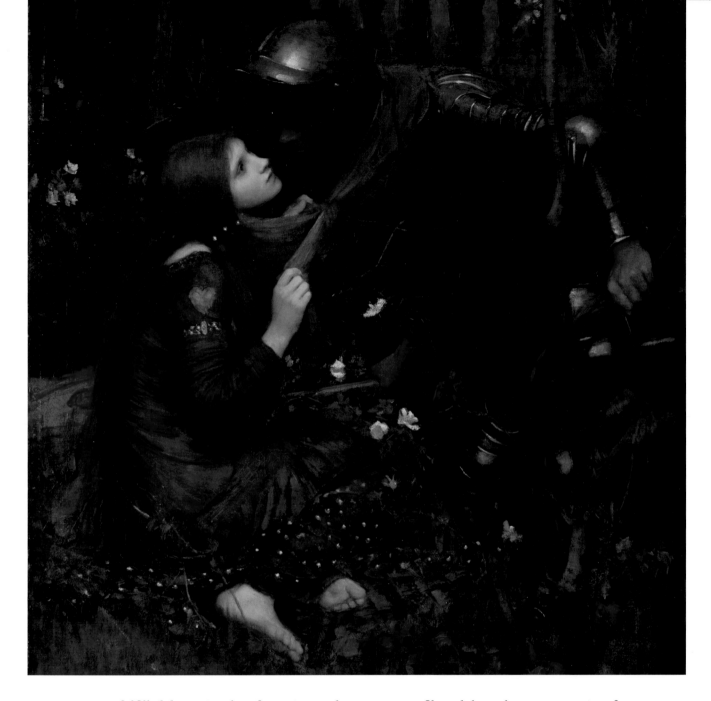

women at court fulfilled dynastic roles of marriage and childbirth, but medieval literature weaves a far more complex tale. A medieval woman could be mother, lover, saint, or sinner, just as much as she could be a mystic, artist, writer, or warrior, depending on rank. There were stories of virtuous ladies even as others recount marital infidelities by both spouses. But the image of the princess as weak and in desperate need of aid is a modern trope, drawing on a relatively narrow set of medieval sources filtered through many centuries of expectations surrounding female behavior, which dominates the stereotype of medieval womanhood today. From their appearances as nameless bystanders in Jacobus de Voragine's *Golden Legend* to the hapless damsels of nineteenth-century fairy tales, the princess archetype was codified in Walt Disney's animated tales, even for characters who are not technically royalty (see chapter 3). Snow White and *Sleeping Beauty*'s Aurora epitomize this

梁木蘭

paradigmatic expectation: motivated by their desire for love and mostly devoid of personality, their narratives are shaped by their status and beauty. More recently, though, Disney heroines are increasingly strong and independent as they follow their dreams. Within a global medieval framework, the characters Mulan, Merida, and Moana blaze their own trails—to bring honor, to be brave, and to see how far they will go—and also defy gender expectations to act with courage in ways that would normally have been reserved for male characters. Their

Figure 52
Mulan from *Gathering Gems of Beauty*, Qing Dynasty, identified as He Dazi. Album leaf, ink and colors on silk. Taipei, Palace Museum

Figure 53
Boucicaut Master, detail of *Cyrus the Great, Founder of the Persian Empire, Killed by Tomyris, Queen of the Massagetae* in *The Fate of Illustrious Men and Women*, by Giovanni Boccaccio, Paris, about 1413–15. Los Angeles, J. Paul Getty Museum, Ms. 63 (96.MR.17), fol. 58

stories also expand the popular view of the Middle Ages beyond the Mediterranean and into greater Afro-Eurasia and the islands of the Pacific. (For chronological clarity, Mulan's tale dates to the Northern Wei period of Chinese history from about 400–500 **(Fig. 52)**); the source material for Merida's adventure comes from about 900–1000 in Scotland; and an archaeological look at Moana suggests a range between 1000 and 1500.

"Who Run the World?"

When Beyoncé asks in her 2011 song "Who Run the World?" her answer is clear: girls. While the Disney princesses of today have evolved in response to contemporary social expectations, the status of women in the Middle Ages was similarly negotiable, contested, and never quite settled. There are numerous examples of royal and noble women who transcended the traditional boundaries set for their gender and ruled either on their own or, as was more often the case, in the stead of a male relative (a son or a husband): Melisende of Jerusalem (1105–1161), Eleanor of Aquitaine (1122–1204), Blanche of Castile (1188–1252), Isabella of France and Navarre (1295–1358), Sancha of Majorca and Naples (about 1281–1345), Margaret of Anjou (1430–1482), and Isabella d'Este (1474–1539), among many others, each made names for themselves with their strong and capable leadership.

Images of noble women feature prominently in medieval devotional and literary manuscripts illustrating the range of acceptable and expected conduct. The tales of saints Catherine of Alexandria, Barbara, and Margaret in the *Golden Legend*, or of the Assyrian queen Semiramis, the Scythian-Massagetae ruler Tomyris, Helen of Troy, Cleopatra, and the rumored Pope Joan in Giovanni Boccaccio's fourteenth-century text *The Fate of Illustrious Men and Women*, all involve acts of independence and free-thinking **(Fig. 53)**. Some of these and other women of the historical and fictional past reemerge as exemplary individuals in the text and illuminations of Christine de

BEYOND BINARIES

Ideas about gender—identity, expression, and roles—and about sexuality vary by place and time. Binaries such as male/female or heterosexual/homosexual only present a partial view of this complex aspect of human identity. Some of the examples in this book—both from the Middle Ages and from later medievalisms—reveal the persistence of negative stereotypes, especially concerning women and queer individuals. Many such people lived fuller lives and had greater agency than texts and images primarily made by and for heterosexual cisgender men might suggest. Throughout the medieval world, homosocial activities among groups of men or women could at times develop into romantic or sexual relationships. Similarly, those assigned one sex at birth could choose to express their gender in myriad ways, by dressing in clothes traditionally expected of one gender or performing tasks regulated by their gender identity. Figures that come to mind include Mulan, who disguises herself as a soldier in her father's stead, and Joan of Arc (about 1412–1431), discussed later (see chapter 5). We cannot know if an individual would have identified with terms developed in later periods, including heterosexual or homosexual, but also more specifically as lesbian, gay, bisexual, transgender, queer,

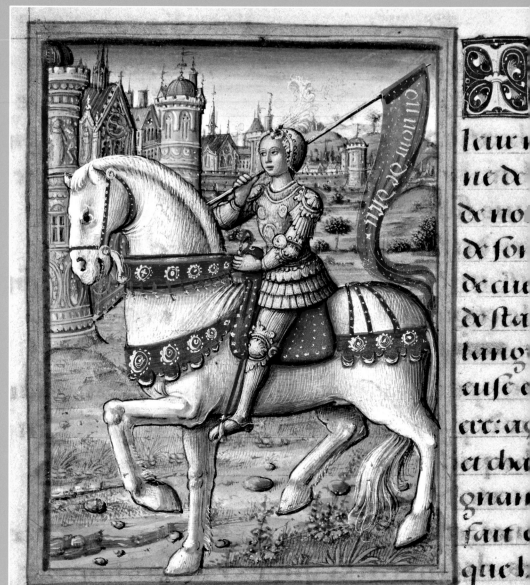

Figure 54
Jean Pichore, detail of *Saint Joan of Arc on Horseback* in *Les Vies des femmes célèbres*, by Antoine Dufour, Paris, France, 1504–6. Nantes, Musée Thomas Dobrée, Ms. 17, fol. 76v

Figure 55
After a show of swordsmanship, the knight Ser Brienne of Tarth asks Lady Arya Stark, "Who taught you to do that?" Arya replies, "No one," a reference to her training as an assassin in the House of Black and White. Film still from *Game of Thrones*, season 7, episode 4, 2019 (HBO)

intersex, asexual, two-spirit, and other gender nonconforming or nonbinary identities and sexualities (abbreviated as LGBTQIA2+). History is filled with numerous examples of individuals who defied societal or religious norms, a fact that fantasy medievalisms have been relatively slow to embrace. We especially reject vile and harmful statements toward the queer and trans communities made by some of the popular writers mentioned in this volume.

The expectations that shaped the images of women in the Middle Ages, both fictional and historical, have often been revised but ultimately reinforced with nearly every new retelling. In postmedieval fantasy one can find warrior women, queens ruling unapologetically, and princesses who refused to marry, but even these are circumscribed by a complex set of gender-based expectations that ultimately adhere to patriarchal patterns. Take the limited example of female knights from the Middle Ages. One of the most famous and controversial figures is Joan of Arc, a peasant girl who aided the French against the English at a decisive moment of the Hundred Years' War, but later still faced a trial on charges of witch-craft, heresy, and dressing like a man **(Fig. 54)**. She was executed at the age of nineteen for her gender transgressions and is revered as a trans heroine today. Women trying to lead in the Middle Ages and in fantasy medievalisms have faced an uphill battle, despite their strong wills. In *Game of Thrones*, while there are several examples of powerful women in the show who exercise influence using their feminine wiles and conform to traditional standards of female beauty—including the dragon queen, Daenerys Targaryen; the direwolf queen of the north, Sansa Stark; and the lion queen, Cersei Lannister (who drops the family name of her husband, the deceased King Robert Bara-theon)—it is Ser Brienne of Tarth and Lady Arya Stark of Winterfell who are truly trailblazing figures in this regard **(Fig. 55)**. In the fictional world of Westeros, Ser Brienne in particular not only assumes the chivalric values, titles, and weaponry of a knight, but also pushes against the gender binary in her physical appearance that is deeply troubling to the other charac-ters (cisgender, heterosexual, and queer alike) with whom she has mean-ingful relationships. A counter-example of gender-bending from Monty Python's Arthurian tale finds Lancelot violently spilling the blood of wed-ding guests in an attempt to rescue a "princess"—whose missive the knight found—but who turns out to be frail, genderqueer Prince Herbert, who does not want to marry but instead pursue study and music. Such images flatten the expectation for gender-based behavior that excludes any non-normative examples. Knights who do not rush bravely into battle and women with an interest in weaponry are out of step with this binary.

Ci commence le liure de la Cite des Dames du quel le premier chapitre parle pour quoy et par quel mouuement le dit liure fu fait.

elon la maniere que iay en vsa
tte et a quoy est disposé le
exercite de ma vie cest assa
uoir en la frequentacion de
stude de lettres vn iour co
me ie feusse seant en ma celle auironnee de
plusieurs volumes de diuerses matieres mo
entendement a celle heure auques trauiel
le de recueillir la pesanteur des sentences
de diuers aucteurs par moy longue piece

de mes volumes qui auec autres liures mauo
este baillie si comme en garde adonc ouuert re
lu te vy en lintitulacion que il se clamoit ma
theolus lors en soubz riant pour ce que onc
ques ne lauoye veu et maintes fois ouy di
re auoye que entre les autres liures cellui
parloit a la reuerence des femmes me pen
say quen maniere de solas le visiterope me
regarde neloz moult long espace quant re
fus appellee de la bonne mere qui porta

Pizan's *Book of the City of Ladies* (early fifteenth century), which urges women to build their knowledge and power networks upon those examples set by women of the past **(Fig. 56)**. Even in these cases, however, the accomplishments or rule of a woman were sometimes seen as problematic, going against the patriarchal status quo. In France, where de Pizan lived and wrote, women were even prevented by law from succeeding to the throne without a husband, and in many other cases women were only allowed to rule other territories as widows or regents for a juvenile male relative, a political position that allowed them far more freedom. Male claims to titles and lands almost always held greater sway.

If Chaucer's cast of characters can be seen as a blueprint for the many inhabitants of the fictionalized Middle Ages, then the corpus of fantasy medievalisms is akin to an expanded Chaucer that includes both historical figures and fictional versions of themselves. These identities have been blended together into stereotypical figures that are visual shorthands for entire groups. Saint George and the princess, together with Dante and Beatrice or Chaucer's knight and the Wife of Bath, find their foils in pairs that bring the gender binary into question. We are reminded firstly of Tolkien's King Aragorn and the shield-maiden and lady of Rohan, Éowyn (who is "no man," as she uttered when dressed in armor to pass as a knight before slaying the Witch King of Angmar) **(Fig. 57)**; or of Jon Snow, the supposedly illegitimate son of House Stark in *Game of Thrones*, who is in fact an heir to the Targaryen throne, and the Iron Throne itself, in contrast to his adopted noble sister, Arya, who trains with a sword called Needle (rather than suffering hours with the embroiderer's craft) and eventually masters even the god of death. As we have seen, many of these fantasy stories draw on medieval characters, thereby making them believable, but this genre is also deeply informed by social expectations of the times in which the tales are created. The characteristics of "masculine" valor and "feminine" virtue reveal deeply ingrained ideas about the construction of gender and sexuality in real life, and the visualization of the gender roles that have defined the characters of knights and princesses in medieval fantasy tell us more about the present than the past. And they may all yet live happily ever after... 🐉

Figure 56
Building the City of Ladies in *The Book of the City of Ladies*, collected works of Christine de Pizan, Paris, about 1410–14. London, British Library, Harley MS 4431, fol. 290

Figure 57
Lady Éowyn of Rohan is one of the few human heroines in J. R. R. Tolkien's Middle-earth. Director Peter Jackson's cinematic adaptation of the book series expanded the roles of the female characters. Film still from *The Lord of the Rings: The Return of the King*, 2003 (New Line Cinema)

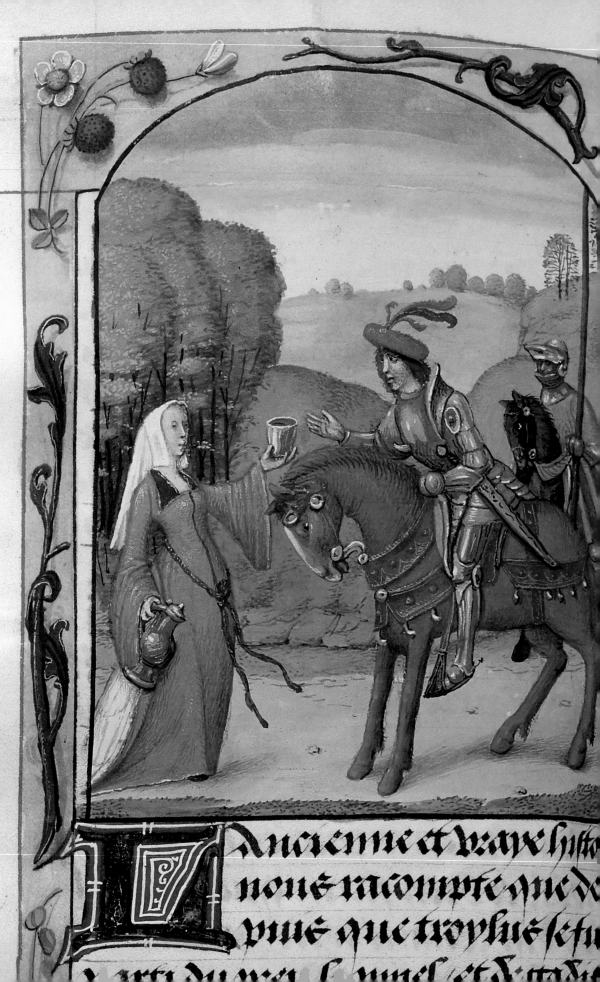

ur d nen-
rachief et
chme que
dyt me
ute la py
ue le corps
um porta
re soir fait
ancre tant
du puissat
le noble
de troie
noble roy
ft ioyeaul
oir pour
se dpartn
sen ala chas

ancienne et vraye histo
none racompte que de
puis que troylus se

And They Lived Happily Ever After: A Magical Middle Ages

In the midst of his quest to wake the Princess Zellandine from her magic-induced sleep caused by a splinter, as foretold in the goddess Thetis's curse, the knight Troylus encounters an old enchantress who offers him a chalice and weaves a spellbinding tale to set him off his course **(Fig. 58)**. This fourteenth-century story is part of *Perceforest*, a six-part romance that survives in a spectacular set of fifteenth-century manuscripts made for Duke Philip the Good of Burgundy (1396–1467; father of Charles the Bold). Known by other names in later centuries (including *Briar-Rose* and *Sleeping Beauty*), this tale was incorporated into manuscripts alongside a wide variety of other events,

including a history of Roman emperors and kings of Britain and mytho-historical accounts of the exploits of Alexander the Great and King Arthur **(Fig. 59)** (see chapter 1 for a look at the medieval imagination and the flexible boundaries between history and legend). Setting the narrative of Troylus and Zellandine in the distant past for a late medieval audience mirrors the approach by Walt Disney Studios to fill the animation of *Sleeping Beauty* with visual markers of the Middle Ages, or as Prince Phillip remarks, "Now father…this is the fourteenth century!" **(Fig. 60)**. The malicious goddess is recast as Maleficent, mistress of evil, who calls upon all the powers of hell before transforming into a dragon. She guards the castle, in which Princess Aurora sleeps, from Phillip and his weapons of righteousness. The live-action films (2014, 2019) expand the scope of the magical world to include all manner of fey folk and take a new look at the backstory of the characters, subverting any attempt to essentialize ideas about the qualities of a hero(ine) or villain.

The popularized Disney version of the story was distilled from the fourteenth-century text as reimagined by the seventeenth-century French author

Figure 58
Troylus in *Perceforest*, follower of the Master of the Prayer Books of about 1500, Bruges, Belgium, about 1490. London, British Library, Royal Ms. 19 E II, fol. 276v

Charles Perrault, who introduced fairies to the cast, as well as the nineteenth-century illustrative and print traditions of the folklorists Brothers Grimm and Pyotr Ilyich Tchaikovsky's score for the ballet *The Sleeping Beauty*, which debuted in 1890. The gradual evolution of this one fairy tale demonstrates the degree to which magic and the Middle Ages have become inseparable in the realm of fantasy. Rather than "Abracadabra!," the formula for these timeless tales is: 1) begin with "Once upon a time"; 2) add some references to kings and queens, plus a touch of supernatural occurrences or creatures, and some animal

Figure 59
Frédéric Théodore Lix, *The Sleeping Beauty of the Wood* (*La Belle au bois dormant*) from *Fairy Tales*, by Charles Perrault (Paris: Garnier Frères, 1890). Fine Arts Museums of San Francisco, A040974

Figure 60
A jewel-encrusted manuscript binding appears as a framing device for the story during the opening and closing credits, set against the background of the Unicorn Tapestries, one of the most famous works of medieval art. Prop book from *Sleeping Beauty*, 1959 (Walt Disney Studios)

Figure 61
This imaginative map takes us to many realms of make-believe, from classical mythology to medieval legend, fairy tales, and more. The possibilities for adventure are seemingly boundless. *An Ancient Mappe of Fairyland Newly Discovered and Set Forth*, designed by Bernard Sleigh, London, 1918. London, British Library, L.R.270.a.46

companions; and 3) they will all live happily ever after. But as Rumpelstiltskin reminds us in Disney's omnibus series *Once Upon a Time*, in which all fairy-tale characters traverse reality and fantasy, "All magic comes with a price."

In the nineteenth century, just as academics codified the idea of the "Middle Ages" as a time between antiquity and the Renaissance, so too did fairies, goblins, and wizards (re)emerge in art and literature through the revival of folktales, lore, and handcrafts. Artists imagined many beloved children's fairy tales, especially those of the Brothers Grimm, as taking place during the Middle Ages. Why? The texts of these tales, and the notes by the Grimms themselves, imply that they take place in a distant past that feels "medieval" based on the visual cues that artists added. The temporal ambiguity of these stories has allowed them not only to be flexible and to accrue aesthetic aspects of medieval art but also to become comfortable homes for magical happenings and beings **(Fig. 61)**. We see this effect especially clearly in Matt Groening's *Disenchantment* (2018–present): set in the dystopian medieval fantasy kingdom of Dreamland, the series follows the adventures of alcoholic princess Bean and her companions Elfo the elf and Luci the demon through enchanted forests, the swamp of Dankmire, the steampunk city of Steamland, the desert kingdoms of magical Maru, the lost city of Cremorrah, and more.

Nature, the Cosmos, and Occult Practices

The concept of magic in the European Middle Ages was fundamentally tied to Christian belief and informed by Greek, Latin, Hebrew, and Arabic writings about all manner of natural and supernatural phenomena. Every occurrence and living thing were seen as part of God's creative power. Aspects of the world that modern readers might think of as "magical" were not interpreted similarly by medieval people, but rather seen as natural phenomena that were ultimately the work of the divine: miraculous works by saints or the curative power of their bodily relics; the existence of beasts, from lions to unicorns; the existence and presence of a spiritual dimension populated by angels and demons; the influence of the movement of the stars and planets on the body and global pandemics; alchemical methods for transforming base metals into gold, and certain pseudoscientific medical practices, such as blood-letting. Medieval codices survive that testify to the existence of examples of scientific knowledge layered with current religious practice and ancient myth and learning. In a thirteenth-century manuscript containing

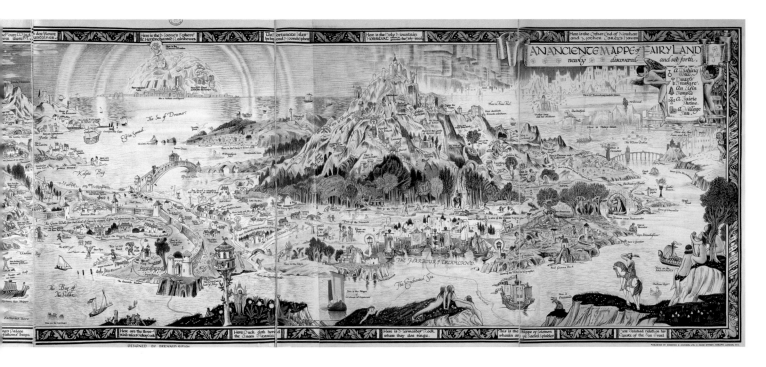

various writings—called a miscellany—we read the universal magical word "abracadabra" in the margins next to a remedy for malaria **(Fig. 62)**. The volume was donated to Saint Augustine's Abbey in Canterbury by the monk and prior William de Byholte (fl. 1292–1336), demonstrating just how closely linked charms were to the church. Universities across Europe organized their courses around the seven liberal arts: grammar, rhetoric, logic, music, geometry, arithmetic, and astronomy. The medieval bookshelf also included natural history texts about legendary peoples (sometimes called "monstrous"), animals, plants, gems and minerals, alchemy, and astrological wonders. This line-up of subjects mirrors those that Harry Potter masters at Hogwarts School of Witchcraft and Wizardry (see chapter 5). A look at a few manuscript examples will elucidate just how magical the Middle Ages really were.

Astronomical manuscripts often illustrate the degree to which cosmic forces were thought to influence one's life. A fifteenth-century compendium features a series of watercolors personifying planets and celestial bodies, including the Sun as an emperor, the Moon as a woman, Mars as an armored knight, Mercury as a doctor, Jupiter as a bishop, Venus as a lady holding an arrow of love, and Saturn as an elderly man **(Fig. 63)**. Each figure is associated with a color and adorned accordingly: golden yellow (the Sun), green (the Moon), red (Mars), silver (Mercury), blue (Jupiter), white (Venus), and black (Saturn). Furthermore, each heavenly sphere was thought to rule over the hours of the day, alternating throughout the week. Their push and pull were thought to affect bodily fluids, known as humors: blood, black and yellow bile, and phlegm. A balanced regimen of diet, exercise, sex, and prayer were a form of medieval mindfulness and spirituality.

The long visual history of fairy tales has made the Middle Ages synonymous with magical events and creatures of all types. But did the staple creatures and beings of fantasy medievalisms—dragons and unicorns, witches and wizards, fairies and elves, goblins and giants, spirits and apparitions (ghosts)—feature in actual medieval art or beliefs? Yes, they all did, and their existence, either as belief or superstition, teetered between heaven and hell, which were also the sources of their power. Several of the most famous epic literary journeys from the time present readers and viewers with wonders and terrors: from the dragons or winged beasts in *Beowulf* (and also Grendel's mother); the seven voyages of Sinbad the Sailor (as part of Scheherazade's *One Thousand and One Nights*) **(Fig. 64)**; Dante's *Divine Comedy*; and Marco Polo's writings (which also feature unicorns and dog-headed men).

Manuscripts known as bestiaries are compendia of beings and phenomena of the natural world, including actual animals such as lions, dogs, and elephants alongside imaginary creatures, such as unicorns, phoenixes, and dragons **(Fig. 65)**. After describing the behaviors and characteristics of these wondrous specimens, one thirteenth-century bestiary also includes a description

Figure 62
Abracadabra Incantation (detail) in medical miscellany, St. Augustine's Abbey, Canterbury, England, about 1250–1300. London, British Library, Royal Ms. 12 E XXIII, fol. 20

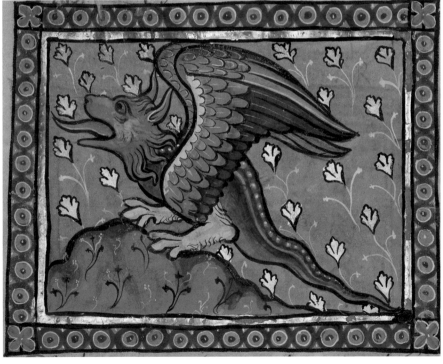

REYNARD AND ROBIN HOOD: THE CASE OF TALKING ANIMALS

Talking animals behaving and dressing as humans are commonplace in fairy tales and children's stories, from Aesop's classic fables to animated films by Disney, Dreamworks' *Shrek* (2001 and sequels), and many others. Similarly, mischievous animals and hybrid creatures populate the margins of medieval manuscripts, where they parody human foibles or offer a moralizing lesson on the text. For example, legends of Reynard, a famously cunning fox, were some of the most widely read in the European Middle Ages. Images of him before King Noble the Lion; evading his archenemy, the wolf Isengrim; or dressed as an itinerant preacher teaching a flock of geese abound in manuscripts **(Fig. 66)**. Reynard survived far beyond the Middle Ages; Jacob Grimm even wrote a text about Reynard in 1834. Disney's choice of a fox to

Figure 66
A Fox Preaching to a Flock of Geese in a missal, Germany, before 1381. New York, The Morgan Library & Museum, MS M.892.3, fol. 1, Gift of the Fellows, 1958

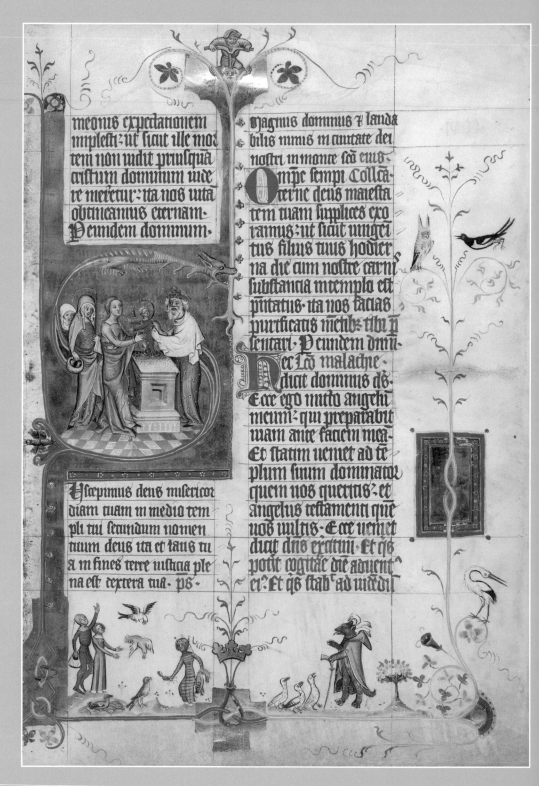

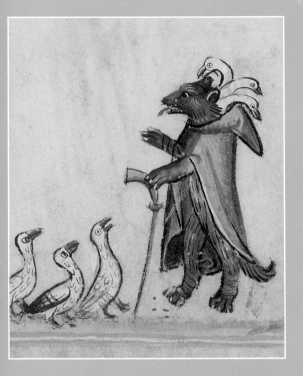

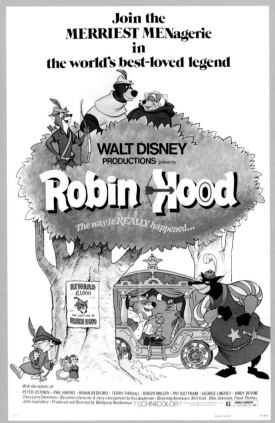

represent another figure from medieval English folklore, the famed archer Robin Hood, is thus particularly apt **(Fig. 67)**. This heroic outlaw who robs from the rich to give to the poor can be traced back to many different medieval texts, with the earliest references coming from the late-fourteenth-century poem *Piers Plowman*. Narratives detailing his prowess with a bow, his rivalry with the Sheriff of Nottingham,

||

Detail of fox in Figure 66.

Figure 67
Disney's *Robin Hood* blends medieval history with characters from the bestiary, literature, and folk tales. Poster for *Robin Hood*, 1973 (Walt Disney Productions)

||

and his friendship with the steadfast Little John exist from the fifteenth and sixteenth centuries. The Robin Hood legend grew and changed from there, gaining Friar Tuck, Maid Marian, and the connection to King Richard.

The layering of history and medieval sources to create Disney's animated *Robin Hood* is clever, with characters from the Reynard stories conflated with people from the Robin Hood legend: Chanticleer the Rooster becomes the bard Allan-a-dale, and Bruin the Bear's twin is Robin's faithful companion Little John. Although the real-life existence of Robin Hood is debatable, the history of the rivalry between Prince John and his brother King Richard of England is right out of

the twelfth century. While the latter, also known as Richard the Lionheart, was on the Third Crusade (1189–92), he left control of England in the hands of several trusted advisors. When these advisors proved unpopular, John positioned himself as an alternative king of sorts. In Richard's absence, John built his own court and government (the film's catchy song "The Phony King of England" notes: "While bonny good King Richard leads the great crusade he's on / We'll all have to slave away / For that good-for-nothin' John"). Making complex medieval history and literary traditions legible and entertaining for children using a memorable animal cast is the true magic of Disney.

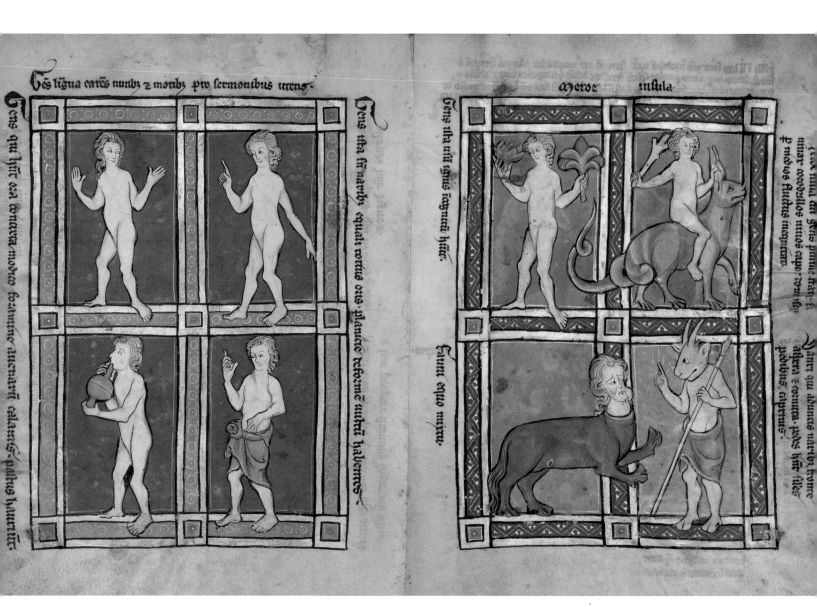

Figure 68
Legendary Peoples, in a bestiary, Thérouanne, France (formerly Flanders), 1277 or after. Los Angeles, J. Paul Getty Museum, Ms. Ludwig XV 4 (83.MR.174), fols. 118v–119

Figure 69
This volume of medieval and Renaissance customs purports to be an encyclopedic work of history, but the illustrations cast the Middle Ages as a time of superstition without concern for science. André Rivaud, *Superstitions* in *Le Moyen Âge et la Renaissance: Histoire et description des mœurs et usages*, vol. 1, edited by P. L. Jacob (Paris: Joseph Lemercier et Cie, 1848). Los Angeles, Getty Research Institute, 83-B1975, pp. 63–64

of the peoples who were thought to live at the edges of the world that were humanlike but which were believed to have physical or behavioral traits that distinguished them from European readers **(Fig. 68)**. It is important to note that these beings and many others (including Muslim "Saracens" and Black or Muslim "Moors") fueled racist views in the medieval past and present. For example, the popular tabletop medieval fantasy game *Dungeons & Dragons* issued a diversity statement in 2020, declaring, " 'Human' in D&D means everyone, not just fantasy versions of northern Europeans, and the D&D community is now more diverse than it's ever been." The bestiary manuscript just mentioned concludes with a discussion of certain precious stones and minerals and a separate

text with diagrams that explains how the earth was divided into different zones of climate, most of which were believed to be uninhabitable in their extreme hot or cool temperatures.

For medieval people, occult magic—or the dark arts—generally entailed dealings with the devil and demonic forces or accusations of the like. Any material, psychic, spiritual, or astral act that used (or purported to use) hidden knowledge beyond traditionally or religiously accepted norms could qualify as magic **(Fig. 69)**. Practitioners might include magicians (from the Greek *magos*), a term that could encompass priest-astrologers or dream interpreters; sorcerers, with abilities to manipulate the laws of chance; wizards (a word rooted in "wisdom") or

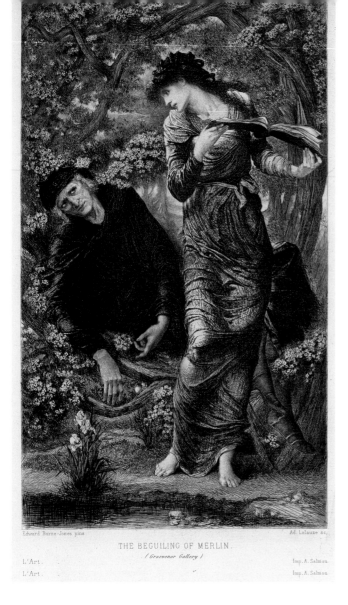

THE BEGUILING OF MERLIN.
(Grosvenor Gallery)

seers and diviners **(Fig. 70)**; necromancers, those who summoned or communed with the dead; and witches, often women who healed by folk medicine but who were maligned for these skills and accused of consorting with creatures of the night and of flying. Although the witch does not frequently appear in the visual tradition of the Middle Ages, she has become associated with medieval history through her inclusion in fairy tales over the course of centuries **(Fig. 71)**. Witches, usually nursing grudges and casting spells out of revenge on beautiful young women and children from their ruined castle lairs or forest abodes, are typical magical villains **(Figs. 72–74)**. Throughout the Middle Ages, laws and theological texts called for the persecution of such people and activities.

Figure 70
Arguably the most mythologized and reimagined wizard of medieval fantasy is Arthur's guide, Merlin, who in turn inspired the looks and personas of J. R. R. Tolkien's Gandalf and J. K. Rowling's Albus Dumbledore. Edward Burne-Jones, *The Beguiling of Merlin*, engraved by Adolphe Lalauze, printed by André Salmon, England, 1890. Etching. Fine Arts Museums of San Francisco, bequest of John Gutmann, 2000.119.3.8

Figure 71
Witches on broomsticks in *The Defender of Ladies* (*Le Champion des dames*), by Martin Le Franc, Arras, 1451. Paris, Bibliothèque nationale de France, Ms. Fr. 12476, fol. 105v

Figure 72
Hans Baldung Grien, *Witches' Sabbath*, Germany, 1510. Woodcut printed in black and gray-green. Fine Arts Museums of San Francisco, Museum Purchase, Achenbach Foundation for the Graphic Arts Art Trust Fund, Ludwig A. Emge Fund, and Gift of Ruth Haas Lilienthal, 1984.1.111

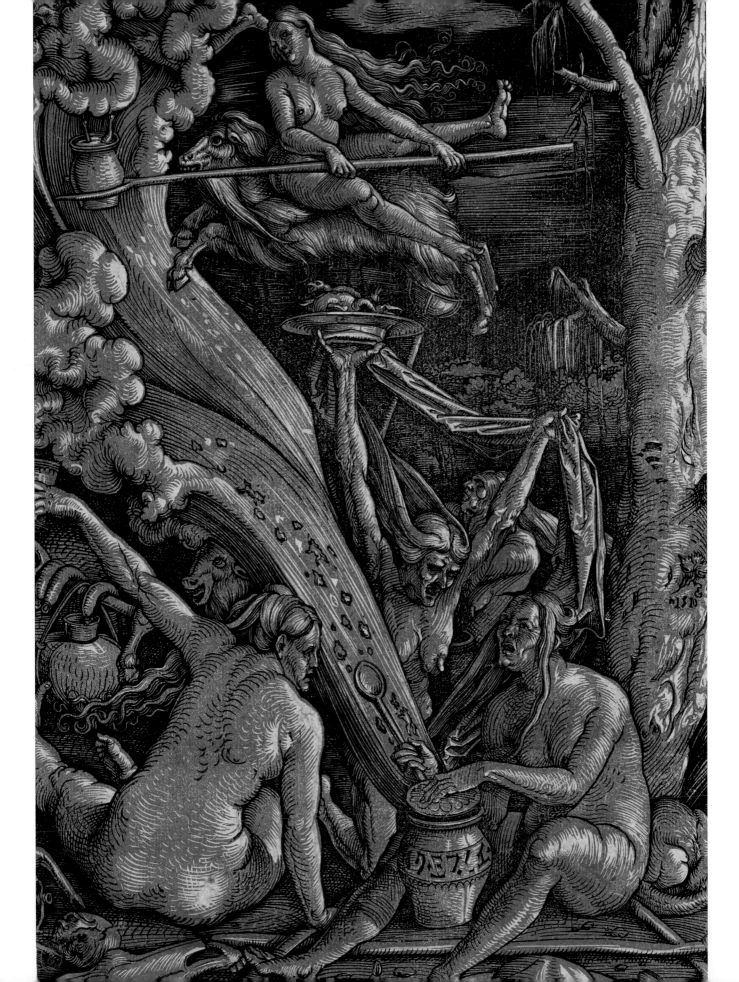

AND there were gossips sitting there,
By one, by two, by three:
Two were an old ill-favovr'd pair:
Bvt the third was yovng, & passing fair,
With lavghing eyes, & with coal-black hair;
A daintie qvean was she!
Rob wovld have given his ears to sip
Bvt a single salvte from her cherry lip.

As they sat in that old and havnted room,
In each one's hand was a hvge birch broom,
On each one's head was a steeple-crown'd hat,
On each one's knee was a coal-black cat;
Each had a kirtle of Lincoln green —
It was, I trow, a fearsome scene.

'Now riddle me, riddle me right, Madge Gray,
What foot vnhallow'd wends this way?
Goody Price, Goody Price, now areed me right,

Who roams the old Rvins this drearysome night?'
Then vp and spake that sonsie qvean,
And she spake both lovd and clear:
'Oh, be it for weal, or be it for woe,
Enter friend, or enter foe,
Rob Gilpin is welcome here!' —

'Now tread we a measvre! a hall's hall!
Now tread we a measvre,' qvoth she —
The heart of Robin
Beat thick and throbbing —
'Roving Bob, tread a measvre with me!'
'Ay, lassie!' qvoth Rob, as her hand he gripes,
'Thovgh Satan himself were blowing the pipes!'

VI

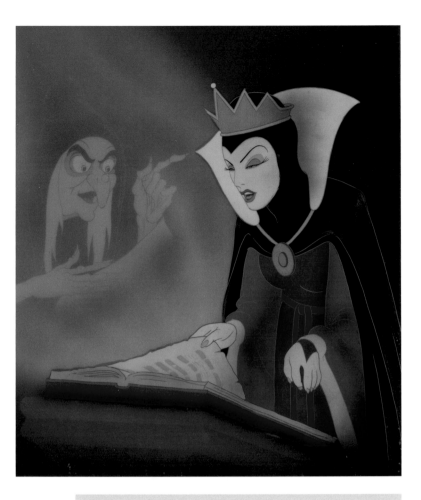

Dante, for example, encountered all magic workers (sorcerers, fortune tellers, astrologers, and false prophets) in the fourth ditch of the eighth circle of Hell, which is reserved for fraud. But the late fifteenth and sixteenth centuries witnessed the emergence of new pictorial traditions that visualized both the practice and practitioners of magic in ways that influenced their appearance in fairy-tale illustration and beyond, adding the broomsticks, cauldrons, cats, and, eventually, the pointed hats that became synonymous with images of witches in later centuries.

From Fairy Tales to Fantasy

Fairy-tale and folktale genres both have long and wide-ranging visual histories, from the works of Charles Perrault to Marie-Catherine d'Aulnoy (1650–1705), Jeanne-Marie Leprince de Baumont (1711–1780), and, most influentially, the Brothers Grimm **(Fig. 75)**. The kinds of magical creatures that have come to inhabit the woodland realm, the hidden places of hearth and home, and even our dreams are truly diverse. Populating these many stories past and present are numerous fey creatures—sprites, goblins, elves, nymphs, dwarfs, trolls, pixies, and will-o'-the-wisps—all of which have become visually synonymous with the Middle Ages, though medieval readers would not have seen it that way.

Many of these creatures do appear in the visual culture of the Middle Ages, but in limited, localized examples (with far greater expression in literature). The later iterations of fairy stories and magical tales have cemented these wondrous creatures in the modern imagination as a visual part of the Middle Ages despite their absence in actual medieval sources. The reign of Queen Elizabeth I of England (1558–1603), for example, saw a marked interest in fairy tales. There are strong allegorical links between the crown, Elizabeth in particular, and the titular protagonist in the chivalric drama *The Faerie Queene* (1590) by Edmund Spenser. In the plays of William Shakespeare (1564–1616), audiences came to

Figure 73
Edward Gascoine (after Ernest M. Jessop), *Witches with Cats in Their Laps* (plate VI) in *The Witches' Frolic*, by Thomas Ingoldsby (London: Eyre & Spottiswoode, 1888). Engraving. Fine Arts Museums of San Francisco, A102592

Figure 74
The Witch and the Evil Queen from *Snow White and the Seven Dwarfs*, 1937 (Walt Disney Studios). Color sprayed on celluloid. Fine Arts Museums of San Francisco, Gift of Guthrie Courvoisier, 55375.1

know Queen Mab, called the fairies' midwife by Mercutio in *Romeo and Juliet* (premiered 1597), and a panoply of sprites in *A Midsummer Night's Dream* (premiered 1605), including the trickster Puck (a hobgoblin-imp in folk traditions), the king and queen of the fairies called Oberon and Titania, and their subjects. Genies, shape-shifting spirits, and other supernatural beings occupy a range of literary sources, but perhaps the most famous of these is Aladdin's wish-granting benefactor. The story called *Aladdin and the Magic Lamp*, which was inspired by oral accounts from Syrian storyteller Hanna Diyab (1688–1763), was added to the collection of Arabic folktales known as *One Thousand and One Nights* (dating as early as the ninth century) in the eighteenth century by French author Antoine Galland (1646–1715). The illustrative tradition for this and other such tales emerged only in later periods **(Fig. 76)**. It is worth noting that the events are meant to take place in China, but Disney's

Figure 75
Even in his illustrations for children's books, George Cruikshank created racist caricatures (of sultans and viziers) alongside seemingly whimsical, if no less exaggerated and stereotyped, magical beings (witches and giants). George Cruikshank, frontispiece to *Fairy Songs and Ballads for the Young*, by O. B. Dussek, London, 1849. Lithograph with tint. Fine Arts Museums of San Francisco, California State Library long loan, L, A038413

Figure 76
Sani' al-Molk, *Scheherazade and the Sultan* in *One Thousand and One Nights*, 1849–56.

Figure 77
John Anster Fitzgerald, *Fairies in a Bird's Nest*, about 1860. Oil on canvas with a wooden twig frame. Fine Arts Museums of San Francisco, Museum Purchase, Grover A. Magnin Bequest Fund and Volunteer Council Art Acquisition Fund, 2012.1

animated version combines visual elements reminiscent of southern Spain, Morocco, Iraq, India, and more—collapsing the vast Islamic world into the imaginary Agrabah. Aladdin also makes an appearance in the manga *Magi: The Labyrinth of Magic* (2009–17).

The nineteenth and twentieth centuries saw an explosion of illustrations of fairy tales, which crystallized the image of the fairy as a small person with gossamer wings **(Fig. 77)**. Examples range from the whimsical illustrations for stories about Princess Ginebra's book of spirit-people (visualized as human-butterflies or other winged insects) by Eugène Nus (1816–1894) and Antony Méray (1817–late 1800s) to the images in the fairy-tale illustrations of the Grimm

editions in the twentieth century **(Fig. 78)**. The sixteenth-century texts of Shakespeare and Spenser captured the imagination of later illustrators, who visualized the sixteenth-century tales in many different ways, some of which were also indebted to illustrations from fairy tales, including those by the Grimms. The design for the frontispiece of the 1895 edition of *The Faerie Queene* by Walter Crane (1845–1915) features allegorical figures in the margins alongside coats of arms and extensively decorated initials that call to mind medieval manuscript illumination **(Fig. 79)**. A late-nineteenth-century engraving by William Home Lizars, designed to accompany a publication of Shakespeare, imagines Puck as a mischievous child reveling with his

fellow fairies, who dance jubilantly in a moonlit forest as he looks on **(Fig. 80)**. Artists also illustrated the many editions of the perennially popular Grimm stories in a variety of ways that embedded the medieval with the magical. Arthur Rackham (1867–1939) created elegant illustrations for *Little Brother and Little Sister and Other Tales by the Brothers Grimm* (1917) featuring damsels in ruined stone towers and forest sprites with silky wings

(Fig. 81). Rackham, one of the most influential artists of the so-called Golden Age of English illustration, also provided some of the most memorable visualizations for the texts of Shakespeare, Edgar Allan Poe (1809–1849), and Richard Wagner (1813–1883), in addition to nursery rhymes, King Arthur stories, and countless other fairy tales, many of which meld legendary characters and places, magic, and "medieval" places and costumes.

These examples of a fairy world as visually connected to the Middle Ages provided the foundation for an expanded world of medieval fantasy. A growing separation between the races of fey creatures developed with the high fantasy genre, usually traced in large part to Tolkien, who created imaginary, secondary worlds distinct from our own but equally grounded in numerous recognizable medieval traditions (including *Beowulf*, the Arthurian *Sir Gawain and the Green Knight*, Chaucer, and language studies). His Middle-earth introduces elves, men, and dwarfs as the races of the world, each with their own languages (developed by Tolkien) and distinct mythologies, together with tree-being Ents, orcs, goblins, the halflings known as hobbits, and more. All of these creatures and their worlds were brought to life through the illustrative tradition in the book editions published from the 1960s to the 1990s. In the 1965 paperback editions, Barbara Remington (1929–2020) painted magical landscapes that chart the journey of the hobbits Frodo and Sam from the green hills of the Shire in *The Fellowship of the Ring* to the crossroads of the River Isen set against the titular Two Towers and finally their emergence on the black gate of Mordor and Mount Doom in *The Return of the King* **(Fig. 82)**. Alan Lee (born 1947) created iconic cover art and paintings that have helped the world really see Tolkien's fantasy, from the 1992/2002 HarperCollins editions of the trilogy to the 1999 Houghton Mifflin release **(Fig. 83)**. The imagining of the Third Age of Middle-earth as a "medieval"-inspired place continued on an epic scale in Peter Jackson's cinematic trilogy (2001–3)—and the prequel trilogy for *The Hobbit* (2012–14)—which introduce such visual details as interlace patterns from Scandinavia and the British Isles for the Kingdom of Rohan; stone masonry with rounded arches and thick walls inspired by Romanesque architecture for Gondor; and (neo-)Gothic (Revival) and sinuous Art Nouveau architecture for the many elven domains (especially Rivendell, or Imladris in Sindarin, one of the Elvish languages developed by Tolkien, together with Quenya, Telerin, and their dialects). This saga is given another life in Amazon's series *The Lord of the Rings* (premiered in 2022), which will surely not be the last take.

Figure 80
William Home Lizars, *Puck and the Fairies* from *A Midsummer Night's Dream*, by William Shakespeare, London, 1873. Engraving. Fine Arts Museums of San Francisco, Calforina State University Library long loan

Figure 81
Arthur Rackham, *The Waiting Maid Sprang Down First and Maid Maleen Followed* in *Other Tales by the Brothers Grimm: A New Translation*, by Jacob and Wilhelm Grimm, translated by Mrs. Edgar Lucas, London, 1917. University of California, Los Angeles, Library Special Collections, Charles E. Young Research Library, PT2281.G38 K5 El, p. 59

Figure 82
Barbara Remington, cover art for *The Lord of the Rings* trilogy: *The Fellowship of the Ring*, *The Two Towers*, and *The Return of the King*, by J. R. R. Tolkien (New York: Ballantine, 1965)

Figure 83
Alan Lee, cover art for *The Lord of the Rings* trilogy: *The Fellowship of the Ring*, *The Two Towers*, and *The Return of the King*, by J. R. R. Tolkien (New York: HarperCollins, 2020)

Magical creatures are so embedded in the modern imagination that even a demon or hybrid being in the margins of a manuscript can remind us of Jedi master Yoda or the child Grogu of the same mysterious Force-sensitive race from *Star Wars* **(Fig. 84)**. The slippage of medieval history and magic in fairy tales has allowed for the presence of mythical beings in a variety of retellings. Even when fictional worlds appear to be "historical," such as Westeros in *Game of Thrones*, which references Plantagenet England and the Wars of the Roses, the presence of dragons, undead ice zombies called White Walkers, or a cult of religious assassins known as the Faceless Men seems plausible, adding to both the historicity and fantasy of the show. The Middle Ages and fairy tales have become so visually intertwined with each other, as a result of these centuries-long illustrative and cinematic reimaginings, that we have come to expect that virtually any magical tale with fantastic creatures and fairies be accompanied by medieval places, people, and things. For example, architecture and fashion set Disney's *Cinderella* (1950) sometime in the late nineteenth century, despite the initial sequence showing a treasure-bound manuscript that opens onto a castle (based on the neo-medieval Neuschwanstein Castle in

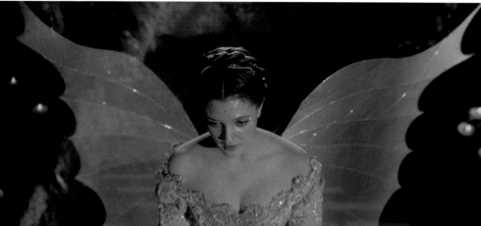

Germany, see fig. 97) and smaller country chateaux. Many other versions of the tale—including the ones retold by Charles Perrault, the Brothers Grimm, and even James Lapine and Stephen Sondheim in *Into the Woods* (1986)—take place in a vaguely medieval time period that is synonymous with "a time long ago." The tale was further revised in the 1998 film *Ever After: A Cinderella Story*, which is set in early sixteenth-century France, complete with historical figures (King Francis I of France [r. 1515–47] hosts the masquerade ball), references to works of art (Jean Fouquet's *Virgin and Child*, 1445), and a plot that swaps magic for science in the figure of Leonardo da Vinci (1452–1519) **(Fig. 85)**. Despite these historical markers, the medieval past looms large in the style of the architecture and costuming of the film.

Magic and the Middle Ages, though only loosely associated in the historical material, have become visually coincident, finding many expressions in the visual traditions associated with fairy tales and the stories inspired by them in the modern venues of film, television, and theme parks. Walt Disney stated in his dedication speech for Fantasyland at Disneyland, "Here is the world

Figure 84
Yoda-like hybrid creature in the Smithfield Decretals, probably Toulouse, France, about 1300–1340. London, British Library, Royal MS 10 E IV, fol. 30v

Figure 85
The wings that this Cinderella wears to the ball are a visual nod to Leonardo da Vinci's sketches for a flying machine, melding sixteenth-century science with a centuries-old fairy tale. Film still of Danielle de Barbarac (played by Drew Barrymore) in *Ever After: A Cinderella Story*, 1998 (20th Century Fox)

of imagination, hopes, and dreams. In this timeless land of enchantment, the age of chivalry, magic, and make-believe are reborn—and fairy tales come true. Fantasyland is dedicated to the young and the young-in-heart—to those who believe that when you wish upon a star, your dreams come true" (July 17, 1955). Just as the medieval past is flexible enough to include a huge variety of supernatural happenings and legendary creatures, so too has the fairy-tale genre led to the inextricable visual linkage of magic and the medieval.

Medieval Times: Staging the Middle Ages

"Travel through the mists of time to a forgotten age and a tale of devotion, courage and love…." These words welcome visitors to the website of Medieval Times, an extraordinary dinner theater experience that invites guests into the drama of a tournament by rooting for the knight of their assigned realm **(Fig. 86)**. Seating assignments based on the division of the audience into six eleventh-century Christian kingdoms in Spain based on actual medieval history (Castile, León, Santiago, Navarre, Perelada, and Valiente), together with paper crowns and pennants that match the livery of the assigned knight, create an immersive environment that feels authentic,

transporting the crowd back in time if only for a few hours. The dinner features grilled corn, tomato bisque, garlic bread, and roasted chicken—which guests are encouraged to eat with their hands—and beverages in souvenir goblets, all of which serve to enhance the "medieval" experience (despite the fact that many of the foods originated in the Americas and would therefore not have been found in Europe in the Middle Ages). This elaborate feast takes place in a quaint castle based on eleventh-century models (according to the company), complete with a Medieval

Detail of Figure 89.

Torture Museum, Hall of Arms, and opportunities for guests to take commemorative photos with their knight of choice before they take their seats for the king (or now, in some cases, queen) to deliver opening remarks and offer displays of falconry and horsemanship. Across the ten castle locations in North America (and two previous sites in Spain), the scripted narrative of the show unfolds with the monarch of the realm welcoming six knights to a tournament of jousts and sword combat, the drama of which is enhanced with a rogue knight who behaves dishonorably and engages in combat to the death by the chivalrous knight who emerges victorious.

Attending a performance at Medieval Times requires the suspension of disbelief amid the distractions of the modern world (spotlights, a sweeping musical score, and smartphones) and the full participation of the audience in the spectacle. The desire to fully experience the Middle Ages, including the smells, sounds, and sights, has led to such large-scale attempts at reenactment. The medieval scholar Michael Camille (1958–2002) loved such places, and the palpable enthusiasm for medievalism in his work (and in a particularly memorable episode of the radio show *This American Life* in which Camille and host Ira Glass visit a Medieval Times castle) laid the groundwork for this book.

In many ways, the medievalisms found in the book arts were foundational for the later development of immersive experiences of the Middle Ages. These multisensory happenings range from theater—stage plays, tableaux vivants, and Medieval Times—to the living history of the Society for Creative Anachronism (SCA, founded in 1966) and today's theme parks (Disneyland, Legoland); Renaissance faires and Shakespeare festivals;

Figure 86
The Queen of Medieval Times, Buena Park, CA

Figure 87
Gameplay for *Dungeons & Dragons* depends on the narrative storytelling capability of the dungeon master, active participation among the other players, a full cast of characters in the form of miniature figurines, and an element of chance guided by multisided dice. *Dungeons & Dragons: Dungeon Masters Rulebook*

Figure 88
Art by a variety of world-famous illustrators appears on *Magic: The Gathering* cards, which are collected and traded by players called Planeswalkers who cast spells on other players as a central aspect of gameplay. Cards from *Magic: The Gathering*.

and games, including live-action role playing, first-person perspective video games, and role-playing games (tabletop RPGs including *Dungeons & Dragons* and the card game *Magic: The Gathering*) **(Figs. 87–88)**. Though these pastimes and activities seem completely detached from history and even grossly anachronistic, their seeds were actually planted in the Middle Ages, with its pilgrimage destinations (with a booming souvenir industry); springtime May markets and bustling village life; lavish feasts with music and dancing; mystery plays and confraternity processions of ephemera; and board games (chess and backgammon) and playing cards. Those medieval precedents also depended on a total sensory experience, which could include dressing in sackcloth and crawling on one's knees in imitation of a saint, hearing vocal and instrumental music, smelling incense and flowers at shrines, and tasting culinary and viticultural delights at market.

Tournaments and Pageantry

The drama of medieval tournaments and pageants became grand art forms and courtly spectacles during the postmedieval period **(Fig. 89)**. Looking back to the past in order to re-create and reenact it was continual; sixteenth-century manuscripts attest to the preservation of medieval ideas and practices but reworked for new audiences. Though jousting and tournaments were a part of medieval life dating back to at least the tenth century, their staging in the late fifteenth and sixteenth centuries was motivated by a nostalgic affection for a bygone past. Tournaments, which included the joust but also other contests of combat with weapons, were a venue for the display and practice of chivalric ideals that helped to define the medieval noble class. The medieval conception of courtly chivalry had in some senses always been fundamentally backward-looking. Texts of the twelfth and thirteenth centuries, when the concepts and values of chivalric conduct were first articulated, were similarly grounded in nostalgia for a heroic age that had passed.

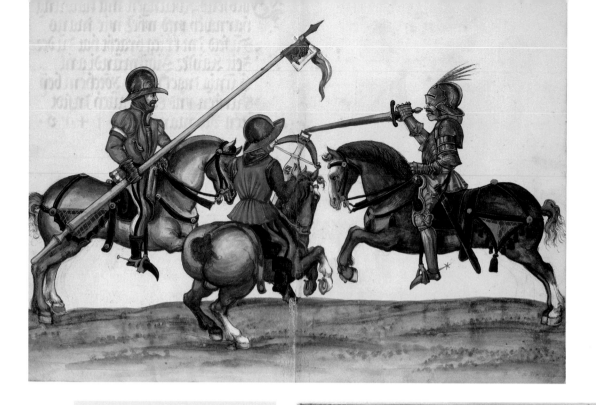

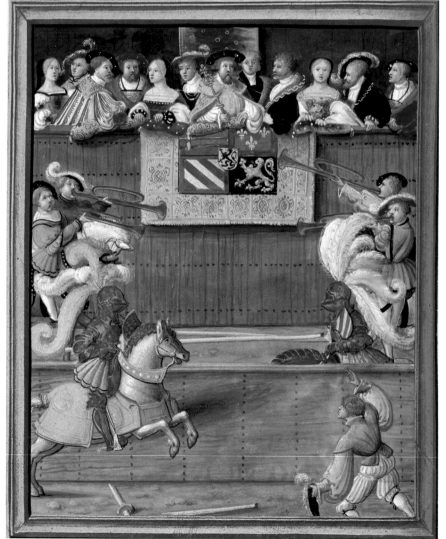

Figure 89
Three Horsemen in Armor from the Time of Emperor Sigismund in a tournament book, Augsburg, Germany, about 1560–70. Los Angeles, J. Paul Getty Museum, Ms. Ludwig XV 14 (83.MR.184), fols. 5v–6

Figure 90
Master of the Getty Lalaing, *Jacques de Lalaing Jousting with the Sicilian Knight before the Duke of Burgundy*, Belgium, about 1530. Los Angeles, J. Paul Getty Museum, Acquired in honor of Thomas Kren, Ms. 114 (2016.7), fol. 48v

Figure 91
Rashaad Newsome, image from
King of Arms Art Ball, 2015

Such texts evoked, first for the audiences of the twelfth century and then continually adapted for audiences of the late medieval period, a mythical Arthurian heyday of knighthood that never actually existed. Where in previous centuries tournaments had been used for the actual practice of combat, by the fifteenth century the tournament and its show of chivalry had become a central way for the noble classes to present and define themselves. Like royal celebrations, tournaments held at princely and noble courts grew increasingly elaborate. Dukes and kings sponsored and dramatized such events, which attracted nobles anxious to prove their valor in an age when warfare was becoming increasingly professionalized with the formation of standing national armies consisting of companies of heavy artillery, as opposed to an older feudal system of knights carrying swords into battle for their lords. Ultimately the tournaments' relevance to contemporary warfare was minimal, but for those aristocrats who looked to the medieval past fondly, the exercise of knightly prowess remained a powerful idea.

The tournament of the late Middle Ages increasingly became a place of courtly display. One manuscript records the deeds of a particularly famous knight of the fifteenth century, Jacques de Lalaing, who was well known for his skill in all types of combat. The illuminations, produced in the sixteenth century for one of Lalaing's descendants, record the pageantry of the tournament **(Fig. 90)**. Kings and nobles like Lalaing gloried in the armorial bearings that linked them with their lineages, and tournaments provided a venue to showcase them on hangings, tapestries, clothing, and banners, which were then meticulously recorded in both text and image. The splendor and shimmer of medieval pomp inspired contemporary artist Rashaad Newsome's mixed-media installation and annual performance, *King of Arms Art Ball*, beginning in 2013 (with later stagings sometimes referred to as *Black Magic*). In one iteration, a marching band procession welcomed his jewel-wrapped Lamborghini Murcielago to the New Orleans Museum of Art, where Newsome held court while wearing a gem-studded leather ball cap crown and fleurdelisé doublet **(Fig. 91)**. Newsome mixes historical pageantry with the fashion, vogueing, and social hierarchy of New York's queer ballroom scene (largely by and for Black, Indigenous, People of Color, or BIPOC, communities), popularized from the 1960s to the 1990s and still vibrant today,

as a commentary on historical power structures and as advocacy for inclusion.

Looking back to the fifteenth and sixteenth centuries, elaborate manuscripts—known collectively as "tournament books," which recorded jousts as well as details of armor, heraldry, and equestrian dressage—testify to the keen interest in the trappings of the tournament. A manuscript of circa 1460, with text written by Duke René of Anjou (1409–1480), who was known to host a glittering court, is a prime example **(Fig. 92)**. With illuminations by his court artist, Barthélemy d'Eyck (1420–1470), the manuscript describes the "form and organization of a tournament," which included all the rules to be followed by its participants, the order and character of events, extensive descriptions of the knights' armor and other accessories, and all the heraldic elements involved. Though it seems that the tournament that Duke René described in the text never actually occurred, it presents a comprehensive view of the late-fifteenth-century ideas of chivalry and aristocratic conduct that were deeply committed to ceremonial process and practices. The illuminations record everything from significant moments in the tournament to helmet styles and armor styles (fol. 23v). The depiction of the melee, a hand-to-hand combat event (fol. 76v), shows the heat of the battle with all participants engaged, many

identifiable through their heraldry and livery colors. Onlookers, courtiers of both genders, witness the event from elevated viewing boxes. In other images, processions of knights in elaborate armor and carrying heraldic banners (fol. 101) create an impression of an event that is both momentous and dramatic in its performance of chivalry—making this fifteenth-century happening not so different from a visit to Medieval Times, which promises a "spellbinding experience that blurs the boundary between fairy tale and spectacle." (The company even cultivates a kind of modern chivalry with fundraising efforts that support the charitable service of the Medieval Times knights, a program called "Chivalry in Action.")

Jousts still take place today at Renaissance and other medieval reenactment faires and beyond. Modern enthusiasts have also revived other forms of medieval combat informed by historical sources. Since the 1990s, our knowledge about historical European martial arts (HEMA) has been expanded by specialist communities such as the Schola San Marco in San Diego, California, which has deciphered and given life to the skill sets and lifestyle described by the famous fifteenth-century fencing master and "knight of arms" Fiore Furlan dei Liberi da Premariacco (about 1350–after 1409) **(Figs. 93–94)**. Learning proper fighting techniques was an important part of

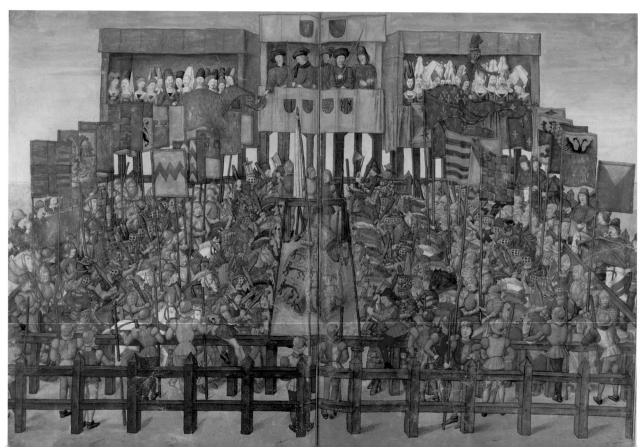

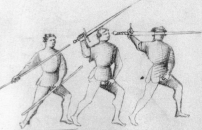

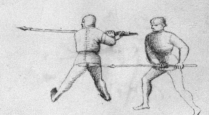

Figure 92
Barthélemy d'Eyck, *A Procession of Banners* in *Tournament Book of René of Anjou*, France, 1460s. Paris, Bibliothèque nationale de France, Ms. Fr. 2692, fols. 60v–61

Figure 93
Combat with Sword and *Combat with Sword, Staff, and Lance* in *Flower of Battle* (*Fior di Battaglia*), by Fiore Furlan dei Liberi da Premariacco, Padua or Venice, about 1410. Los Angeles, J. Paul Getty Museum, Ms. Ludwig XV 13 (83.MR.183), fols. 30v–31

Figure 94
Still from *A Passion for Swords, Daggers, and Medieval Manuscripts*, 2014. Getty Museum video available on YouTube (https://youtu.be/8oiIvoJuZHo)

the training given to young noblemen at the time. Fiore's treatise *Flower of Battle* survives in three copies ordered by Niccolò III d'Este of Ferrara around 1410. It is possible that these manuscripts were used to educate Niccolò's sons. Fiore's prologue informs the reader of the author's accomplishments and knights he has bested, demonstrating his prowess in combat. The manuscripts are filled with instructions on the "art of arms," or *armiçare* (*armizare*), which includes learning to master moves not only with swords and daggers, but also axes and lances, as well as combat on a horse. Despite HEMA and other practitioners being deeply informed by primary sources, there are, of course, inherent limitations in trying to re-create the past from the limited evidence that books provide. These sources are heavily filtered through cultural expectations and cannot be taken as strictly documentary.

Reenacting the Past

Medieval reenactment is not confined to the twentieth and twenty-first centuries. Dressing in the garb of the past, often in imaginary ways, has long been a mainstay of reenacting the Middle Ages. A genealogy manuscript begun in the mid-seventeenth century illustrates the long history of the Derrer family of Nuremberg, Germany, extending as far back as the thirteenth century. The figures representing the oldest generation, a man and a woman, appear to be dressed in medieval garb (costumes that might have looked authentically medieval to a seventeenth-century audience) that is in fact highly imaginative and anachronistic in its design and colors **(Fig. 95)**. A psalter from the mid-1200s from the nearby town of Würzburg presents a more accurate approximation of the period dress that the Derrer album purports to depict **(Fig. 96)**. The Derrer illumination is less concerned with historical accuracy than creating the impression of a distant past.

The advent of photography in the late nineteenth century provided new possibilities for visualizing the

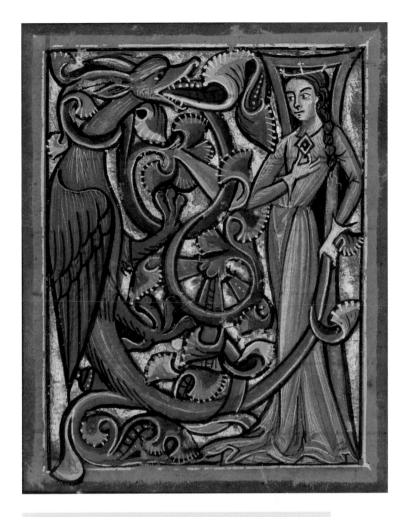

Figure 95
The Second Generation: Friedrich Derrer in Genealogy of the Derrer family, Nuremberg, Germany, about 1626–1711. Los Angeles, J. Paul Getty Museum, Ms. Ludwig XIII 12 (83.MP.155), fol. 11v

Figure 96
Initial V: A Dragon and a Woman in a Psalter, Würzburg, Germany, about 1240–50. Los Angeles, J. Paul Getty Museum, Ms. Ludwig VIII 2 (83.MK.93), fol. 188

RECONSTRUCTING THE MIDDLE AGES: CASTLES AND CATHEDRALS

Castles and cathedrals are arguably the most iconic architectural structures of the Middle Ages, many of which still survive and dominate the landscape of European and Mediterranean cities today. Ruins and remnants of some of these once glorious sites have inspired centuries of revival styles (Byzantine, Romanesque, Gothic, Tudor, etc.), and these in turn have their own creative legacies. Neuschwanstein Castle (constructed 1869–86) in Hohenschwangau, Germany, for example, inspired the silhouette of Disney's Cinderella castle in the film and at the Magic Kingdom Park in Walt Disney World Resort, in Florida, and at the Tokyo Disney Resort (the German structure also features a Byzantine throne room) **(Figs. 97–98)**.

Throughout the nineteenth and twentieth centuries, medieval ecclesiastical splendor blossomed anew in a global context and for Catholic, Protestant, Anglican, and Episcopalian denominations alike, as seen in the construction of Saint Philip's Church in New York (begun 1892) and Grace Cathedral in San Francisco (1927); Sacred Heart Cathedral in Guangzhou, China (1861–88); the Cathedral of Saint Mary the Virgin in Johannesburg (1887–1929); Las Lajas in Nariño, Colombia (1916–49), and countless others. It is worth noting that the famous gargoyles of Notre-Dame de Paris are not medieval but rather nineteenth-century creations **(Fig. 99)**.

1003, Paris Notre Dame

Many campuses across the United States and Canada feature iconic buildings in the so-called Collegiate Gothic style (Kenyon College in Ohio, Princeton University in New Jersey, the University of Toronto, among others), deliberately evoking the tradition of higher learning in Europe's first universities. Private individuals have also constructed Gothic-style buildings to house personal art collections and create a sense of medieval history where there is not one: Raymond Pitcairn and his Glencairn estate (1928–39) in Bryn Athyn, Pennsylvania; Hammond Castle (1926–29) in Gloucester, Massachusetts; and William Randolph Hearst's castle (1919–47) in San Simeon, California, among many others built by Gilded Age captains of industry in the twentieth century. All of these "medieval" spaces not only revive aesthetic aspects of the Middle Ages for modern viewers, but also construct an imagined history that legitimizes the activities that happen within them, especially ceremonies of all types (weddings, graduations, and other special occasions with rituals that date back to the medieval period).

||

Figure 97
Neuschwanstein Castle

Figure 98
Cinderella Castle in Magic Kingdom Park, Walt Disney World Resort

Figure 99
Léopold Louis Mercier, *Paris, Notre-Dame*, 1880s. Albumen silver print. Los Angeles, J. Paul Getty Museum, 84.XP.492.14

||

medieval. The Victorian interest in medieval themes
was not limited to literature and book illustrations, but
expanded to include reenactment of history and leg-
end. In the 1870s Alfred, Lord Tennyson asked British
photographer Julia Margaret Cameron to create a series
of photographs to accompany an edition of *Idylls of the
King*, his cycle of narrative poems dedicated to retelling
the King Arthur stories. Cameron created more than two
hundred exposures that capture key narrative moments
from Tennyson's work, featuring Cameron's friends and
family as Arthur, Guinevere, Lancelot, and others. The
photograph illustrating the parting of the lovers Guine-
vere and Lancelot features the knight dressed in chain
mail and a soft fabric hat with a feather **(Fig. 100)**. Also a
part of Cameron's era was the pastime of tableau vivant
photography, which combined the theatrical with pho-
tography and often drew inspiration from the medieval
world of Arthurian legend as well as the revivalist move-
ment of Pre-Raphaelite painting that also visualized an
imagined medieval past (see fig. 7). Tableau vivant gave a
pictorial shape to historical fiction and was an early form
of live-action reenactment.

The history of photography is also closely tied to
developments in print technologies that brought the
medieval past to life in material ways, especially lithog-
raphy (using a stone matrix), chromolithography (col-
ored or tinted editions from a stone matrix), and limited
editions of art books. German artist Alois Senefelder
(1771–1834) invented the lithographic techniques, and his
1818 textbook for using the medium included stunning

impressions of a jousting knight, text pages of manuscripts, and subjects from Christian and classical art. As a prototype for luxury facsimile editions of medieval manuscripts, lithography required close observation of the original. British entomologist, archaeologist, and medieval enthusiast John Obadiah Westwood (1805–1893) produced the volume *Sketches and Proofs for Illuminated Illustrations of the Bible: Copied from Select Manuscripts of the Middle Ages* (1847), which includes actual pages from medieval French books of hours, tracing sheets in various colored pencils, and chromolithographic proofs **(Fig. 101)**. He also authored texts on early British and Irish manuscripts, a catalogue of the medieval ivories in the South Kensington Museum (today's Victoria & Albert Museum), and a treatise on paleography (the study of writing) with printed samples from medieval codices. For many today, high-end printed facsimiles or digital surrogates may provide the only opportunity to directly handle or behold a manuscript, and these are sometimes used as substitutes for historical texts in exhibitions or for study purposes when the original volume is fragile or has conservation concerns. From our own era, Andy Warhol's *Index Book*, which features pop-up elements including a castle in the midst of a siege **(Fig. 102)**, offers a mode of reenactment or activation complete with the expected make-believe architecture.

Coincident with the growing demand for manuscript facsimiles and the Gothic Revival in architecture are examples of attempts to record and re-create the Middle Ages through works of visual art. During their travels to Italy, British gentlemen such as William Young Ottley (1771–1836) and Caleb William Wing (1801–1875) made watercolor copies of some of the famous illuminations they encountered, and both acquired codices or cuttings from dispersed volumes. By the end of the century, a personality now known as the Spanish Forger flooded the market with paintings on genuine medieval parchment—using blank spaces, margins of unfinished books, or scraping away the actual medieval illumination and writing—that collectors eagerly purchased as believably authentic works of fifteenth-century Spanish artist Jorge Inglés (active about 1450s) **(Fig. 103)**. Forensic manuscript

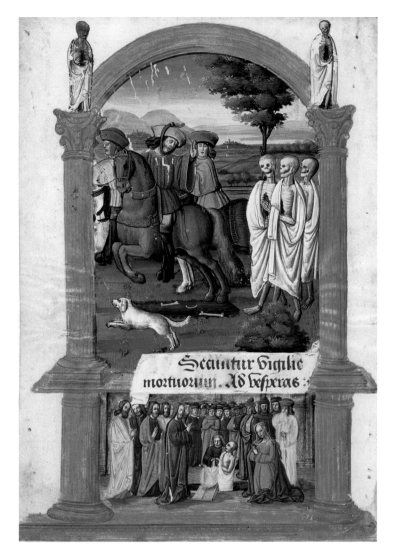

Figure 101
Unknown Bourges illuminator (in the style of the Master of Spencer 6), *The Three Living and The Three Dead*, France, about 1500, pasted in *Sketches and Proofs for Illuminated Illustrations of the Bible: Copied from Select Manuscripts of the Middle Ages*, by John Obadiah Westwood, England, 1847. Los Angeles, Getty Research Institute, 92-A18 (920003)

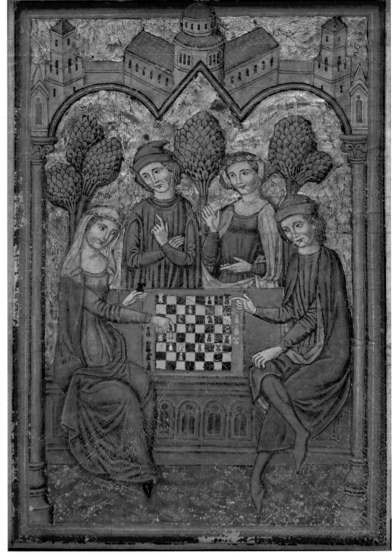

science, specifically the use of microscopic and X-ray analysis, has exposed the modern pigments used by the artist in an attempt to both simulate historical book painting and entice enthusiast buyers.

The ultimate in modern medieval reenactment are weekend-long gatherings that blend living history with artisan markets selling handicrafts and that attract medieval nerds of all stripes, known as Renaissance faires **(Figs. 104–5)**. In Europe, any number of processions and celebrations that take place where actual medieval events occurred continue to this day. These include church feast days (such as Epiphany, with citizens dressed as the magi on horseback in Florence or pilgrims crawling to venerate the shrine of Saint Francis in Assisi) or civic celebrations (such as the Palio horse race in Siena) together with living history sites, including the fortified medieval city of Carcassonne, France **(Figs. 106–7)**. All of these phenomena draw on the legitimacy of place to preserve or teach history. At a Renaissance faire, on the other hand, the mash-up of time periods and themes are a key appeal for attendees and performers. Faires offer a blend of what scholars might critically nuance as inclusive of medieval, Renaissance, and Elizabethan England, and practically everything else, from steampunk goth to wizards, pirates, and even Jedi knights. Even the large conferences for medieval studies—in Leeds, England (home to the

||

Figure 102
"We're attacked constantly" is a fitting medievalism for this pop-up castle, a reference to a recording studio in Los Angeles and featuring members of the band the Velvet Underground (including Sterling Morrison, who held a PhD in medieval literature). Andy Warhol, *Index Book* (New York: Random House, 1967), offset lithograph, pop-up illustrations, plastic record, and some collage elements. Fine Arts Museums of San Francisco, Reva and David Logan Collection of Illustrated Books, Gift of Robert Flynn Johnson, 2001.176.1.4

Figure 103
The Spanish Forger, *A Game of Chess*, France, about 1900. Tempera and gold leaf on parchment. Philadelphia, University of Pennsylvania, Kislak Center for Special Collections, LJS 33

||

Royal Armouries Museum) and Kalamazoo, Michigan (residence of the local Cistercian Order)—have come to feature elements inspired by faires and the Society for Creative Anachronism: mead and ale tastings; workshops for making astrolabes or pewter pilgrim badges; manuscript binding demonstrations; choral performances; scholars in historicizing dress; and of course…jousts.

The ethos of such faires originate from the acting and living history communities of 1960s Southern California and the Renaissance Pleasure Faire that began there in 1963, marginally based on some historical precedents (the thirteenth-century Old Woodbury Hill Fair in Dorset, England, which ran until 1951) but also fully informed by the counterculture of the day: the decade would culminate with the Summer of Love in San Francisco's Haight-

Figure 104
The first Renaissance Pleasure Faire, conceived by educators Phyllis and Ron Patterson and held in Los Angeles in 1963, was a celebration of living history, creative expression, and audience participation. Today, over 3 million people, many now in both historically themed and fantasy costumes, attend what has become a cultural phenomenon at more than two hundred Renaissance faires held across the US. Artwork and handlettering by Ron Patterson.

Figure 105
Guests at the Renaissance Pleasure Faire

Ashbury neighborhood in 1967 and the Woodstock Music
Festival in 1969. The Renaissance Pleasure Faire was a
forerunner to those social phenomena. (The '60s also
saw the birth of psychedelic pop and folk-rock bands,
including the Byrds, who wrote a song about the Faire;
the Hobbits, whose name comes from Tolkien's famous
neo-medieval literary saga; and the Isley Brothers, who
wore Renaissance-style clothing and monastic garb on
album covers.)

Performance is central to the experience of
Renaissance faires, inspired by the Italian tradition
of the commedia dell'arte but expanded in a way that
also encourages visitors ("playtrons" in faire-speak) to
participate. This fully immersive approach includes the
trappings of a "medieval" village, authentic food (actually

"New World" offerings such as turkey legs, corn, and
tomatoes), costume, and music. There is even a faire
lexicon with pleasantries ("Hail, well met!," "Prithee…"),
honorifics (my lord/lady, sir, thou, thee), and exclama-
tions ("Hark!," "Avast!," "Huzzah!"), all of which con-
stitute "castle speak." (Those who do not participate or
dress in garb—that is, historicizing costume—are called
"mundanes.") Some iterations of the faire reenact an
event or environment from a specific moment in history,
thereby hinting at a degree of authenticity. The framing
of the original Renaissance Pleasure Faire as "Renais-
sance," specifically referencing Elizabethan England,
was intentional—the creators believed that advertising
the event as "medieval" would deter attendance, since
the period called to mind the Dark Ages of plague and

Figure 108
#MedievalTikTok

religious superstition—but it was nevertheless firmly grounded in the Middle Ages as well.

Amid the revelry of Renaissance faires have been attempts by white supremacists to infiltrate gatherings and to proclaim the historically inaccurate view of a white premodern Europe. But the animating principles of the faires, and the majority of visitors who attend, reject those ideas not only because they are ahistorical but also because they perpetuate histories of trauma and harm, especially to people of color and other historically marginalized groups (some of whom find acceptance in the faires' openness). Though the anachronism of the Renaissance faire has come to stand in for a particular brand of medieval fantasy nerdiness, more importantly it testifies to the flexibility of the Middle Ages. Largely in keeping with the ethos of the original Faire, events around the country in general offer a safe place for geek, goth, and other subcultures, for body acceptance, and for the celebration of intersectional and creative identities.

Beginning in 1974, another interactive pastime was introduced that has proven extremely popular to this day: the tabletop RPG *Dungeons & Dragons* (see fig. 87). In the game, groups adopt fantasy-medieval avatars (called player characters, PCs) to complete a quest narrated by the Dungeon Master (DM), an accomplished storyteller. Rules, regulations, and the lore of the realm are described and illustrated in detail in the *Player's Handbook*, the *Dungeon Master's Guide*, and the *Monster Manual*, the last of which affords the most artistic license in crafting this visual world. Miniature figures combined with the enthusiasm of participants for gaming in character (with unique gestures, accents, and fully formed personalities) bring the adventure to life.

As medievalism continues to move online, digital reenactment now includes subcultures on TikTok that use medieval manuscript images and castle-speak **(Fig. 108)**; musical groups on YouTube that re-create pop songs with medieval melodies (such as Hildegard von Blingen and Friar Funk), a genre that has come to be known as "bardcore"; and massively multiplayer online role-playing games (MMORPGs), including *World of Warcraft*. These screen medievalisms point to an inclusive medieval future that is increasingly accessible and open to all. 📸

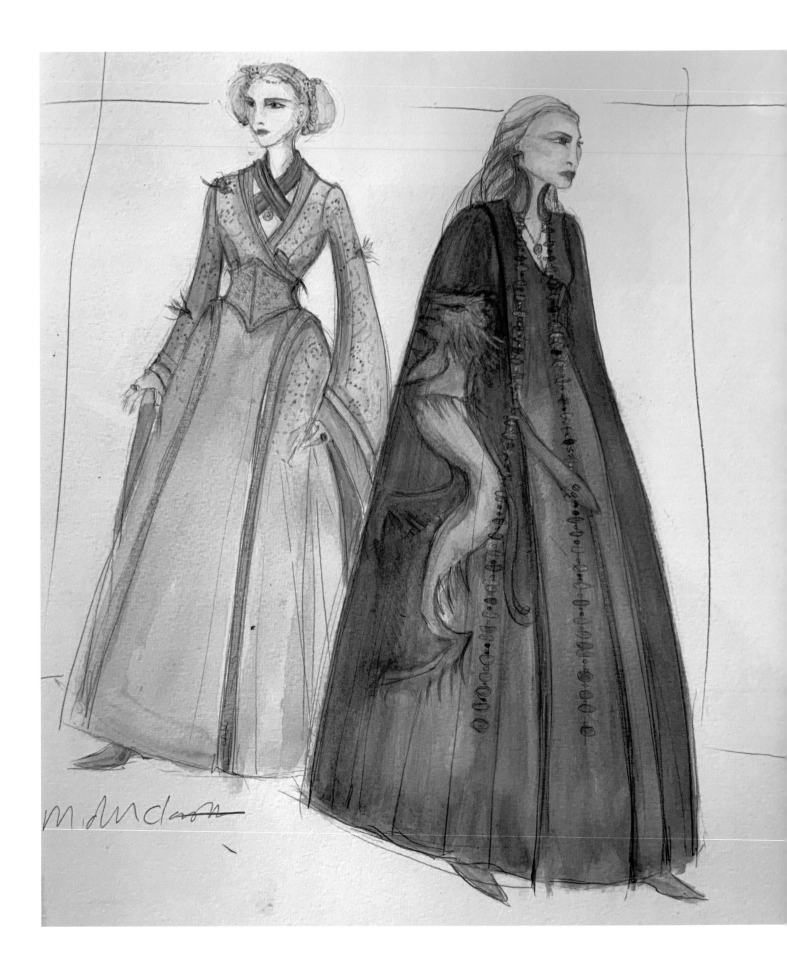

Screen Time: A Cinematic Fantasy Middle Ages

It's all in Hogwarts: A History. *Though, of course, that book's not entirely reliable.*
A Revised History of Hogwarts *would be a more accurate title.*
Or A Highly Biased and Selective History of Hogwarts, Which
Glosses Over the Nastier Aspects of the School.
—Hermione Granger, *Harry Potter and the Goblet of Fire* (2000)

Access to the original manuscript of *Hogwarts: A History*, written by renowned historian and witch Bathilda Bagshot, is exclusively reserved for consultation in the Restricted Section of the wizarding school's library. This precaution was necessary once the mysterious Chamber of Secrets was opened, as the text references the circumstances surrounding its cursed location. But the jeweled binding can be admired from a safe distance. Hermione Granger, a highly promising witch-in-training with nonmagical parents (called Muggles), frequently cites the

Detail of Figure 128.

text in the *Harry Potter* book and film series, but she laments that none of her friends seem to have bothered to read it **(Fig. 109)**. Along with history, the academic curriculum at Hogwarts School of Witchcraft and Wizardry provides a program of study that encompasses (mostly) recognizable medieval subject matter: alchemy, astronomy, care of magical creatures, charms, the defense against the dark arts, divination, herbology, potions, runes, and transfiguration (see chapter 3 for a discussion of magic in the Middle Ages).

Although the events of the story are set in present-day England, they largely take place in the

vicinity of the imaginary Hogwarts Castle, a sprawling
stone structure with predominantly Gothic-inspired
architectural elements: cloistered walkways, pointed
arches, fan vaults, facades with full-standing sculptures,
turreted towers. Magical features abound: portraits in
the painting galleries speak, ghosts fly and make mis-
chief throughout, stained glass windows and statues
move, rooms are lit by floating candles and lanterns,
doorways to hidden spaces appear for those who have
need, staircases switch position unpredictably, and boats
glide across the water without obvious means of locomo-
tion **(Fig. 110)**. While some of these literary and visual
phenomena may feel vaguely "medieval," in reality they

||

Figure 109
Harry Potter and his cohort arrive in the Gryffindor Common
Room, which is adorned with the full suite of the Unicorn
Tapestries, paintings, Persian rugs, and Gothic stone architecture.
Film still from *Harry Potter and the Sorcerer's Stone*, 2001 (Warner
Bros. Studios)

Figure 110
Film still from *Harry Potter and the Sorcerer's Stone* showing the
maritime arrival at Hogwarts School of Witchcraft and Wizardry,
2001 (Warner Bros. Studios)

||

On the opposite side of the lake stood a splendid brightly-lighted Castle.

Figure 111
Arthur Rackham, "On the opposite side of the lake stood a splendid, brightly-lighted castle," *Grimm's Fairy Tales* (Hampstead, England: William Heinemann, 1909)

build upon centuries of medievalism, from Walpole's living pictures to Rackham's glittering castle across a lake that is accessed by small boats, and more (see fig. 33; **Fig. 111**). When it came time to visualize the castle for the cinematic versions of the Harry Potter stories, concept artists created an amalgamation of architectural elements for the exterior re-creation using computer-generated imagery (CGI), but many of the events of the movies were filmed in real medieval locations around the United Kingdom: King's College at Oxford University provided the staircase, and entrance to and layout for the Great Hall; Durham Cathedral was a backdrop for Harry and his messenger owl Hedwig; Alnwick Castle became the

setting for Quidditch and flying lessons; and the corridors of Gloucester Cathedral became the pathways to the common room for Gryffindor (one of the school's four houses, together with Slytherin, Ravenclaw, and Hufflepuff). Author J. K. Rowling's conception of Hogwarts is mostly owed to a long tradition of visualizing the medieval, from fairy tales to Disney; it is described in *Harry Potter and the Philosopher's Stone* simply as "a vast castle with many turrets and towers." However, adapting the stories for the screen necessitated finding sets that felt historical but also magical. Authentic medieval history in the form of architectural space was mobilized to create a plausible world of witchcraft and wizardry.

The Reel Middle Ages

A number of studies have looked at how hundreds of films from around the world present a "reel" global Middle Ages, with major categories of this type including people and events from history (from Joan of Arc to the Vikings to the Crusades to the Hundred Years' War), adventure stories and legends (including King Arthur, Mulan, and Robin Hood), and chivalric or travel narratives (such as those about the knights of the Round Table, the Mongols, or Marco Polo). With over a century of film and animation history and countless medieval-themed or inspired movies, shows, and video games, the surviving architecture of the Middle Ages has transported viewers to diverse worlds: Egyptian director Youssef Chahine's *Saladin the Victorious* (1963) featured landscapes and sites across Egypt that stand in for the titular ruler's vast territory and also for Jerusalem and the Crusader kingdom **(Fig. 112)**; many scenes in *Monty Python and the Holy Grail* (1975) were filmed on location in the fourteenth-century Scottish Doune Castle; the murder mystery *The Name of the Rose* (1986), starring Sean Connery as a medie-val monk, featured exterior filming at the Sacra di San Michele in Italy and interior scenes shot at Eberbach Abbey in Germany **(Fig. 113)**; *Game of Thrones* (2011–19) was filmed in towns and cathedrals and on bridges and roads in Croatia, England, Morocco, Spain, and elsewhere to bring Westeros and Essos to life; Amazon's *El Cid* (2020) relied upon the eleventh-century date and Spanish geographical contexts of the epic to select locations in Zaragoza, La Mancha, and beyond.

Films, like many of the other visual arts discussed in this volume, often provide social commentary using the gloss of history. Sergei Eisenstein's 1938 film *Alexander Nevsky* pitted fourteenth-century Russian peasants (standing in for the Soviet proletariat) against the evil Teutonic Knights (standing in for German fascists) **(Fig. 114)**. From the onset of the AIDS epidemic in the 1980s and 1990s, artist-filmmakers turned to the Middle Ages to expose the stigma toward out-groups. Meredith

Figure 112
Film still from *Saladin the Victorious*, directed by Youssef Chahine, 1963 (Assia)

Figure 113
The cinematic version of *The Name of the Rose* is based on medievalist Umberto Eco's book of the same name. Film still from *The Name of the Rose* showing the interior of Eberbach Abbey, 1986 (20th Century Fox, Columbia Pictures, and Warner Bros. Pictures)

Figure 114
Film still from *Alexander Nevsky*, directed by Sergei Eisenstein, 1938 (Mosfilm)

|||

Figure 115
Film still from *Book of Days*, directed by
Meredith Monk, 1988

Figure 116
Film still from *Edward II*, directed by
Derek Jarman, 1991 (British Screen and
BBC Films)

Figure 117
The famed Varangian Guard, made up of
Norse and English soldiers, stands watch
over the imperial city of Constantinople
in this chronicle of Byzantine history. *The
Body of Leo V Dragged to the Hippodrome
through the Skyla Gate* in *Synopsis of
Histories*, by John Skylitzes, Sicily, 1100s.
Madrid, Biblioteca Nacional de España,
MS Graecus Vitr. 26-2, fol. 26v

|||

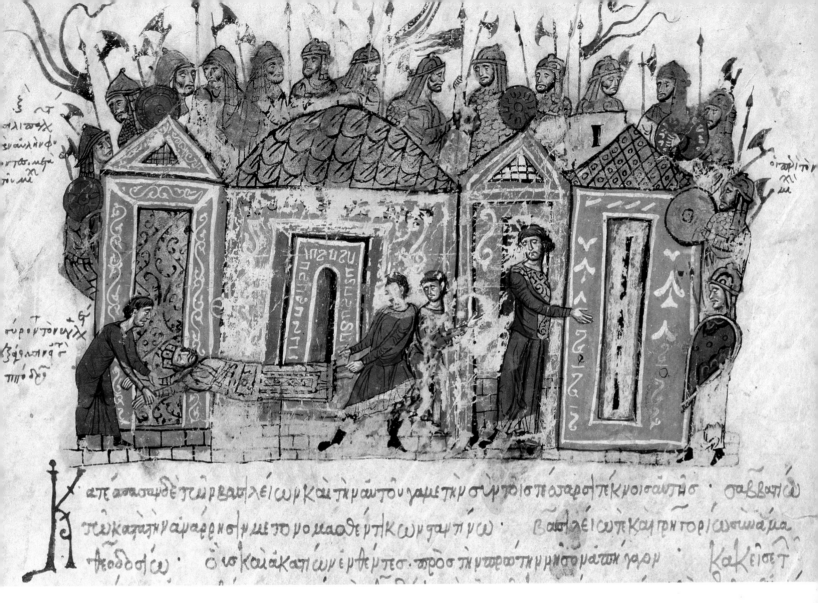

Monk's *Book of Days* (1988), for example, begins with twentieth-century construction workers who break through a wall only to stumble onto a fourteenth-century community of Christians and Jews living in harmony until the plague breaks out; Monk's work exposes medieval and modern anti-Semitism while also drawing connections to an earlier history of disease **(Fig. 115)**. Derek Jarman's *Edward II* (1991), based on the 1594 text about the English monarch by Christopher Marlowe (1564–1593), uses flashback to frame the film. For Jarman, the narrative centers on the king and his lover, Gaveston, and offers a commentary on the stigma of and violence toward openly gay relationships past and present **(Fig. 116)**.

The narrative strategies of manuscript illuminators—such as sequential scenes across a page or throughout a volume, flashbacks or dream sequences, texts embedded as banderoles or captions (or even as speech bubbles), and the role of the viewer to complete the story with their imagination—carry over into later book arts and eventually into film and video games as the Middle Ages appear on screen **(Figs. 117–19)**. Episodic streaming series such as *The Last Kingdom* (2015–present), *Vikings* (2013–20), *Marco Polo* (2014–16), and more bring a sensationalized version of history to life, not too dissimilar to the kind of historical reenactment in BBC or History Channel documentaries. As we have seen with other

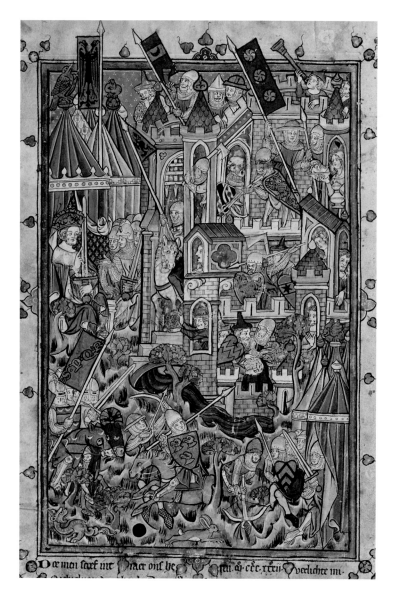

Figure 118
Multiple events in different locations and moments play out across this page, condensing the frenzied action of a multiday battle into a single image. Michiel van der Borch, *The Siege of Jerusalem* in *Rijmbijbel* (Rhymed Bible) (1271), by Jacob van Maerlant, Utrecht, 1332. The Hague, Koninklijke Bibliotheek, MMW, 10 B 21, fol. 152v

Figure 119
The famous warrior Takezaki Suenaga commissioned this scroll depicting battles between the Japanese and Mongol armies in order to record his acts of valor. *Samurai Takezaki Suenaga under Fire from the Mongol Army during the Battle of Brun'ei in 1274* on a scroll of the *Illustrated Account of the Mongol Empire* (*Moko Shurai Ekotoba*), Japan, about 1293. Tokyo, Imperial Palace, Museum of the Imperial Collection

Figure 120
Eyvind Earl, concept art for Walt Disney Studios' *Sleeping Beauty*, 1958. Gouache on board. Orange, CA, Chapman University, The Hilbert Collection, Ear-3, 2018

visual traditions, the migration from medieval text and image to the screen always involves several intermediary layers, often from many postmedieval periods.

Just as medieval locations frequently provide "authentic" backdrops for fantasy stories, animated and virtual environments also depend on real architecture to imbue fiction with history. Illustrator Eyvind Earle's concept art for Disney's *Sleeping Beauty*, though highly stylized, draws on Gothic castles to create a plausible world for the film **(Fig. 120)**. Similarly, interactive sets for video games evoke the full range of possibilities for

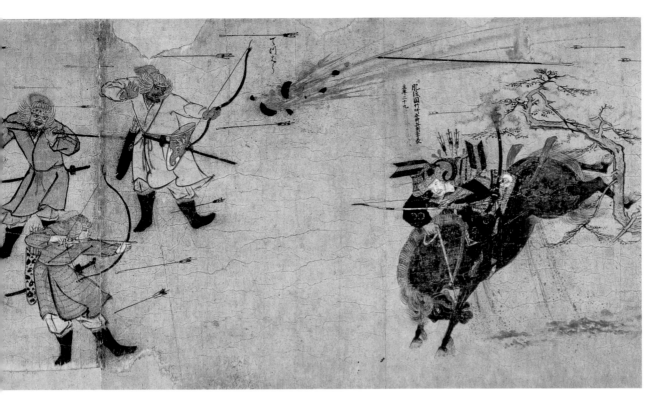

LUTES AND FLUTES

The visual evocation of the Middle Ages on screen is often enhanced through musical scores. Liturgical music, pieces written for the celebration of Mass and other Christian rites, is frequently used in contemporary medievalism to stand in for an entire age. Gregorian chant, sometimes known as plainchant, with its melodic choral intonation sets the tone of many medieval movies. The Latin *Dies irae* (The Day of Wrath) of the Requiem, or funeral mass, forms the basis of cinematic melodies by composers for all manner of film, with or without medieval themes: *The Shining* (1980), *Home Alone* (1990), *The Nightmare Before Christmas* (1993), *The Lord of the Rings: The Fellowship of the Ring* (2001), *Frozen 2* (2019), and the *Harry Potter* films. This trend favoring vocal song overlooks many secular genres of instrumentation and music from other religious traditions, especially of Jews and Muslims. The secular medieval music of confraternities, court minstrels, and professional musicians is often evoked in movie music by scores with string instruments (such as lutes) and woodwinds (especially flutes) **(Fig. 121)**. The producers of *Game of Thrones* specifically requested that composer Ramin Djawadi's score not include, as they said, any "lutes and flutes" because of the instruments' stereotyping as the only medieval music that existed, and its contemporary connotation as faux-historical and campy. The show did feature a haunting performance of House Lannister's anthem, "The Rains of Castamere," performed by Icelandic post-rock band Sigur Rós with vocals by Jónsi, just one of several cameos by contemporary musicians in the series **(Fig. 122)**. From the mid-1960s to today, some bands and musicians have adapted the range of global medieval music forms just mentioned and more as part of folk rock, metal, techno, and other genres. In short, the sounds of the Middle Ages continue to resound powerfully across time.

Figure 121
Beneath a scene of the talking horse Fauvel and Vainglory in the marital bed, bands of costumed musician-protestors perform a mock parade in the streets. Fauvel Master, *A Charivari* in *Romance of Fauvel*, by Gervais du Bus et Raoul Chaillou de Pesstain, 1318–20. Paris, Bibliothèque nationale de France, Ms. Fr. 146, fol. 34

Figure 122
Sigur Rós sings "The Rains of Castamere" on *Game of Thrones*, season 4, episode 2, "The Lion and the Rose," 2014 (HBO)

Figure 123
The aesthetics of the classic video game *The Legend of Zelda*, first introduced in 1986 and released in many different iterations since, depend on medieval-inspired characters, places, and plots to create the fantasy world of Hyrule. *The Legend of Zelda: Breath of the Wild*, 2017 (Nintendo)

telling a high fantasy medieval story: the overworlds in the *Legend of Zelda* franchise allow the sword-wielding hero Link to journey across a range of connected, playable lands, including the kingdom of Hyrule (a place of castles, towns, and mysterious landscapes), the unusual geography of the island of Koholint, and the Great Sea and the Sky (not to mention the chance to encounter numerous magical beings and creatures) **(Fig. 123)**. Other games reference real places. Critics have praised Ubisoft's open-world adventure game *Assassin's Creed* (first released in 2007) for its detailed depiction of medieval cities, including Constantinople and Florence, populated by fictional characters (members of a secret Order of Assassins) and a dramatized version of the Catholic military order of the Knights Templar, all presented alongside historical figures including Leonardo and Niccolò Machiavelli (1469–1527).

Costume and Set Design

The characters that inhabit both live-action and animated sets must be clothed in the fashionable dress of the Middle Ages as well; costuming is an integral part of reimagining the medieval for the screen. Designs for contemporary theater, films, and television build on attempts to catalogue accurate medieval dress based on surviving clothing as well as images in manuscripts, reliquaries, tomb sculpture, and other materials. Costume books emerged in the sixteenth century to document contemporary dress, often providing a global outlook from the European perspective that reveals the prejudices of the creators. By the nineteenth century, with the rise of nationalism and in light of long-standing colonial enterprises, the genre grew to include attempts to record historical clothing. François-Séraphin Delpech (1778–1825) traced a historical national identity and heritage through clothing in his tome about French civil and military dress from 1200 to 1820 (the date of publication) **(Fig. 124)**. The two volumes by Henry Shaw (1800–1889) called *Dress and Decorations of the Middle Ages* (1840–43) feature a variety of full-color chromolithographs and monochrome prints with detailed descriptions that focus on the cut of a garment, terms for the parts of a suit of armor, and other indications of fabric, jewelry, and accessories of Europe's medieval period **(Fig. 125)**.

These images informed the kinds of clothes that felt authentically medieval to costume designers for stage and early cinema, but ultimately, costuming the Middle Ages is anachronistic—a pastiche of contemporary fashion and a subjective interpretation of medieval style. For example, in a costume sketch for the character of Lady Edith for the film *King Richard and the Crusaders* (1935), designer Marjorie O. Best (1903–1997) imagines a gauzy gown with swooping sleeves, form-fitting bodice, and draped neckline **(Fig. 126)**. Aspects of the costume recall the historical houppelande (an outer garment characterized by its flared sleeves), but the puffed shoulders and hip-defining upper skirt are much more reminiscent of

Imp. lithog. de F. Delpech.

Capitaine des Archers de la ville de Paris.
(1470.)

Date about 1445.

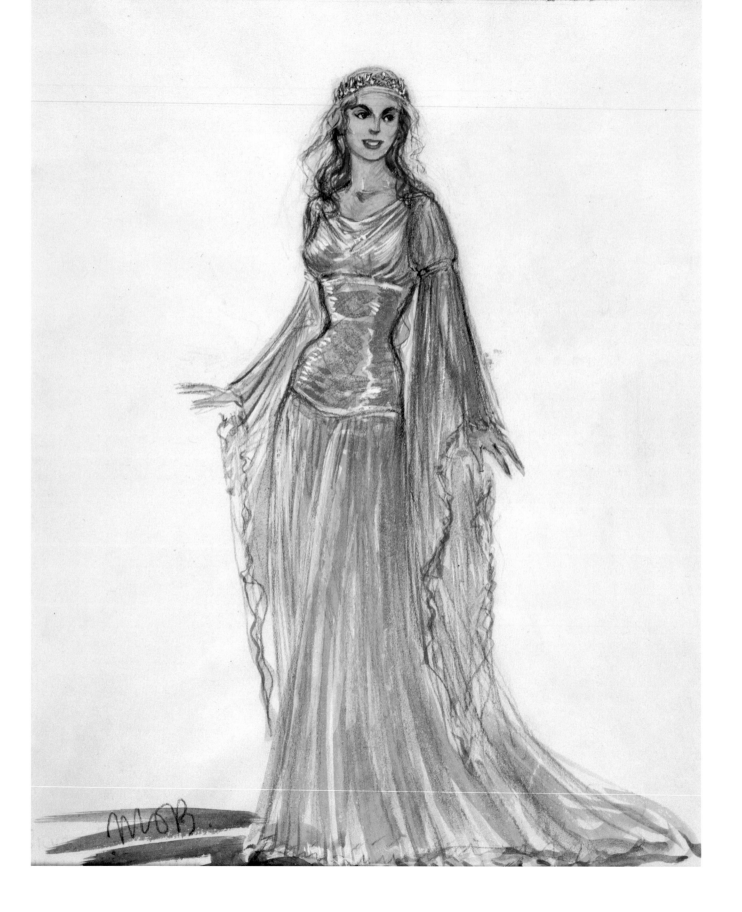

LADY EDITH

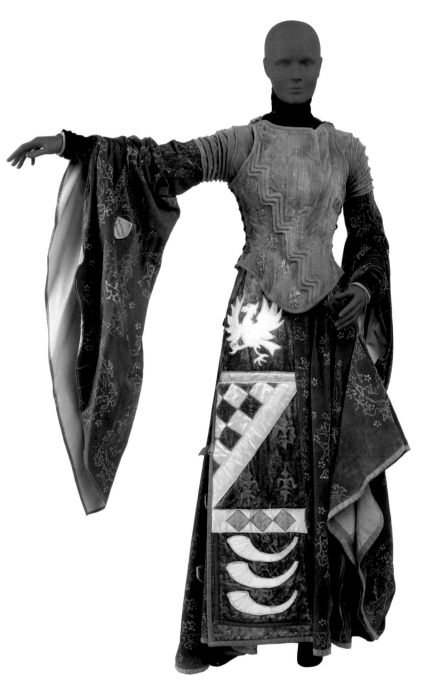

1930s American women's fashion. When designing the costumes for the 1968 presentation of *Sleeping Beauty* at the Royal Ballet in London, designer Lila De Nobili (1916–2002) and producer Peter Wright (b. 1926) looked first at Gustave Doré's fairy-tale illustrations (1864) and opted for a distinct look aimed at feeling more "medieval" than previous iterations of the ballet, but which was ultimately a vision of the Middle Ages filtered through the Victorian Gothic style of their late-nineteenth-century source material. For the costume of an "aristocratic lady," De Nobili transformed felt, resin, and plastic into heraldic devices that adorn a striking floor-length skirt **(Fig. 127)**. The swooping sleeves, as seen in Best's and De Nobili's women's gowns, are based on medieval material evidence but are largely imaginative re-creations. They have become an iconic medievalism, visual shorthand for "medieval" costume broadly conceived.

Michele Clapton's costume designs in *Game of Thrones* build further on the legacy of medievalism in dress (see Preface; **Fig. 128**). Her working process involves gathering source material from many premodern cultures, and the ideation process draws further inspiration from set designer Gemma Jackson's paintings for each corner of the realm. Ruler Cersei Lannister's gowns, for example, are often made from gold and red fabrics, the heraldic colors of her family, and in the rich brocades and velvet (embroidered and patterned alike) that befit a lady of her status. The gowns reference archetypal "medieval" silhouettes and materials but also serve important functions in developing the narrative arc of her character,

Figure 126
Marjorie O. Best, costume sketch of Virginia Mayo as Lady Edith in *King Richard and the Crusades*, Hollywood, 1954 (Warner Bros.). Pencil, watercolor, and silver wash on paper. Los Angeles County Museum of Art, Costume Council Fund, M.85.144.3

Figure 127
Lila De Nobili, costume for an aristocratic lady in *Sleeping Beauty*, produced by Peter Wright, Royal Ballet, London, 1968. London, Victoria & Albert Museum, given by the Royal Academy of Dance, S.1532/A-1982

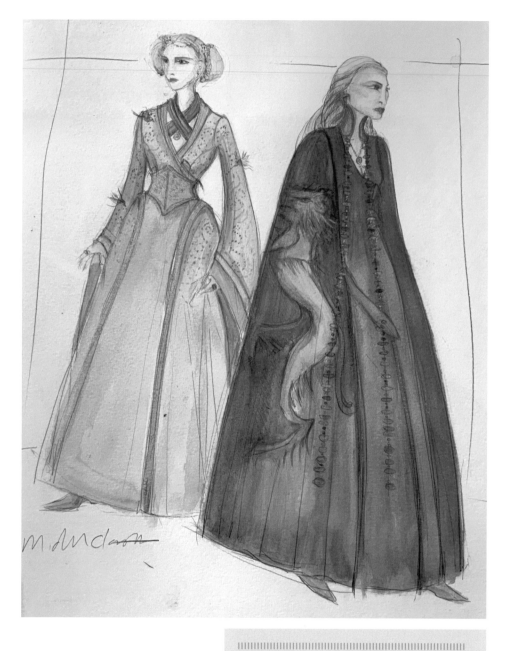

||

Figure 128
Sketch by Michele Clapton,
costume designer for *Game
of Thrones*, 2011

Figure 129
Women's medieval warrior
costume from halloween-
costumes.com

||

from feminine queen consort to powerful queen regent to radicalized queen regnant. Clothing has the power to define and distinguish places and peoples; from the silhouette of a garment to subtle embroidery patterns or a characteristic headdress, fashion can encapsulate the complex influences of geography, climate, trade commodities, and regional crafts.

The popular understanding of medieval dress has been distilled into several key elements by these stage and screen re-creations, evidenced in the genre of costuming produced for widespread consumption at Halloween. From "medieval maiden" and "lady of the castle" to "royal knight" and "crusader warrior," costumes need only have a few key elements to qualify as medieval dress: an approximation of gleaming armor; a red or gold brocade; fur trim; a laced bodice; a swooping sleeve; a cape. Costumes like this also offer the opportunity to combine different elements to rewrite history, as the description on halloweencostumes.com for "Women's Medieval Warrior" costume, which combines a velvet gown with armored shoulders and sword, suggests **(Fig. 129)**:

> See the misty peak of dragon mountain, yonder? They say there's a maiden who's trapped by the wretched beast up there. She weeps day and night, waiting for a prince to save her. Yeah, no. Not this maiden you see here. She's not in distress, she causes distress. She'd like to watch you try to stick her in a high tower somewhere. It would give her a reason to exercise her sword hand.

Creating a plausible theatrical or cinematic medieval world also involves filling the set with the trappings of luxury associated with medieval courts. Certain works of art have become so iconic as to stand in for the entire period, and are often deployed by set designers as a visual shorthand for a time long past. For example, the two sets of elaborate Unicorn Tapestries produced in Paris around 1500 appear in "medieval" interiors from the opening credits of Disney's *Sleeping Beauty* (1959) to the Gryffindor common room or entrance to the Room

of Requirement in the *Harry Potter* films (2001–11) (see fig. 109). In *Harry Potter and the Sorcerer's Stone* (2001), Harry and Hermione's friend Ron Weasley plays a game of wizard's chess, with living pieces based on a group of twelfth-century ivory pieces now known as the Lewis chessmen. The pieces were also used in the Crusader film *Kingdom of Heaven* (2005) and were animated in Disney's Scottish epic *Brave* (2012). Eagle-eyed viewers of *Game of Thrones* will remember numerous visual nods to the long Middle Ages through props and set design, including the eleventh-century Bayeux Tapestry in King Renly Baratheon's tent (which inspired a contemporary weaver to tell the entire story with needle and thread) and one of Paolo Uccello's paintings of *The Battle of San Romano* (1438–40) in the Small Council Chamber at King's Landing. The mere inclusion of these iconic medieval objects immediately grounds fantasy in the semblance of historical reality.

Taken together, these visual and auditory hallmarks create plausible medieval worlds, even when that world is fictional. The flexible and expansive idea of what the Middle Ages looks like and what it can be has made it the perfect historical period to be embedded in fantasy. There is now the expectation that cinematic fantasy worlds will be medieval; there will be castles and churches filled with somber choral music; people will ride horses; characters will inexplicably speak with English accents regardless of where the plot actually unfolds (except for dwarfs, who have Scottish accents); women will be dressed in fancy gowns; and men will carry swords. And as we have seen, book arts are the driving forces and constant influences that enrobe fantasy in all the fabrics of the Middle Ages and its many medievalisms. ⚹

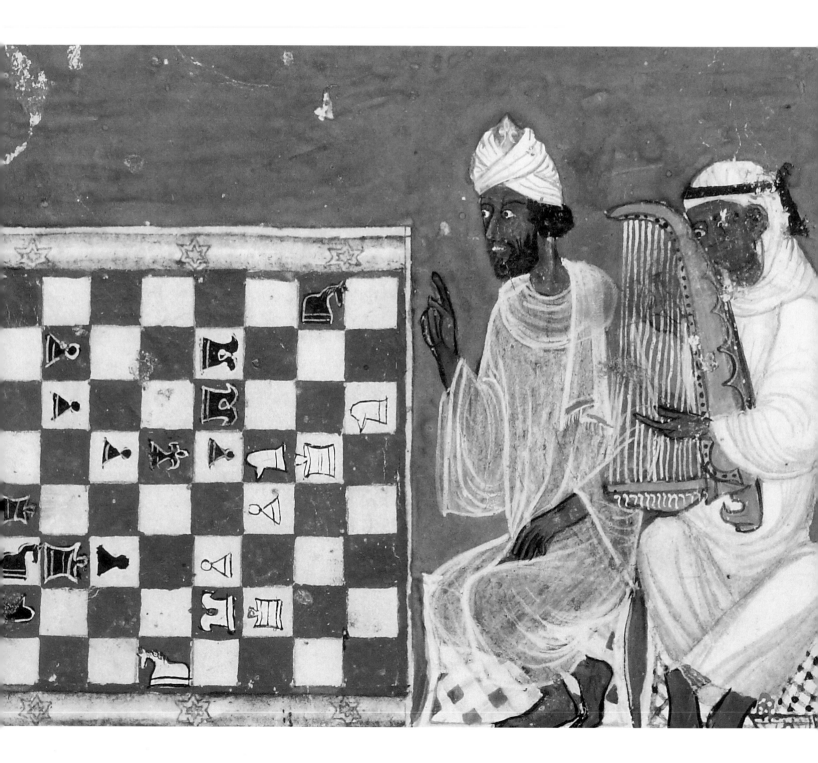

Epilogue: A Medieval Future of the Past

Throughout this volume, we have approached book arts and their medievalisms as inherently palimpsestic, to use a medieval metaphor. Like a palimpsest—a parchment or other surface that has been scraped to be reused but maintains a trace of the original writing—medievalisms carry the memory of the past, are relevant in new ways in the present, and have many possible futures as new eyes and hands view and touch them (physically or digitally). Indeed, manuscripts are handmade, handled, and haptic objects that are handed down over generations. The global audiences of printed and digitized images inspired by the Middle Ages ensure that new perspectives

will continually reevaluate and offer new receptions of centuries-old tales. Just as the images in medieval manuscripts and illustrated books built upon lived and imagined histories, chronicled and mythologized the present, and effectively looked toward the future, so too are medievalisms founded on such layered ideas of a fantasy past.

We, the authors, view medievalisms (including the very concept of the "medieval period") as fundamentally anachronistic—in that these creative reworkings of the Middle Ages always reveal more

Detail of Figure 132.

about the present than the past—and extremely valuable because of this temporal ambiguity. All of the things we have explored in this volume—the possibility of dragons and beliefs in magic, powerful female warriors, queer relationships, and diverse communities (in terms of race, religion, language, and more)—were present in the Middle Ages, if sometimes in different forms than they have come to be imagined throughout their long history. Yet the very foundations of medieval studies and museum collections of medieval art are dependent on whitewashed myths of Western European national identities that exclude most of the world and prevent a consideration of the

complexity of medieval reality even in that small yet intimately connected corner of the globe. Such rigid disciplinary and departmental boundaries have fragmented the serious study of medievalism, for indeed medieval studies is also a form of medievalism. White supremacy has conditioned the retelling of the past in both overt and subtle ways, many of which have resulted in the censorship of the racial, gender-based, religious, and intimate sexual realities of the Middle Ages. So pervasive are these fantasies of the medieval period that they have become a key component of how the past is imagined today, and how it continues to be exclusionary and traumatic to marginalized groups who have long fought for their/our place in history.

Dutch historian Johan Huizinga (1872–1945) proposed that every action and event in the Middle Ages was a type of game, with rules, moves, and countermoves similar to the game of chess. If the Middle Ages, as we have seen, can be virtually anything, include anyone, and respond to the "urgencies of the present" (as medieval scholar Geraldine Heng has noted), then let us set the metaphorical board for a more inclusive Middle Ages that highlights the diversity of the past and welcomes equitable popular medievalisms **(Figs. 130–32)**. The future of medieval studies, of museum presentations of the Middle Ages, and of medievalism itself must be audience-driven; be in dialogue with an expanded global public; seek to break down disciplinary and departmental divisions; and be mobilized to dismantle harmful stereotypes about the many pasts disguised as "medieval." Medievalism, as a fantasy construct that is capacious enough to encompass more than the singular European or Mediterranean conception of the past, has the power to change the way we view and write/right history—and ultimately the ways in which we approach the present and shape the future. 👑

cua xii anni pauo. Ter ii te blan

Este es otro iuego departido en q̃ ha ste
te tablero que han à seer entablados

del alffil blanco alferzandolo. zentra
el Rey blanco por fuerça en la casa de su

Este es otro iuego departido en que a
ueynt un tablero que an aseer enta

blanco en la segunda casa de su alfer
za. El quarto iuego por la vagne

Figure 130
Images in a gaming manual made for
Alfonso X of Spain (1221–1284) show a
full range of chess players, including
men and women, Christians, Jews,
and Muslims, Black Africans, and
peoples of many social classes. Real
Biblioteca de San Lorenzo, El Escorial,
Spain, fol. 63

Figure 131
Real Biblioteca de San Lorenzo,
El Escorial, Spain, fol. 18

Figure 132
Real Biblioteca de San Lorenzo,
El Escorial, Spain, fol. 22

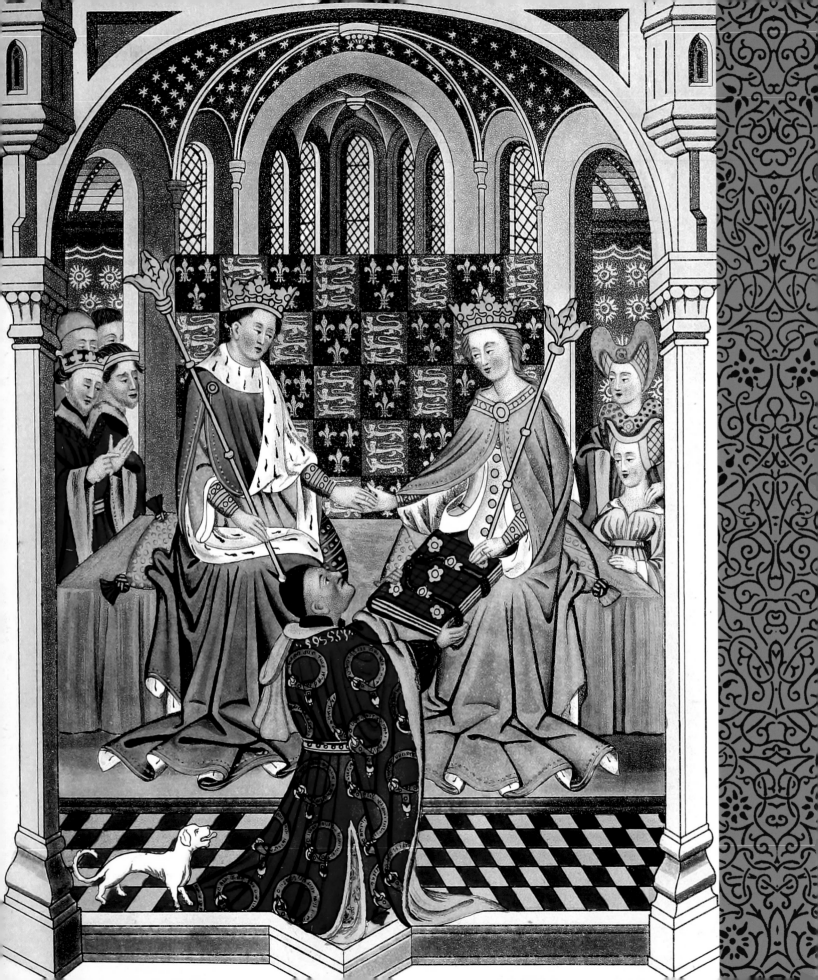

Selected Bibliography

Andrew Albin, Mary C. Erler, Thomas O'Donnell, Nicholas Paul, and Nina Rowe. *Whose Middle Ages? Teachable Moments for an Ill-Used Past*. New York: Fordham University Press, 2019.

Michael Alexander. *Medievalism: The Middle Ages in Modern England*. New Haven, CT: Yale University Press, 2017.

Natalie Altschul. *Politics of Temporalization: Medievalism and Orientalism in Nineteenth-Century South America*. Philadelphia: University of Pennsylvania Press, 2020.

Karl Alvestad and Robert Houghton, eds. *The Middle Ages in Modern Culture: History and Authenticity in Contemporary Medievalisms*. London: Bloomsbury Academic, 2021.

François Amy de la Bretèque. *L'Imaginaire médiéval dans le cinéma occidental*. Paris: Honoré Champion, 2018.

Gail Ashton, ed. *Medieval Afterlives in Contemporary Culture*. London: Bloomsbury Academic, 2015.

Rebecca Barnhouse. *Recasting the Past: The Middle Ages in Young Adult Literature*. Portsmouth, NH: Boynton/Cook Publishers, 2000.

Ruth Barratt-Peacock. *Medievalism and Metal Music Studies: Throwing Down the Gauntlet (Emerald Studies in Metal Music and Culture)*. Bingley, England: Emerald Publishing, 2019.

Brian Bates. *The Real Middle-Earth: Exploring the Magic and Mystery of the Middle Ages, J. R. R. Tolkien, and "The Lord of the Rings."* London: Palgrave Macmillan, 2003.

Viviane Bergue, ed. *Fantasy Art and Studies: Beyond Tolkien*, no. 1 (2016).

———, ed. *Fantasy Art and Studies: Cities and Wonders*, no. 2 (2017).

———, ed. *Fantasy Art and Studies: Science Fantasy*, no. 3 (2017).

———, ed. *Fantasy Art and Studies: Victorian Roots*, no. 4 (2018).

———, ed. *Fantasy Art and Studies: Made in Japan*, no. 5 (2018).

———, ed. *Fantasy Art and Studies: Pop Norse*, no. 6 (2019).

———, ed. *Fantasy Art and Studies: Arthurian Fantasy*, no. 7 (2019).

———, ed. *Fantasy Art and Studies: Tribute to Terry Pratchett/Fantasy Humoristique*, no. 8 (2020).

———, ed. *Fantasy Art and Studies: Amazing Animals*, no. 9 (2020).

Benjamin Bertrand and Tirumular (Drew) Narayanan, "Medieval Dreams and Far Right Nightmares," *Current Affairs*, 6:4 (2021): 43–48.

Kathleen Biddick. *The Shock of Medievalism*. Durham, NC: Duke University Press, 1998.

Jennifer Borland and Martha Easton. "Integrated Pasts: Glencairn Museum and Hammond Castle." *Gesta* 57, no. 1 (2018): 95–118.

Margaret Bridges and J. Christoph Bürgel. *The Problematics of Power: Eastern and Western Representations of Alexander the Great*. Bern: P. Lang, 1996.

Michael Camille. *Image on the Edge: The Margins of Medieval Art*. Cambridge: Cambridge University Press, 1992.

———. *The Gargoyles of Notre-Dame: Medievalism and the Monsters of Modernity*. Chicago: University of Chicago Press, 2009.

Michael Camille, "The 'Très Riches Heures': An Illuminated Manuscript in the Age of Mechanical Reproduction," *Critical Inquiry* 17:1 (1990): 72–107.

Michael Camille, "'For Our Devotion and Pleasure': The Sexual Objects of Jean, Duc de Berry," *Art History* 24:2 (2001): 169–94.

Humphrey Carpenter. *J. R. R. Tolkien: A Biography*. Boston: Houghton Mifflin, 2000.

Shiloh Carroll. *Medievalism in "A Song of Ice and Fire" and "Game of Thrones."* Woodbridge, England: D. S. Brewer, 2018.

Maria Sachiko Cecire. *Re-Enchanted: The Rise of Children's Fantasy Literature in the Twentieth Century*. Minneapolis: University of Minnesota Press, 2019.

Jane Chance and Alfred Siewers, eds. *Tolkien's Modern Middle Ages*. London: Palgrave Macmillan, 2005.

Michele Clapton. *Game of Thrones: The Costumes. The Official Book from Season 1 to Season 8*. San Rafael, CA: Insight Editions, 2019.

Albrecht Classen. *Imagination and Fantasy in the Middle Ages and Early Modern Time: Projections, Dreams, Monsters, and Illusions*. Berlin: DeGruyter, 2020.

Paul Cobb. *The Race for Paradise: An Islamic History of the Crusades*. Oxford: Oxford University Press, 2014.

Kristen Collins and Bryan C. Keene, eds. *Balthazar: A Black African King in Medieval and Renaissance Art*. Los Angeles: J. Paul Getty Museum, 2022.

Thomas Coomans and Jan De Maeyer, eds. *The Revival of Medieval Illumination: Nineteenth-Century Belgium Manuscripts and Illumination from a European Perspective*. Leuven: Leuven University Press, 2007.

Corning Museum of Glass. "Glass That Reminds Me of Game of Thrones," https://www.cmog.org/set/glass-reminds-me-game-thrones.

Michael A. Cramer. *Medieval Fantasy as Performance: The Society for Creative Anachronism and the Current Middle Ages*. Lanham, MD: Scarecrow Press, 2009.

Joyce Crick. *Jacob and Wilhelm Grimm: Selected Tales*. Oxford: Oxford University Press, 2005.

Louise D'Arcens. *The Cambridge Companion to Medievalism*. Cambridge: Cambridge University Press, 2016.

Carolyn Dinshaw. *Getting Medieval: Sexualities and Communities, Pre- and Postmodern*. Durham, NC: Duke University Press, 1999.

Stephanie Downes and Helen Young. "The Maiden Fair: Nineteenth-Century Medievalist Art and the Gendered Aesthetics of Whiteness in HBO's Game of Thrones." *postmedieval: A Journal of Medieval Cultural Studies* 10, no. 2 (2019): 219–35.

Matteo Duni. *Under the Devil's Spell: Witches, Sorcerers, and the Inquisition in Renaissance Italy*. Syracuse, NY: Syracuse University Press, 2007.

Umberto Eco. "Dreaming of the Middle Ages." In *Faith in Fakes: Travels in Hyperreality*, translated by W. Weaver, 61–72. New York: Vintage, (1973) 1998.

Jennifer Edwards. "Casting, Plotting, and Enchanting: Arthurian Women in Starz's 'Camelot' and the BBC's 'Merlin.'" *Arthuriana* 25, no. 1 (2015): 57–81.

Andrew B. R. Elliott. *Medievalism, Politics, and Mass Media: Appropriating the Middle Ages in the Twenty-First Century*. Woodbridge, England: D. S. Brewer, 2017.

Elizabeth Emery and Richard Utz, eds. *Medievalism: Key Critical Terms*. Woodbridge, England: D. S. Brewer, 2014.

Laurie A. Finke and Martin B. Schichtman. *King Arthur and the Myth of History*. Gainesville: University Press of Florida, 2004.

Kavita Mudan Finn. "How to Talk to Your Kids about Old-School Disney." *Public Medievalist*, November 12, 2020, https://www.publicmedievalist.com/talk-to-kids-old-school-disney/.

Tara Foster and Jon Sherman. "King Arthur in the Twenty-First Century: 'Kaamelott,' BBC's 'Merlin,' and Starz's 'Camelot.'" *Arthuriana* 25, no. 1 (2015): 3–4.

Karl Fugelso, Vincent Ferré, and Alicia Montoya, eds. *Studies in Medievalism XXIV: Medievalism on the Margins*. Woodbridge, England: Boydell & Brewer, 2015.

Torben Gebhardt. "Homosexuality in Television Medievalism." In *The Middle Ages on Television: Critical Essays*, edited by Meriem Pages and Karolyn Kinane, 197–214. Jefferson, NC: McFarland, 2015.

J. Paul Getty Museum. *Game of Thrones*. The Iris: Behind the Scenes at the Getty, 2014–19, http:// blogs.getty.edu/iris/tags/game-of-thrones/.

———. *Designing the Middle Ages: The Costumes of GoT*. YouTube, May 4, 2016, https://www.youtube.com/watch?v=fVv1oH1hLlo.

Elyse Graham. "What I Learned on Medieval Twitter." Public Books, July 24, 2019, https://www.publicbooks.org/what-i-learned-on-medieval-twitter/.

Richard Firth Green. *Elf Queens and Holy Friars: Fairy Beliefs and the Medieval Church*. Philadelphia: University of Pennsylvania Press, 2016.

Larisa Grollemond and Bryan C. Keene. "A Game of Thrones: Power Structures in Medievalisms, Manuscripts, and the Museum." *postmedieval: A Journal of Medieval Cultural Studies* 11, nos. 2–3 (2020): 326–37.

Sandra Hindman, Michael Camille, Nina Rowe, and Rowan Watson. *Manuscript Illumination in the Modern Age*. Chicago: Mary and Leigh Block Museum of Art, 2001.

Sandra Hindman and Laura Light. *Neo-Gothic Book Production and Medievalism*. Chicago and Paris: Les Enluminures, 2015.

Kevin Harty. *The Reel Middle Ages: American, Western and Eastern European, Middle Eastern, and Asian Films about Medieval Europe*. Jefferson, NC: McFarland & Company, 1999.

———, ed. *Medieval Women on Film: Essays on Gender, Cinema, and History*. Jefferson, NC: McFarland & Company, 2020.

Johan Huizinga. *The Waning of the Middle Ages: A Study of the Forms of Life, Thought, and Art in France and the Netherlands in the Fourteenth and Fifteenth Centuries*. London: Penguin Books, 1922.

Carol Jamison. *Chivalry in Westeros: The Knightly Code of "A Song of Ice and Fire."* Jefferson, NC: McFarland & Company, 2018.

Terry Jones and Alan Ereira. *Terry Jones' Medieval Lives.* London: BBC Books, 2004.

Amy Kaufman and Paul Sturtevant. *The Devil's Historians: How Modern Extremists Abuse the Medieval Past*. Toronto: University of Toronto Press, 2020.

Bryan C. Keene, ed. *Toward a Global Middle Ages: Encountering the World through Illuminated Manuscripts*. Los Angeles: J. Paul Getty Museum, 2019.

Dorothy Kim, ed. "Critical Race and the Middle Ages." Special issue, *Literature Compass*, September–October 2019.

Jesse Kowalski, ed. *Enchanted: A History of Fantasy Illustration*. New York: Abbeville Press, 2020.

Erin Felicia Labbie. "Pop Medievalism." In *Studies in Medievalism XXIV: Medievalism on the Margins*, edited by Karl Fugelso, Vincent Ferré, and Alicia Montoya, 2–29. Woodbridge, England: Boydell & Brewer, 2015.

Carolyne Larrington. *Winter Is Coming: The Medieval World of "Game of Thrones."* London: I. B. Tauris, 2017.

Stacey Leasca. "The Ultimate Guide to 'Game of Thrones' Filming Locations around the World." *Travel and Leisure*, May 13, 2019, https://www.travelandleisure.com/culture-design/ tv-movies/game-of-thrones-filming-locations.

Mary Levkoff. *Hearts, the Collector*. New York: Harry N. Abrams, 2008.

Esther Liberman-Cuenca. "Devil Worship, Regicide, and Commerce: The Professional Necromancer in Late Medieval England." *Hindsight* 2 (2008): 116–35.

———. "Medievalism, Nationalism, and European Studies: New Approaches in Digital Pedagogy." *Europe Now: Imagining, Thinking, and Teaching Europe*, June 3, 2020, https://www.europenowjournal.org/2020/06/02/medievalism-nationalism-and-european-studies-new-approaches-in-digital-pedagogy/.

Sierra Lomuto. "Public Medievalism and the Rigor of Anti-Racist Critique." *In the Medieval Middle*, April 4, 2019. https://www.inthemedievalmiddle.com/2019/04/public-medievalism-and-rigor-of-anti.html.

George R. R. Martin. n.d. *Not a Blog*, http://georgerrmartin.com/notablog/.

Catherine McIlwaine. *Tolkien: Maker of Middle-Earth*. Oxford: University of Oxford, Bodleian Library, 2018.

Met Museum Presents: 2014–15 Season. "Dressed to Kill: Arms and Armor from Medieval Knights to *Game of Thrones*." Listing for a conversation with Michele Clapton, Miya Ando, and Pierre Terjanian at the Metropolitan Museum of Art, December 2, 2014, https://issuu.com/metmuseum/docs/met_museum_presents_brochure_2014-1/31.

Mariah Junglan Min. "Whose Past Is It Anyway? Whiteness as Property in Medieval Studies." Paper presented at the 94th annual meeting of the Medieval Academy of America, University of Pennsylvania, Philadelphia, 2019.

Ken Mondschein. *Game of Thrones and the Medieval Art of War*. Jefferson, NC: McFarland, 2017.

Elizabeth Morrison and Anne D. Hedeman. *Imagining the Past in France: History in Manuscript Painting, 1250–1500*. Los Angeles: Getty Publications, 2010.

William Paden. "I Learned It at the Movies: Teaching Medieval Film." In *Studies in Medievalism XIII: Postmodern Medieval*, edited by Richard Utz and Jesse Swann, 79–98. Woodbridge, England: D. S. Brewer, 2005.

Joanne Parker and Corinna Wagner, eds. *The Oxford Handbook of Victorian Medievalism*. Oxford: Oxford University Press, 2020.

Brian Pavlac, ed. *Game of Thrones versus History: Written in Blood*. Hoboken, NJ: John Wiley and Sons, 2017.

James Poniewozik. "GRRM Interview Part 2: Fantasy and History." *Time*, April 18, 2011, http:// entertainment.time.com/2011/04/18/grrm-interview-part-2-fantasy-and-history/.

Tison Pugh and Susan Aronstein. *The Disney Middle Ages: A Fairy-Tale and Fantasy Past*. New York: Palgrave Macmillan, 2015.

Tison Pugh and Susan Aronstein, eds. *The United States of Medievalism*. Toronto: University of Toronto Press, 2021.

Tison Pugh and Kathleen Coyne Kelly, eds. *Queer Movie Medievalisms*. Milton Park: Routledge, 2009.

Mary Rambaran-Olm. "Misnaming the Medieval: Rejecting 'Anglo-Saxon' Studies." *History Workshop*, November 4, 2019, https://www.historyworkshop.org.uk/misnaming-the-medieval-rejecting-anglo-saxon-studies/.

Mary Rambaran-Olm, M. Breann Leake, and Micah James Goodrich. "Medieval Studies: The Stakes of the Field." *postmedieval: A Journal of Medieval Cultural Studies* 11, no. 4 (2020): 356–70.

Lynn Ramey and Tison Pugh. *Race, Class, and Gender in "Medieval" Cinema*. New York: Palgrave Macmillan, 2007.

Matthew Reeve. "Living in the New, New Middle Ages," *The Rambling*, October 18, 2018, https://the-rambling.com/2018/10/18/living-in-the-new-middle-ages/.

Deborah Riley. *The Art of Game of Thrones: The Official Book of Design from Season 1 to Season 8*. San Rafael, CA: Insight Editions, 2019.

Helen Sloan. *The Photography of Game of Thrones: The Official Photo Book of Season 1 to Season 8*. San Rafael, CA: Insight Editions, 2019.

Markus Stock. *Alexander the Great in the Middle Ages: Transcultural Perspectives*. Toronto: University of Toronto Press, 2016.

Paul Sturtevant. *The Middle Ages in Popular Imagination: Memory, Film, and Medievalism*. London: Bloomsbury Academic, 2018.

——. *The Public Medievalcast: Episode I (Game of Thrones)*. June 6, 2019. https:// www.publicmedievalist.com/category/pop-culture/film-tv/game-of-thrones/.

J. R. R. Tolkien. "On Fairy-Stories." In *Tree and Leaf*. Sydney: Unwin Hyman, 1988.

David Tollerton. "Multiculturalism, Diversity, and Religious Tolerance in Modern Britain and the BBC's 'Merlin.'" *Arthuriana* 25, vol. 1 (2015): 113–27.

Richard Utz. *Medievalism: A Manifesto*. York: Arc Humanities Press; 2017.

Michael Vernon. *The Black Middle Ages: Race and the Construction of the Middle Ages*. New York: Palgrave Macmillan, 2018.

Marina Warner. *Once Upon a Time: A Short History of Fairy Tale*. Oxford: Oxford University Press, 2014.

Annabel Jane Wharton. *Selling Jerusalem: Relics, Replicas, Theme Parks*. Chicago: University of Chicago Press, 2006.

Helen Young. "Game of Thrones' Racism Problem." *Public Medievalist*, July 21, 2017, https://www.publicmedievalist.com/game-thrones-racism-problem/.

——, ed. *Fantasy and Science-Fiction Medievalisms*. Amherst, NY: Cambria Press, 2015.

——, ed. *Race and Popular Fantasy Literature: Habits of Whiteness*. New York and London: Routledge, 2015.

Illustration Credits

Figs. 1, 71, 92, 121: Bibliothèque nationale de France

Fig. 3: Su Concessione del Ministero per beni e le attività culturali e per il turismo – Palazzo Ducale di Mantova. Divieto di duplicazione in qualsiasi forma e con qualsiasi mezzo

Fig. 4: © RMN-Grand Palais / Art Resource, NY. Photo: Jean-Gilles Berizzi.

Figs. 5, 59, 70, 72–75, 77, 80, 102, 124: Fine Arts Museums of San Francisco

Fig. 6: Los Angeles, Getty Research Institute (91-B18220)

Fig. 9, p. 20: Digital Image © 2021 Museum Associates / LACMA. Licensed by Art Resource, NY

Fig. 10: *Story of King Arthur and His Knights*, Modern Juvenile Collection. Library Special Collections, Charles E. Young Research Library, UCLA.

Fig. 11: Reprinted by permission of HarperCollins Publishers Ltd © 1996 J. R. R. Tolkien

Fig. 12: © 1973 Warner Bros., Inc. / Everett Collection, Inc. / Alamy Stock Photo

Fig. 13: © 1963 Walt Disney Productions / AF archive / Alamy Stock Photo

Fig. 14: © 1995 Columbia Pictures Industries, Inc. / Photo 12 / Alamy Stock Photo

Fig. 15: © Touchstone Pictures and Jerry Bruckheimer, Inc. / AA Film Archive / Alamy Stock Photo

Fig. 16: © 2017 Warner Bros. Ent. / AF archive / Alamy Stock Photo

Fig. 18: © 2001 ™ New Line Productions, Inc. / AF archive / Alamy Stock Photo

Fig. 19: Illustrated by Jonathan Roberts

Fig. 20: © 2020 Netflix Worldwide Entertainment, LLC.

Fig. 21: © 2021 Green Knight Productions LLC. All Rights Reserved.

Fig. 22: Hofbibliothek Aschaffenburg, Ms 14, CC BY-NC-SA 4.0

Fig. 23: *Merry Adventures of Robin Hood of Great Renown in Nottinghamshire*, Children's Book Collection. Library Special Collections, Charles E. Young Research Library, UCLA.

Fig. 24: © Kodansha

Fig. 28: Image copyright © The Metropolitan Museum of Art. Image source: Art Resource, NY

Figs. 30, 39, 66, p. 126: The Morgan Library & Museum, New York

Fig. 31: www.metmuseum.org, CC0

Fig. 32: Courtesy of the Department of Special Collections, Stanford University Libraries

Fig. 33: Photo © Tate

Fig. 34: Courtesy of Toronto Public Library

Fig. 35: Los Angeles, Getty Research Institute (93-B12030)

Fig. 36: © 1974 National Film Trustee Company Ltd / Shapero Rare Books

Fig. 37: The University of Toronto Library

Fig. 40: © Columbia Pictures

Fig. 41: Heidelberg University Library, Codex Manesse, Cod. Pal. germ. 848, Bl. 237r

Fig. 42: The Huntington Library, San Marino, California

Fig. 43, p. 36: Rights courtesy of Plattsburgh State Art Museum, State University of New York, USA, Rockwell Kent Collection, Bequest of Sally Kent Gorton. All rights reserved. / Fine Arts Museums of San Francisco

Fig. 45: The William Andrews Clark Memorial Library, University of California, Los Angeles

Fig. 47: © 1977 Twentieth Century Fox Film Corp. / World History Archive / Alamy Stock Photo

Fig. 48: Based on characters and events from *The Mandalorian*™ © 2019/2020 Lucasfilm Ltd. / Courtesy Nicolas Tetreault-Abel, @ Lodgiko

Fig. 49: Los Angeles, Getty Research Institute (91-B16260)

Fig. 50: Los Angeles, Getty Research Institute (85-S395)

Fig. 51: bpk Bildagentur / Hessisches Landesmuseum, Darmstadt, Germany / Wolfgang Fuhrmannek / Art Resource, NY

Fig. 52: Taipei, Palace Museum, npm.edu.tw, CC BY 4.0

Fig. 54: © C. Hémon / Musée Dobrée – Grand Patrimoine de Loire-Atlantique

Fig. 55: © Home Box Office, Inc.

Fig. 57: © 2003 Lord Dritte Productions Deutschland Filmproduktion GmbH & Co. ™ New Line Productions Inc.

Figs. 60, 74, 98: © Disney

Fig. 64: *Arabian Nights*, *Sinbad the Sailor*, Bound Manuscripts Collection (Collection 170). Library Special Collections, Charles E. Young Research Library, UCLA

Fig. 67: © 1973 Walt Disney Productions / PictureLux / The Hollywood Archive / Alamy Stock Photo

Fig. 69: Los Angeles, Getty Research Institute (83-B1975)

Fig. 76: Ivan Vdovin / Alamy Stock Photo

Fig. 78: Los Angeles, Getty Research institute (92-B6545)

Fig. 79: Los Angeles, Getty Research Institute (90-B26783)

Fig. 81: *Little Brother & Little Sister: and Other Tales*. Library Special Collections, Charles E. Young Research Library, UCLA

Figs. 83: Reprinted by permission of HarperCollins Publishers Ltd © 2020 J. R. R. Tolkien. Illustrated by Alan Lee

Fig. 85: © Twentieth Century Fox Film Corp.

Fig. 86: Casey Sykes/Atlanta Journal-Constitution via AP

Fig. 87: © Wizards of the Coast LLC, a subsidiary of Hasbro, Inc. / David Pimborough / Alamy Stock Photo

Fig. 88: © Wizards of the Coast LLC, a subsidiary of Hasbro, Inc. / Valery Voennyy / Alamy Stock Photo

Fig. 91: © Rashaad Newsome Studio LLC

Fig. 97: imageBROKER / Alamy Stock Photo

Fig. 101: Los Angeles, Getty Research Institute (920003)

Fig. 103: University of Pennsylvania Libraries, CC BY 4.0, openn.library.upenn.edu

Fig. 104: Reprinted with permission from Red Barn Productions LLC and the Patterson family event archives (fairehistory.org)

Fig. 105: Photo credit: New York Renaissance Faire/Deborah Grosmark

Figs. 106–7: Courtesy Opera di Santa Maria del Fiore, New press photo

Fig. 108: Autumn Johnson @autumnraejo / @lily_macdonald / @stinkyasher / @superdevin64 / Read Choi @readchoi / Kelly Bouslaiby @kellybtiktok / Tyler Gunther @greedypeasant

Figs. 109–10: © 2001 Warner Bros.

Fig. 112: © Lotus Films

Fig. 113: © 1986 Twentieth Century Fox

Fig. 114: © Mosfilm Cinema Concern *Alexander Nevsky* 1938, director Sergei Eisenstein

Fig. 115: Film still of the Churchyard Entertainment scene from *Book of Days* (1988) directed by Meredith Monk. Cinematography by Jerry Pantzer. Courtesy The House Foundation for the Arts

Fig. 116: © National Film Trustee Company 1991

Fig. 117: Courtesy Biblioteca Nacional de España

Fig. 118, p. ii: The Hague, The Hague, MMW 10 B 21, f. 152-153r

Fig. 119: Usiwakamaru / Wikimedia Commons / CC0

Fig. 120: © Disney / Chapman University, The Hilbert Collection

Fig. 122: © Home Box Office, Inc.

Fig. 123: © Nintendo / Photo: Ryan Gladney

Fig. 125, p. 116: Los Angeles, Getty Research Institute (87-B16667)

Fig. 126: © Warner Bros. / Digital Image © 2021 Museum Associates / LACMA. Licensed by Art Resource, NY

Fig. 127: Courtesy Assunta and Gianni De Nobili / Victoria and Albert Museum, London

Fig. 128, p. 94: Costume illustration by Michele Clapton

Fig. 129: HalloweenCostumes.com

Fig. 130, p. vi.a: Patrimonio Nacional, T-I-6 f63r-1

Fig. 131, p. vi.b: Patrimonio Nacional, T-I-6 f18r-1

Fig. 132, p. 112: Patrimonio Nacional, T-I-6 f22r1- y

Author Photo: Sarah Waldorf

Emojis designed by OpenMoji, the open-source emoji and icon project. License: CC BY-SA 4.0

Acknowledgments

In Disney's *The Sword in the Stone* (1963), the wizard Merlin makes many humorous pronouncements about the time in which he is living, including, "what a medieval muddle" and "one big medieval mess." In preparing this volume, we have tried to account for many of the ways in which the Middle Ages have become a wonderful muddle of magic and at times a frightening mess of misinformation.

We wish to begin by acknowledging that the Getty Center, where the exhibition was on view and where much of the research for this volume was conducted, is on the traditional, ancestral, and unceded territories of the Tongva, Tataviam, Chumash, and other Indigenous peoples whose presence here stretches back in time immemorial and remains vibrant today. We also wish to acknowledge the role the institution's founder, J. Paul Getty (1892–1976), played in acquiring oil in Oklahoma from the Osage people, as well as in Kuwait and Saudi Arabia, and for the impact his involvement in that industry continues to have on lands and peoples across the world. We commit to being good stewards of this place, and thank the Getty-wide diversity, equity, inclusion, and accessibility council and program task forces for working toward meaningful change across the institution.

Foremost among those fantastic beings who believed in and supported this project are Elizabeth Morrison and Sarah Waldorf. We are grateful to Beth for advocating that serious scholarship can be fun and that it often requires us to rethink many of our own preconceptions about and reasons for studying the medieval period. We are indebted to Sarah for her unmatched imagination, willingness to explore new ideas, superb video editing skills, and always having a finger on the pulse of pop culture medievalisms.

Some of our preliminary thoughts for this volume emerged as Getty Iris blog posts or on social media. For the #GettyOfThrones series that recapped *Game of Thrones* with medieval art, we thank above all Sarah Waldorf and Tristan Bravinder, as well as Thuy Bui, Morgan Conger, Amy Hood, Leandro Huerto, Alexandra Kaczenski, Aleia McDaniel, Michelle Prestholt, and Christopher Sprinkle. Working with Michele Clapton has transported us to every corner of Westeros and Essos and allowed us to see our own world through the lens of dress. We wish to express our gratitude for her poignant preface here and for sharing her stunning costume designs with us and Getty audiences.

In our manifesto for "social mediaevalism," or active curatorial engagement with the many forms that the Middle Ages take online, in an article for *postmedieval,* we benefited from the generous edits of Afrodesia McCannon and feedback from co-editors Abdulhamit Arvas and Kris Trujillo and two additional anonymous reviewers. We also thank Annelisa Stephan and Caitlin Shamberg for their helpful insights that helped shape our writing about medievalisms in Disney animated films, Arthurian connections in the Netflix series *Cursed,* and the Twitter series that ranked the different castle emojis on various operating systems.

Other fellow curators who value engaging with the public on social media and finding ways to make history relevant today include Idurre Alonso, Judith Barr, Nicole Budrovich, Mazie Harris, Arpad Kovacs, Kim Richter, and

David Saunders—we are indebted to your encouragement and collaboration.

We celebrate all aspects of nerd culture in these pages and were inspired by the passion for the Middle Ages that exists in so many different aspects of modern life. A team of game designers and creators at Activision Blizzard shared a truly memorable evening at Getty with us, looking at illuminated manuscripts in the study room and reveling in tales of epic quests. Roger Chacon shared with us his skill at *Dungeons & Dragons,* opening a door to this wondrous world. We also thank Deborah Nadoolman Landis (UCLA) for her enthusiasm to connect fashion students with medieval art and for introducing us to Michele Clapton.

Publishing a book today, similar to creating manuscripts in the Middle Ages, involves a team of creatives. We are ever appreciative of the full support from our editor Ruth Evans Lane, whose guidance, humor, and embrace of all the magic of medieval fantasy made this book a reality. A host of additional wonder-workers ensured that this publication would be spellbinding, including Kara Kirk, Karen Levine, Leslie Rollins, Dina Murokh, Libby Hruska, Kelly Peyton, Jim Drobka, and Michelle Deemer, as well as Maggie M. Williams and Helen Young for their helpful comments. Similarly, the installation of the exhibition was brought to life with flair by designers Jessica Harden, Julie Garnett, and Erin Hauer. Additionally, several conservators took up the challenge to enliven wands, tableau vivant photographs, costume sketches, books of all kinds, and medieval memorabilia in the galleries—we thank Jane Bassett,

Madeline Corona, BJ Farrar, Stephen Heer, Mark Mitton, Ronel Namde, Ron Stroud, Michelle Sullivan, and Stephan Welch for their magical touch. We also thank Maite Alvarez, Cherie Chen, Isoke Cullins, Mustafa Eck, Natalie Espinosa, Susan Green, John Giurini, Tim Halbur, Julie Jaskol, Amber Keller, Debby Lepp, Anne Martens, Mike Mitchell, Grace Murakami, Val Tate, Sahar Tchaitchian, Karen Voss, Desiree Zenowich, and many others in the departments of Collections Information & Access, Communications, Conservation, Education, Exhibitions, Imaging Services, Preparation, and Registrar who all had a hand in ensuring that both the catalogue and the exhibition would be truly magical.

We thank all those who have been part of the Manuscripts Department for following each newly emerging medievalism along with us. Thank you, Kristen Collins, Morgan Conger, Andrea Hawken, Rheagan Martin, Aleia McDaniel, Christine Sciacca, Nava Streiter, Nancy Turner, and Jessica Wheeler. To Timothy Potts, Carolyn Marsden-Smith, and Richard Rand, we are excited to welcome visitors to see the Middle Ages in a new light and appreciate your unwavering support to showcase the realms of wizards, dragons, fairies, and witches in art.

The exhibition that this publication accompanies was made possible by many generous loans, and we express our gratitude to the following individuals: Mary Miller, Marcia Reed, and David Brafman at the Getty Research Institute; Emily Beeny, Karin Breuer, Melissa Buron, Thomas Campbell, and Furio Rinaldi at the Fine Arts Museums of San Francisco; Mark Hilbert and Mary Platt at the Hilbert Museum of California Art, Chapman

University, Santa Ana, CA; Gwendolyn Collaço, Linda Komaroff, Sharon Takeda, and Bobbye Tigerman of the Los Angeles County Museum of Art; Genie Guerard, Courtney Jacobs, Chela Metzger, and Hannah Moshier of Special Collections at Charles E. Young Research Library, UCLA; Bronwen Wilson and Nina Schneider at the William Andrews Clark Memorial Library, UCLA; Lynda Tolly of the English Reading Room at UCLA; Mary Walsh, Fox Carney, and Kristen McCormick of the Walt Disney Animation Research Library; and Rebecca Cline, Lynne Drake, Robert Maxhimer, and Melissa Pankuch of the Walt Disney Archives.

On behalf of Larisa: It is thanks to my parents, Theresa and Steve Grollemond, that I grew up with a true sense of wonder and the encouragement to pursue every medieval interest. And to my husband, Andrew, and our son, Leo, I'm so happy to be on this epic adventure with you.

On behalf of Bryan: I thank my parents, Rosemarie and Kenneth Keene, for teaching my siblings and me to have courage in the unknown. My utmost love and gratitude to Mark Mark Keene because the most magical "Once upon a time . . ." stories are the ones we are writing with our children, Alexander Jaxon and Éowyn Arya.

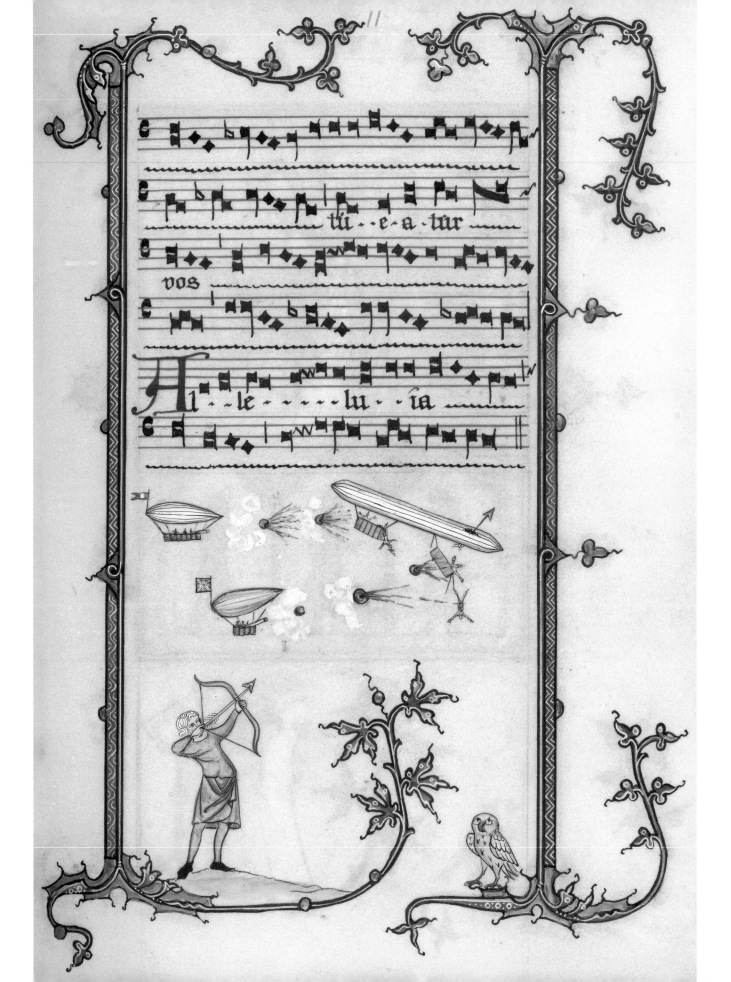

Index

Page numbers in *italics* refer to illustrations.

About the Authors

We did not know we would become medievalists and curators of manuscripts when we saw our first Disney films or attended our first Renaissance faires, but we were bewitched by how they portrayed the Middle Ages. Studying the past requires a great deal of imagination, and in recognizing that, we affirm the value of a scholarly practice that engages with medievalism to inform our reconstruction of a diverse and inclusive Middle Ages, one that also foregrounds equity and justice for those in the present. Medieval studies is, after all, the ultimate medievalism.

Larisa Grollemond (she/her) of Houses Slytherin and Tyrell spent many summers exploring the grounds of the Bristol Renaissance Faire in Wisconsin and, after visiting the *Medieval Times* castle in Chicago, IL, on a school trip, harbored a childhood dream to be a falconer, or maybe a knight. She earned a PhD in art history from the University of Pennsylvania and is assistant curator of manuscripts at the Getty Museum. She was the assisting editor for *Book of Beasts: The Bestiary in the Medieval World* (Getty, 2019). She still wants to learn falconry.

Bryan C. Keene (he/él/they/elle) of Houses Baratheon, Mandragoran, and Ravenclaw attended prom as an elf of Lothlórien, has traveled across Europe to film locations for *Game of Thrones* and *Harry Potter,* follows the knight Link on his many adventures throughout Hyrule, and collects comic books and graphic novels inspired by the Middle Ages. He teaches at Riverside City College and was previously associate curator of manuscripts at the Getty Museum. He holds a PhD from the Courtauld Institute of Art, University of London. From Getty Publications, he is contributing author to *Florence at the Dawn of the Renaissance: Painting and Illumination, 1300–1350* (2012), author of *Gardens of the Renaissance* (2013), co-author with Alexandra Kaczenski of *Sacred Landscapes: Nature in Renaissance Manuscripts* (2017), editor of *Toward a Global Middle Ages: Encountering the World through Illuminated Manuscripts* (2019), and co-editor with Kristen Collins of *Balthazar: A Black African King in Medieval and Renaissance Art* (2022).

This publication is issued on the occasion of the exhibition *Fantasy of the Middle Ages,* on view at the J. Paul Getty Museum at the Getty Center, Los Angeles, from June 21 to September 11, 2022.

Published by the J. Paul Getty Museum, Los Angeles

Getty Publications
1200 Getty Center Drive, Suite 500
Los Angeles, California 90049-1682
getty.edu/publications

Ruth Evans Lane, *Project Editor*
Libby Hruska, *Manuscript Editor*
Jim Drobka, *Designer*
Michelle Woo Deemer, *Production*
Kelly Peyton and Leslie Rollins, *Image and Rights Acquisition*

Distributed in the United States and Canada by the University of Chicago Press

Distributed outside the United States and Canada by Yale University Press, London

Printed in China

Library of Congress Cataloging-in-Publication Data

Names: Grollemond, Larisa, author. | Keene, Bryan C., author. | J. Paul Getty Museum, host institution, issuing body.

Title: The fantasy of the Middle Ages : an epic journey through imaginary medieval worlds / Larisa Grollemond and Bryan C. Keene.

Description: Los Angeles : J. Paul Getty Museum, [2022] | Issued on the occasion of the exhibition Fantasy of the Middle Ages, on view at the J. Paul Getty Museum at the Getty Center, Los Angeles, from June 21 to September 11, 2022. | Includes bibliographical references and index. | Summary: "This illustrated book explores the impact of medieval imagery on three hundred years of visual culture up until the present day"—Provided by publisher.

Identifiers: LCCN 2021054978 (print) | LCCN 2021054979 (ebook) | ISBN 9781606067581 (hardback) | ISBN 9781606067604 (epub) | ISBN 9781606067598 (pdf)

Subjects: LCSH: Middle Ages in popular culture—Exhibitions. | Middle Ages in art—Exhibitions. | Civilization, Medieval, in art—Exhibitions. | Medievalism in art—Exhibitions. | Illumination of books and manuscripts, Medieval—Exhibitions.

Classification: LCC NX650.M53 G76 2022 (print) | LCC NX650.M53 (ebook) | DDC 704.9/4990907—dc23/eng/20211203

LC record available at https://lccn.loc.gov/2021054978
LC ebook record available at https://lccn.loc.gov/2021054979

Front cover: adapted from *Saint George and the Dragon* (detail, fig. 44)
Endpapers: *An Ancient Mappe of Fairyland Newly Discovered and Set Forth* (detail, fig. 61)
p. ii: *The Siege of Jerusalem in Rijmbijbel* (detail, fig. 118)
p. iv: *Paris, Notre-Dame* (detail, fig. 99)
p. vi: Gaming manual made for Alfonso X of Spain (details, figs. 130–31)
p. viii: *The Second Generation: Friedrich Derrer* (detail, fig. 95)
Back cover: Costume sketch by Mary Kay Dodson (detail, fig. 9); *Saint Maurice* (detail, fig. 22); Neuschwanstein Castle (fig. 97); The Queen of Medieval Times (detail, fig. 86)